Art Nouveau

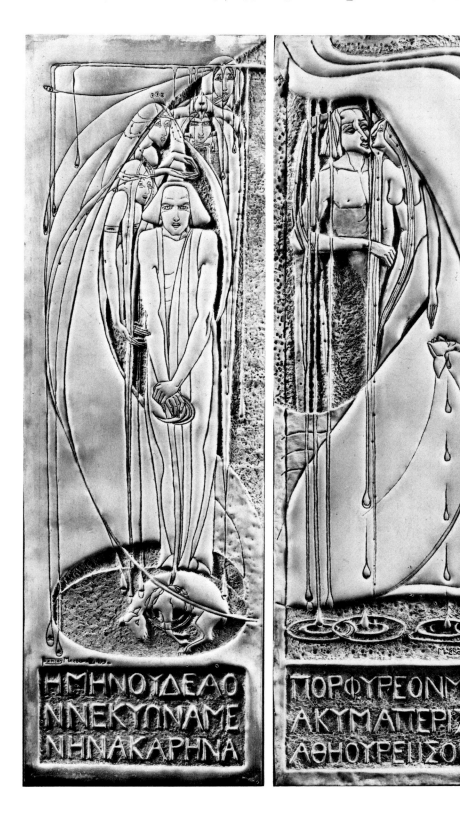

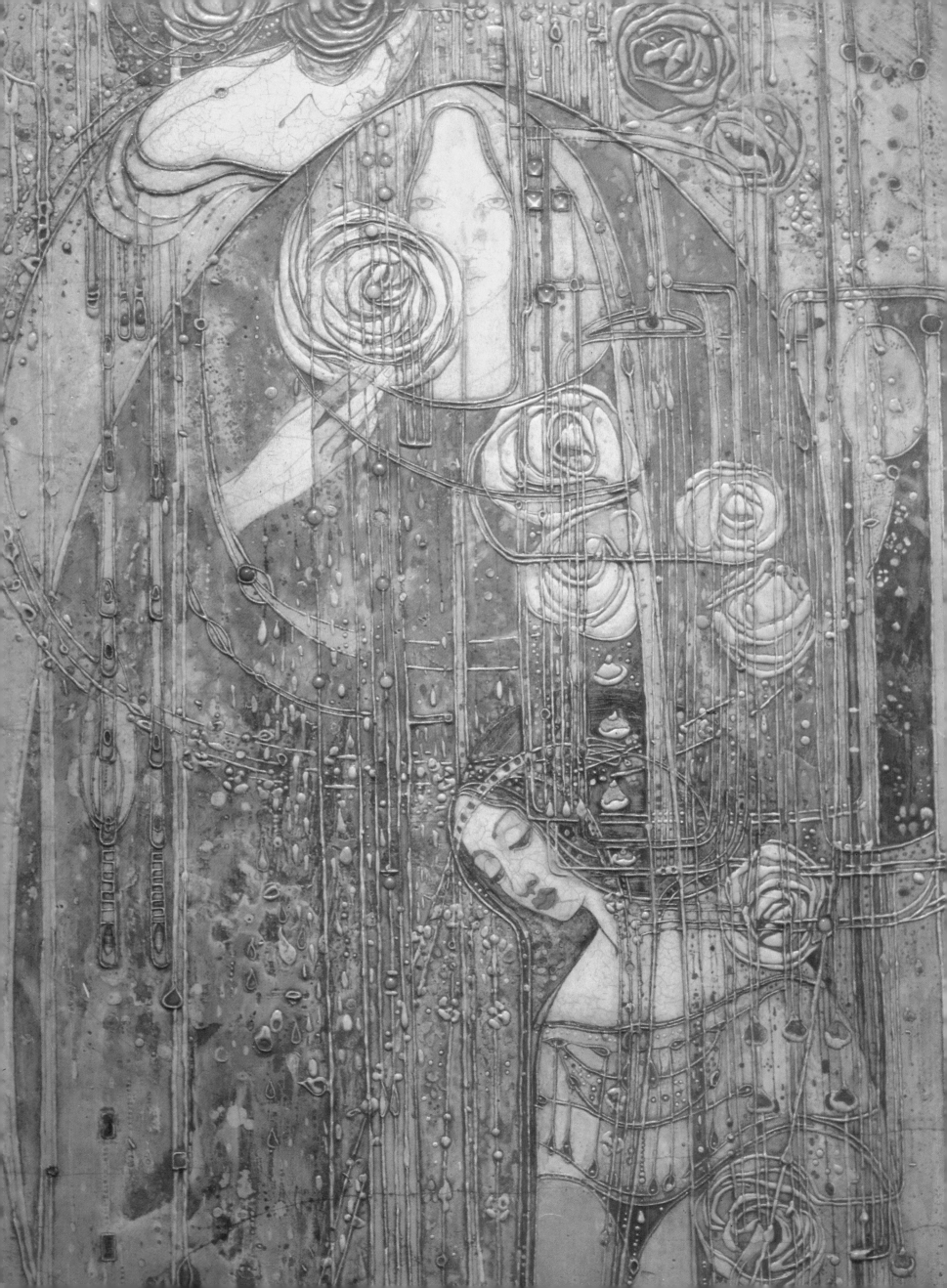

Art Nouveau

MARIA COSTANTINO

Brompton

First published in the UK in 1989
by Brompton Books
a division of the Bison Group
Kimbolton House
117A Fulham Road
London SW3 6RL

ISBN 0-86124-518-0

Printed and bound in Spain by Gráficas Estella, S.A. Navarra.

PAGE 1: *A pair of decorative panels designed by the Macdonald sisters,
Frances and Margaret, in 1899.*

PAGE 2: *Detail of a painted panel by Margaret Macdonald Mackintosh
designed for Miss Cranston's Tea Rooms at 199 Sauchiehall Street,
Glasgow.*

Contents

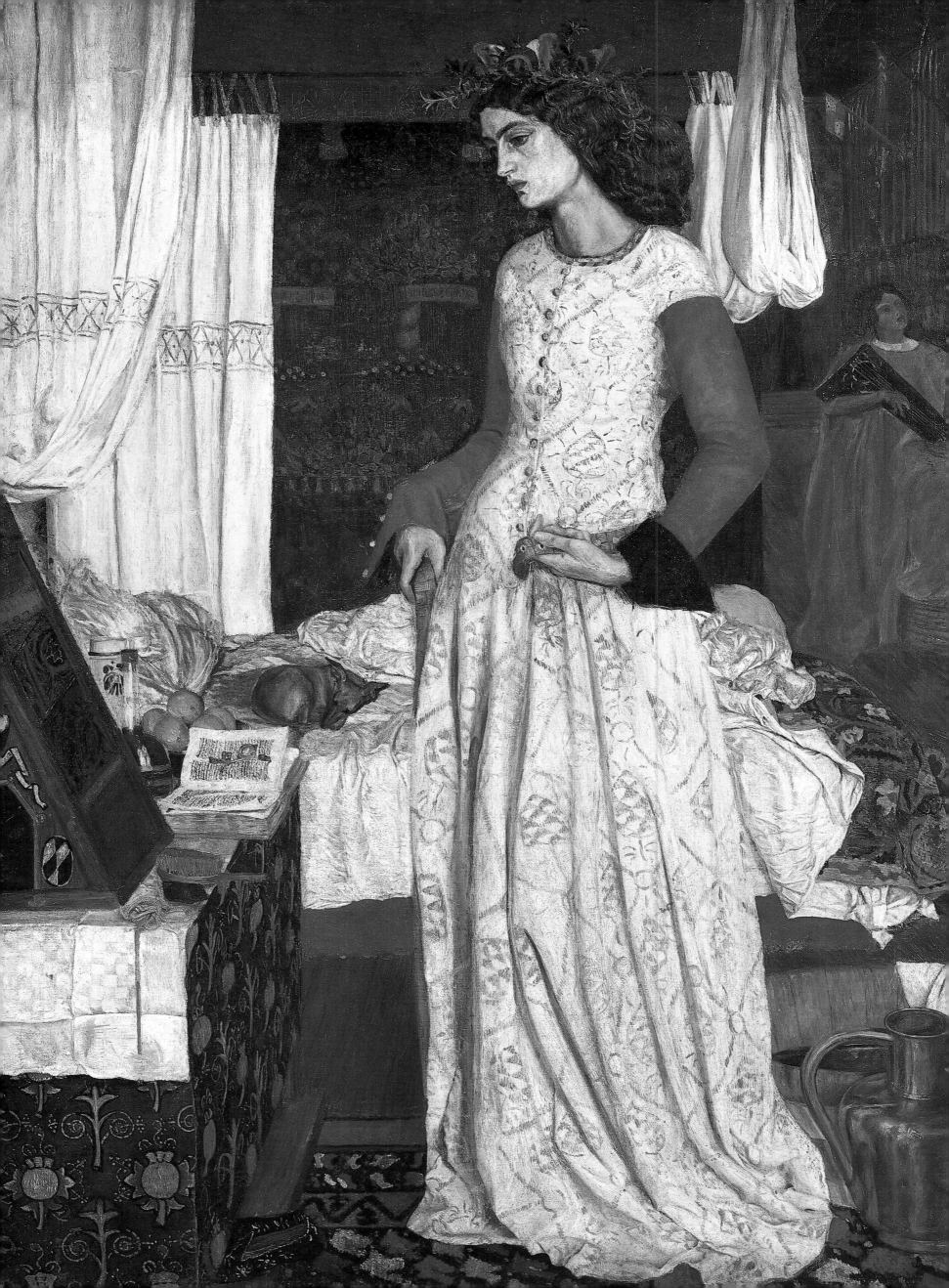

A
Changing
Society

When we look at the objects created in the Art Nouveau style, marvel at their ingenuity and wonder at their beauty, it is all too easy to forget the society that produced them. The artist does not work in isolation but is subject to the cultural, social, economic and political forces that shape his existence, and an understanding of the history of the period in which Art Nouveau appeared and flourished will, I hope, go some way to redress the imbalance inherent in a book of this nature. Furthermore the majority of Art Nouveau objects were designed and produced for a cultured elite with avant-garde tastes and beliefs. Those objects which were designed for mass consumption and made by the latest technologies and industrial methods, like advertising posters and some articles of metalwork and jewelry, were only a small part of the popular culture of the period.

After the devastation of World War I, the last decades of the nineteenth century seemed, in retrospect, an idyllic period and were remembered nostalgically as the 'belle epoque.' Certainly these years saw the flowering of civilization – with economic expansion and technological development, the arts and sciences flourished. Europe reached its zenith in terms of wealth, power and prestige. But it was also an era when many challenged the liberal assumptions about the nature of Europe's progress while other, more militant, voices sought the end of capitalism itself.

Art Nouveau, though a widespread movement, was not the only art style to flourish in this period; traditional and historical forms still maintained their position. What Art Nouveau came to represent was a break away from these traditional forms and styles. Art and design, like society at the end of the nineteenth century, were undergoing profound changes.

In 1870 Britain was still virtually unchallenged in its economic supremacy. Britain's output of raw materials and industrial goods was rising to record heights and, despite periods of depression, industrialization was spreading through Europe and beyond. In the United States the results of rapid industrialization would later have far-reaching effects on the economic, political and cultural supremacy of Europe.

Industrial expansion was closely linked to new technology. For example, new chemical processes and synthetics led to products ranging from artificial silk, plastics, dyes and bleaches to superphosphate fertilizers and explosives. More striking than the new technology itself, however, was the speed at which it was adapted to commercial and private use, spurred on by greater public purchasing power. Within two decades of its invention in 1879, the telephone rapidly became a necessary piece of business equipment and then a private convenience. The effect of the new electrical industry, made possible after the development of the steam-turbine in 1884, was enormous. In the 1860s arc-lamps were in use in public places, and by the following decade it was possible to light both streets and homes at night, and new leisure pursuits became available both in the home and outside. Electricity would further revolutionize communications: the 1890s saw the introduction of electric trams, trains

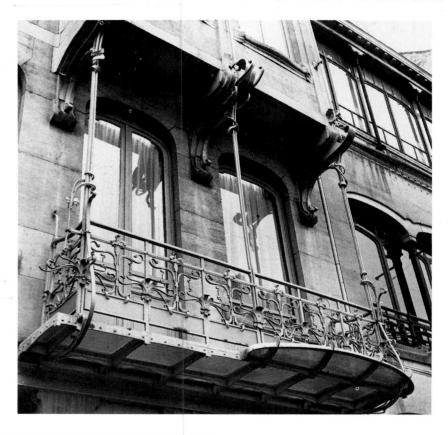

ABOVE: *The balcony of the* Hôtel Horta *(1898) in the Rue Americaine in Brussels. The curling, plant-like iron supports are typical of the curvilinear style of Art Nouveau that was popular in Belgium and France.*

LEFT: *The Palace of Electricity at the Paris Exhibition of 1900. The introduction of new technology in the last decades of the nineteenth century had far-reaching effects not only on industry but also on the arts and architecture.*

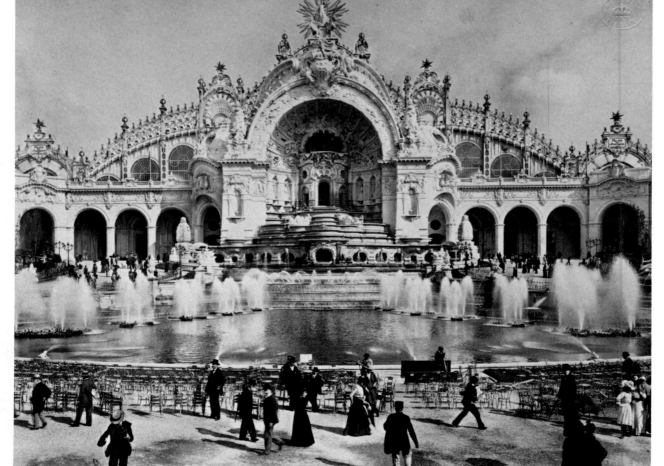

RIGHT: *The entrance hall at Hill House, Helensburgh (1902-1903), by Scottish architect C R Mackintosh. Like his Viennese and German contemporaries, Mackintosh favored rectilinear forms of Art Nouveau.*

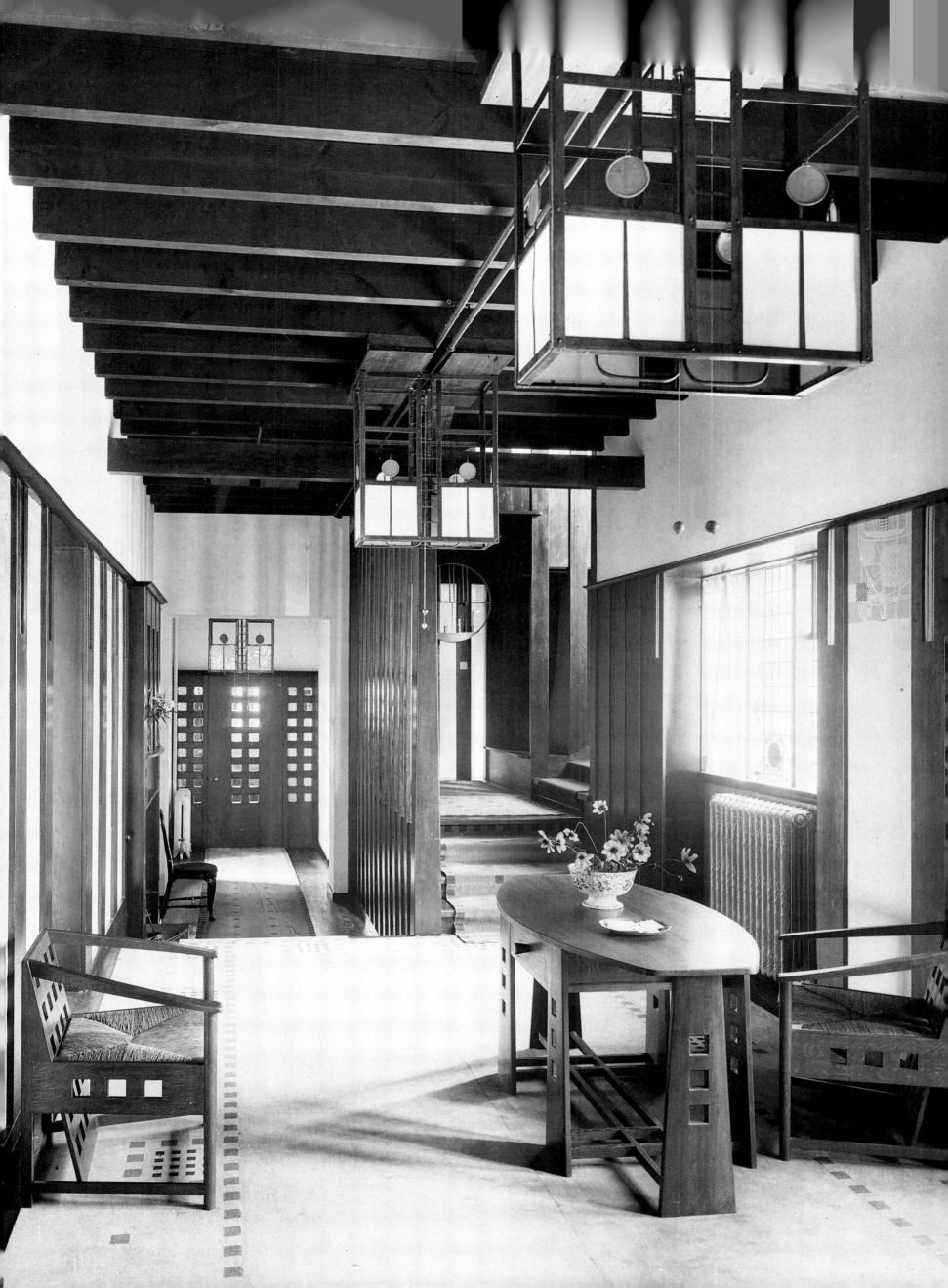

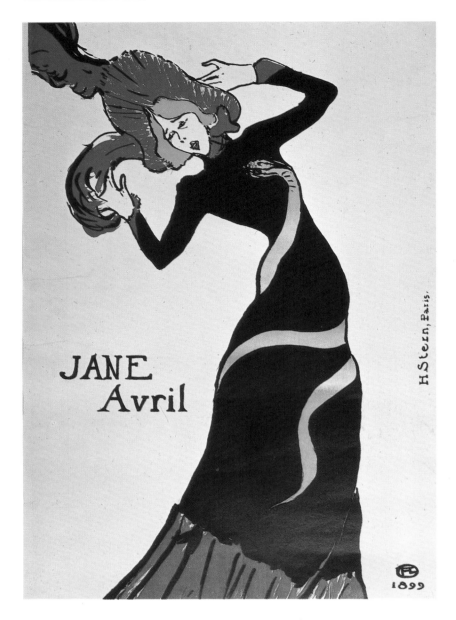

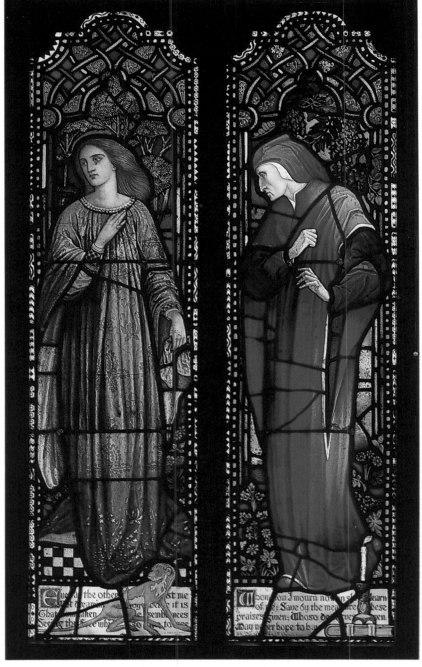

ABOVE: Jane Avril with a Snake *(1899) by the French master of posters, Henri de Toulouse-Lautrec.*

RIGHT: *This stained glass by William Willet of Philadelphia (c 1910-1920) depicts the legendary lovers Beatrice and Dante.*

and subway systems in London, Paris and Berlin, as well as other major cities. Add to these bicycles, and for the first time in history men and women enjoyed mobility without the aid (and expense) of horses. Other inventions dependent on electricity allowed for communications at great distances: the electric telegraph, the telephone and, at the end of the century, wireless telegraphy.

Sustaining the industrializing nations were growing populations – between 1870 and 1914 the population of Europe nearly doubled. In part due to industrial expansion, the growing population benefited from increased food supplies created by improved farming techniques and then opening up of huge tracts of land in the United States, Canada, Australia, New Zealand and Argentina. Thanks to railroads, faster steamships and refrigeration, these countries provided cheap food for the urban workers of Europe.

From the 1870s to the end of the century one of the most severe periods of deflation in European history took place, with falling prices, profits and interest rates. Smaller, less efficient and undercapitalized industries which often relied on handcrafting were now forced out of business, leading to the loss of many traditional skills and practices.

Improvements in health care, sanitation and medicine led *fin-de-siècle* society to believe that disease was no longer inevitable. Diphtheria, whooping cough and scarlet fever declined, and after slight outbreaks in Spain and southern Russia in 1899, plague disappeared from Europe. Louis Pasteur's work contributed to a change in attitudes to illness by showing the way forward to effective bacteriology. Analgesics and anesthetics became more readily available and effective aspirin was produced in 1897, followed soon after by Novocain, giving rise to the belief that pain itself would soon be defeated.

Industrialization and a larger, more healthy population led to continued urban growth, and by 1880 cities like London, Paris and Berlin had well over one million inhabitants. The attractions of city life, coupled with improved transport, allowed for the recruitment of labor from a wider area. The migration of people from the countryside to the cities was only a small part of a greater movement of people, however. In the last quarter of the nineteenth century over 25 million Europeans emigrated overseas, 50 percent of them to North America. News of the increased opportunities in the New World, in both North and South America, and visions of a better life spread among the newly literate lower classes and, encouraged by cheap fares, they fueled an exodus of migrants from the largely agricultural communities of Ireland, Italy, Spain and Portugal. Mainly the young and poor, these emigrants added to the overall sense of restlessness and change within and beyond Europe.

In a world that believed in progress, the attendant problems of uncontrolled industrialization and urban deprivation were hard to excuse. As the products of the very social system that generated so much wealth, they were seen as outward signs of society's imminent collapse and produced new efforts to change society itself.

Alongside a growth in the number of co-operative production and distribution societies were the efforts of trade union movements to improve wages and working conditions. Skilled craftsmen, threatened by the new methods of production, spearheaded extensive labor agitation in the last decades of the century. At the same time various socialist movements became an important part of political life in nearly every European country. In Britain a number of socialist groups working through the mechanics of parliamentary democracy united to form the Labour Party in 1900. Germany had

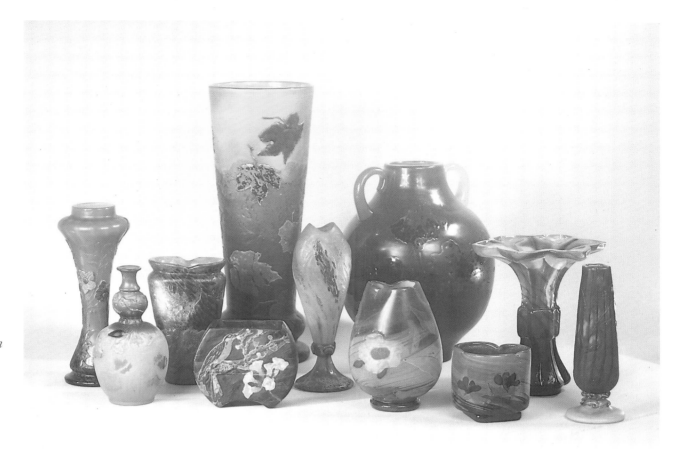

RIGHT: *A selection of glass by the botanist, furniture maker and Symbolist Emile Gallé. Like many artists and designers in the Art Nouveau style, Gallé did not confine his energies to a single field but attempted to remove the barriers that existed between the arts. Many of the forms employed by Gallé were derived from his native area of Lorraine, where he established the Nancy School.*

BELOW: *An important influence on Art Nouveau was the work of the Symbolist poets and painters. The movement was not confined to France; Symbolist works, such as* An Idyll *by the Italian painter Giovanni Segantini (1858-1899), appeared throughout Europe.*

established a socialist party in the 1870s and by the 1890s socialism was a considerable force in Spain, France and Italy. In Russia, where few advances toward democracy were made, socialism became a revolutionary force. Most socialist groups were willing to work within the existing political frameworks, but some advocated a new system entirely. For most people, however, there was no clear distinction between socialists, labor organizers and anarchists, particularly since the anarchists made headlines in both the popular press and the more serious newspapers with the assassination of five heads of state between 1893 and 1901.

Attacks on liberalism, capitalism and materialism came not only from socialists and anarchists but also from the established Church. The publication of Darwin's *The Origin of Species* in 1859 marked a key point in the challenge to established theological assumptions. In the eyes of the Church, liberalism and progress were synonymous with selfishness and materialism, and the clergy responded with a revival of biblical and theological studies as well as increased activity from charitable establishments and religious missions.

A part of this rising opposition to liberal society was anti-Semitism. Jewish practices and beliefs were often misunderstood and attacked

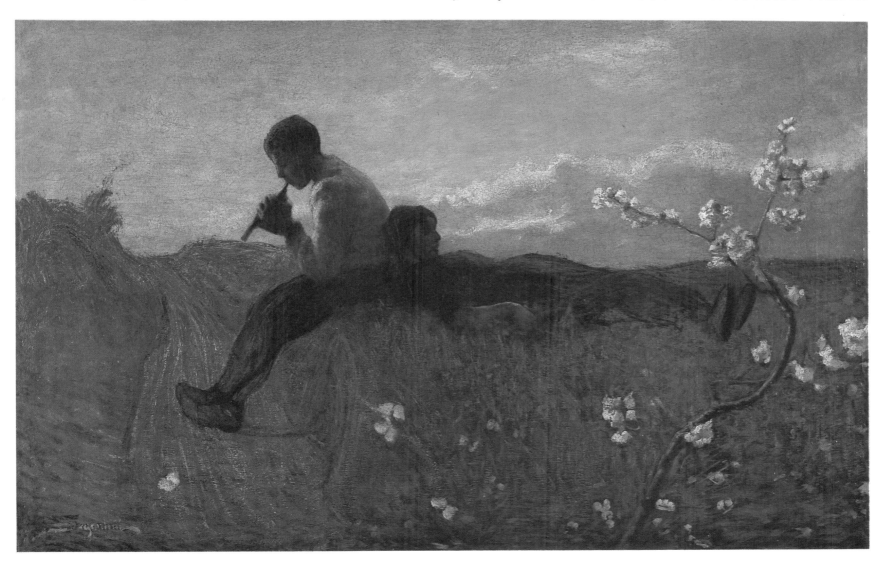

as avaricious and lacking in patriotism. Viewed as symbols of liberal capitalist society, who lived primarily in the new urban areas, Jews had found opportunities in commerce and science, the expanding businesses and professions of the century. But in their dress, culture, speech and religion, the Jewish colonies of Europe found themselves classed as foreign since nationalists had come to stress native folk culture and race. Literature of racial supremacy, often in the form of a bastardized Darwinism, appeared in the 1880s. In 1889, H S Chamberlain produced a Teutonic variation in his *Foundations of the Nineteenth Century*. Despite the Berlin Treaty which attempted to protect Jews in the Balkan states, 1880 saw a German anti-Semitic league formed in Berlin under Christian Socialist auspices. In 1881 German students rioted against Jews. In France anti-Semitism produced the best-seller *La France Juive* which was reprinted more than 100 times, and the Dreyfus affair.

Europe, with its economic power and technical superiority, was well able to dominate the less developed countries of the world. By

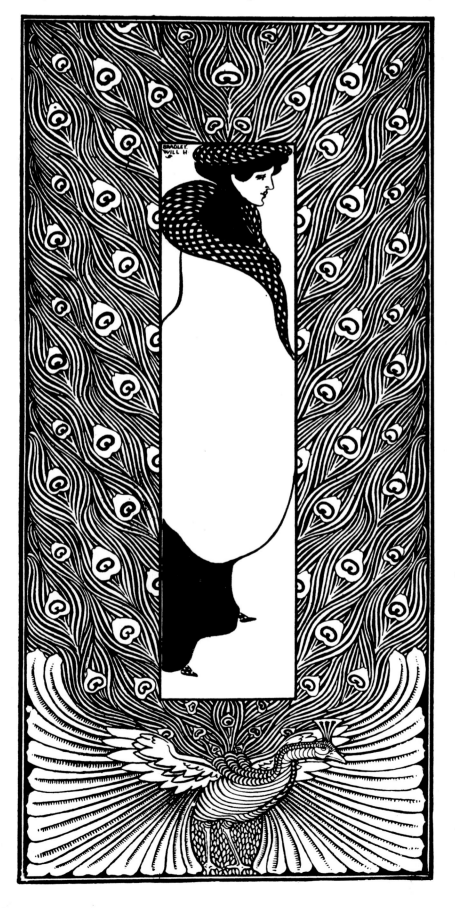

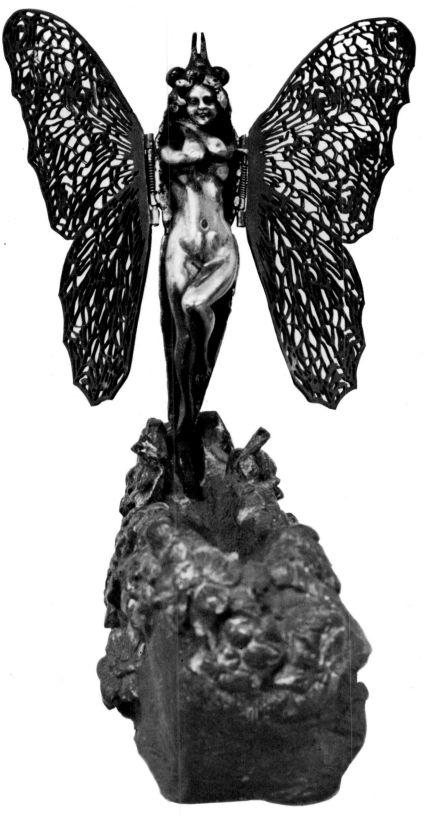

LEFT: *Two popular Art Nouveau motifs, woman and animals, feature in the work of the American posterist Will Bradley.*

ABOVE: *This bronze inkwell in the form of a moth (c 1900) has wings that open to reveal a naked nymph.*

1900 Europe controlled almost all of Africa, Southeast Asia, India, the Pacific and had gained a foothold in China. The nationalism and imperialism of the late nineteenth century was a mix of competition in economics, politics, culture and ideology among the major European powers. Many genuinely believed they were bringing civilization to savages and actively supported the religious, medical and educational missions. Alongside the collective motives for expansion were the individual ambitions of explorers and businessmen seeking fame and fortune in Africa, Asia and the Far East. But as political tensions increased in Europe, encouraged by ententes and alliances, conflicts were transferred abroad.

Despite having the military and economic power to exert pressure on the international scene, the United States, by the 1890s the richest nation in the world, had a long tradition of isolation from European affairs and confined its influence within its own hemisphere. Though not seriously engaged in extending its national boundaries, the

RIGHT: *C F A Voysey's toast rack, jug and teapot (1896-1900) break away from the Victorian practice of embellishing objects with ornate historical styles; instead, Voysey allowed the function of objects to influence their form.*

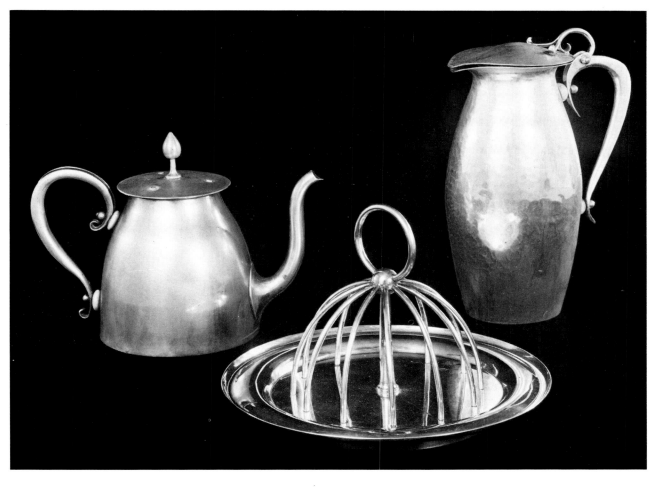

BELOW LEFT: *In this 1888 design for a printed textile, Voysey makes use of the familiar curvilinear motifs of plant forms. The most popular flowers for Art Nouveau designers included lilies, tulips and irises.*

BELOW RIGHT: *The Quezal Art Glass and Decorating Company was established in Brooklyn in 1902 by Martin Bach and Thomas Johnson. Both were former employees of Tiffany, whose influence is apparent in this Quezal vase.*

United States followed nationalist ideas of racial superiority in its attitudes and policies toward blacks, indigenous American ethnic groups and the immigrants from Europe and Asia.

Against this background of industrialization, urbanization, scienticism, nationalism and imperialism, the arts must be placed. The arts of the late nineteenth century, like the bicycles, sewing machines and cameras, were also the product of the age, and in many ways reflected the changes that society was undergoing. Furthermore, the forms and materials that arts used, their purposes and meaning, would change. If the political message of the early nineteenth century was of progress, its history appears to be the story of man's increasing power over his environment and the elements. By the late nineteenth century, this was the subject of internal criticism and debate. In the arts, while the Realists had been preoccupied with objective reality, the artists of the late nineteenth century attempted to break through surface reality to seek out a subject's innermost qualities. Art no longer needed slavishly to imitate nature, but now turned to revealing the hidden aspects of reality, including the reality of the senses, emotions and the unconscious. In such the arts would radically depart from tradition, abandoning the accepted historical and academic forms and styles.

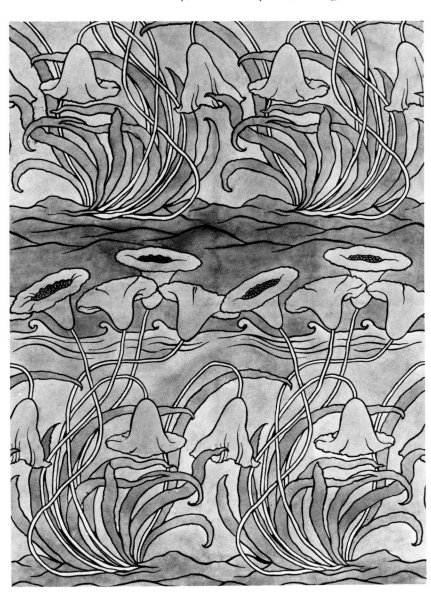

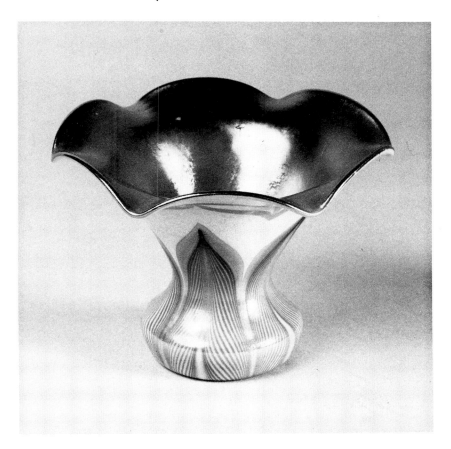

Introducing a New Style

The term Art Nouveau is applied to a style of architecture, figurative and applied arts that flourished in the last decades of the nineteenth century and the early years of the twentieth. It must be remembered however, that there was a long preparatory stage and a lasting period of influence.

From the Victorian period to the present day, design style has been split between two camps. On the one side, there is design that is machine oriented, whose products make use of angular and geometric forms and lines and are made by machine techniques in industrial materials such as glass, concrete and steel. On the other, there are design products oriented towards natural forms with curved lines in stone, wood and other materials that lend themselves to hand crafting. In the Art Nouveau period, both these tendencies are equally apparent. The curving biomorphic forms which can be found in the work of Louis Comfort Tiffany and in the illustrations by Aubrey Beardsley are perhaps the most familiar traits of Art Nouveau but, although less widespread, the rectilinear forms favored by the Scottish, Viennese and German designers would later come to dominate style in the twentieth century.

The stylistic phenomenon of Art Nouveau has been seen by many of its critics and admirers as the last European style in art and design, for after Art Nouveau we speak of individual, essentially national movements such as German Expressionism or Italian Futurism. Art Nouveau shows the last vestiges of a unity in European culture and the continuous interchange of ideas within it.

It has been said that Art Nouveau was a short-lived movement, yet when we consider its precedents, it can be seen to have lasted over thirty years – about as long as Rococo. It subsequently permeated design to such an extent that even the most common of objects such as door handles were affected by it. The whiplash curve, the *leitmotif* of Art Nouveau, is evident as far back as the Rococo style and some of the dynamic forms of Art Nouveau continued to persist in the works of Le Corbusier, Nervi and Eero Saarinen.

The sources of Art Nouveau are as diverse as the names the style was given. The earliest, *'Stile Liberty'*, was adopted by the Italians and derived from the London shop founded in 1875 by Arthur Lazenby Liberty. Under the influence of imported silks from the East – for which there had been a fashion since the Great Exhibition in 1851 – Liberty experimented with printing techniques and created his own workshops. By 1880 he had held the first of his successful exhibitions of silks and furnishings, and with exports throughout Europe, met the growing demand for the 'oriental' style fabrics that were some of the most characteristic of Art Nouveau designs from England.

The more familiar name of 'Art Nouveau' itself was given to the style by German-born art dealer Samuel Bing, whose gallery was called 'L'Art Nouveau.' Opened in 1895, Bing's gallery specialized in objects in the new 'avant-garde' style by the leading designers and artists of the day: stained glass designed by Vuillard and Toulouse-Lautrec, art glass by Louis Comfort Tiffany and Émile Gallé, posters by Will Bradley and Aubrey Beardsley and jewelry by René Lalique. Nevertheless, the Paris newspaper *Le Figaro* described Bing's products as a *'mélange'* that reflected the influence of 'vicious' English, morphine addicts, Jews and Belgian spivs. Nor did the curvilinear motifs meet with approval among the Germans, who labelled the curving style *'Bandwurmstil'* (tapeworm style) and *'Schnorkelstil'* (noodle style).

The name 'Modern Style' was on the whole used by the French in recognition of the English origin of Art Nouveau as a descendent of the Arts and Crafts Movement. However, after Hector Guimard had built the series of entrances for the Paris Métro, the French also used the term *'Style Métro'*. The name *'Jugendstil'* was inspired by the German magazine *Jugend*, first published in Munich in 1896. The *Sezession* movement, a revolt against official taste in Munich, Berlin and Vienna, gave Art Nouveau the name 'Secession Style.'

Despite the variety of names, the motive of Art Nouveau was common to all the designers: to break with the style of their immediate

LEFT: *Fabric design by Lindsay Butterfield for Liberty and Co (c 1896). One of the earliest names for Art Nouveau was 'Stile Liberty.' Arthur Lazenby Liberty had opened his shop in Regent Street in 1875 and employed many of the leading designers in his workshops.*

TOP RIGHT: *Fabric Design by Arthur Wilcox for Liberty and Co. The fashion for eastern-influenced patterns had been established at the Great Exhibition in London in 1851.*

TOP FAR RIGHT: *This design by C F A Voysey employs the interlaced floral motifs typical of much Art Nouveau design.*

RIGHT: *The Great Exhibition by the Dickinson Brothers (1852). The Crystal Palace marked a new era in industrial building techniques.*

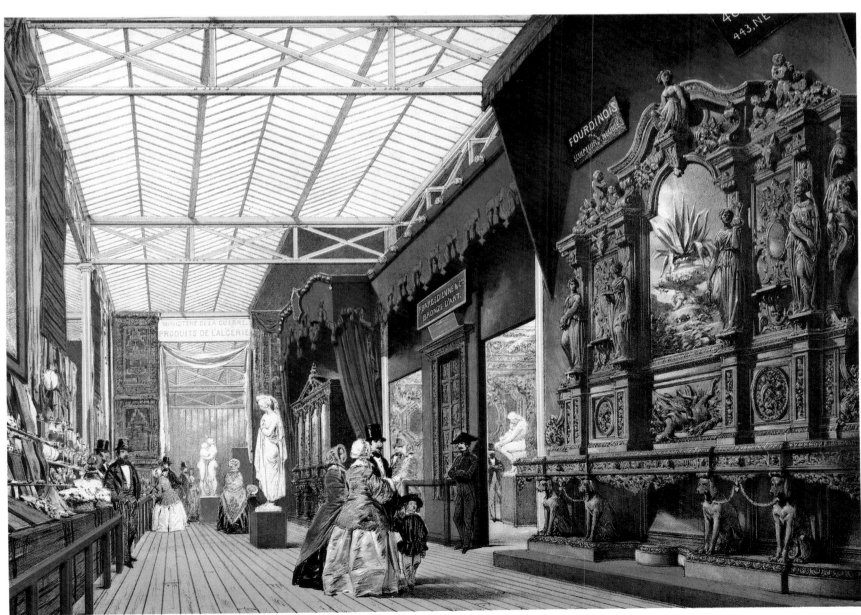

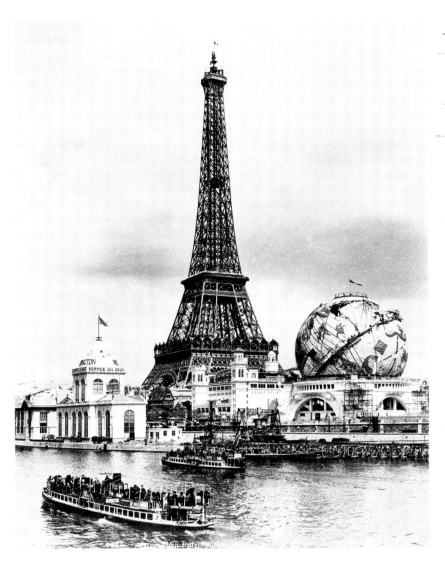

end of the eighteenth century, a schism emerged between the architect and the engineer – itself part of the overall division between art and science – that was to characterize much of the work of the nineteenth. In a period of rapid scientific development, when new materials and methods were being discovered, artists hid behind a veil of romanticism. While engineers were triumphant, architects sought sanctuary in historical styles. A Greek revival and an Egyptian revival overlapped with the Gothic, only to be followed by a Renaissance revival. This stylistic chaos, the result of the competition by architects for public attention, led to an indiscriminate application of a pastiche of historical styles and motifs, and was known as the 'Battle of the Styles.'

While the architects were busy arguing the merits of one style over another, engineers were developing new structural systems which had grown out of the need for more space in factories. As cast and wrought iron were improved both in quality and appearance, a new architecture of iron, wood and glass developed. At first cast-iron columns were used with timber girders and beams. The outer walls of masonry covered the framework and carried much of the weight of the roof. As iron girders replaced timber, much greater spans between columns became possible since the span width was no longer reliant on the length of trees. For industrial expositions, large column-free spaces were needed to house the exhibits. For these, the building forms were designed around an iron framework; once this had become self-sustaining, the outer shell lost its structural importance, and non-structural materials such as glass could be used for the exterior surface. This 'greenhouse' type construction was the precursor of the the modern steel-frame, 'curtain-wall' construction technique that is so familiar today.

The Crystal Palace, designed by Joseph Paxton (former landscape gardener to the Duke of Devonshire at Chatsworth House in Derbyshire), was built for the Great Exhibition of 1851 and marked the first major break with the emphasis on historical styles in architecture. In terms of the materials used – iron, wood and glass – there was little new; the use of iron in architecture had begun in France as early as the 1780s with the work of Soufflot and Louis. What was new about the Crystal Palace was the industrial production of its components and its prefabrication. The Crystal Palace, followed later by the Halle des Machines (primarily the work of the engineer Contamin) and Eiffel's hat-pin tower, both built for the Paris Exhibition of 1889, demonstrated that the machine was to be of modern style and that technology would provide the new building materials. Architects would be preoccupied with the steel-ribbed glass cage for the next century until its stylistic problems were resolved in 1958 with Mies van der Rohe's Seagram Building.

predecessors and to revolutionize design by adopting an aesthetic where the *function* of an object was influential on its form. In a period of intense industrialization, many Victorian objects (which were often very functional) had been designed using forms that disguised their function under a heavy cloak of historical styles. But the apparently new forms of the Art Nouveau designers actually had their precedents in a variety of sources from the Industrial Revolution to a growing taste for Japanese prints, and from a renewed interest in ancient civilizations to the works and teachings of William Morris and the art and literature of the Symbolists.

Probably the greatest force in the development of nineteenth- and twentieth-century art and design was the Industrial Revolution. At the

ABOVE: *The Eiffel Tower at the Paris Exhibition of 1889. The revolutionary iron tower marked a break with historical styles in its use of new construction materials and methods, and came to symbolize the modern age of the machine.*

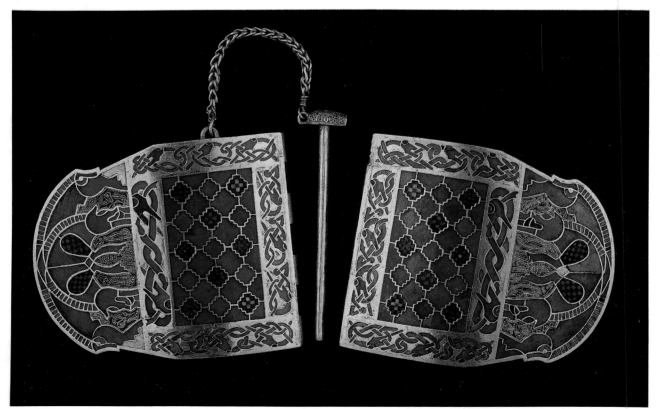

LEFT: *Art Nouveau designers often borrowed motifs and patterns from early medieval artifacts that featured twisting, interlaced animal forms such as those on this hinged clasp from the seventh-century Anglo-Saxon ship burial at Sutton Hoo.*

RIGHT: *The late nineteenth century saw a revival of interest in Celtic culture. Illuminated manuscripts such as the* Book of Kells, *with its intricate patterns of interlaces and abstract animals, were a potent source of imagery for the rectilinear style of Art Nouveau. This resurgent nationalism was not confined to the Celtic countries; artists in Europe and America were seeking forms that echoed their own countries' history and culture. The nationalist ideas that were coming to the forefront of the political life of the period were making themselves felt in the arts.*

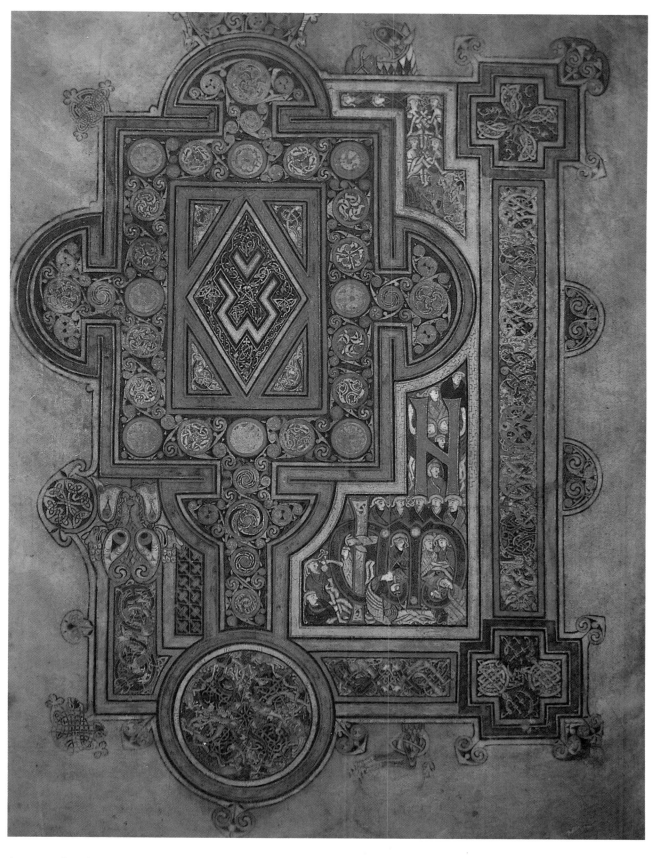

Despite efforts to break with the historical styles that preceded it, Art Nouveau nevertheless continued a tendency to use motifs and themes from the styles of the past. Art Nouveau artists justified this by proclaiming that their work was based on their 'current reality.' Where the Victorian artists and designers revived elements of historical styles to create association, Art Nouveau artists introduced symbols to stand directly for specific ideas.

In the last years of the nineteenth century, Scottish and Irish culture found itself linked to what amounted to a revival in national pride. From the pattern of interlaces and abstracted animals found in Celtic manuscripts and early medieval artefacts, Art Nouveau designers borrowed motifs that would be the source of rectilinear style. And since the original intention of psalters and illuminated texts such as the *Book of Kells* was to be a means of instruction and enlightenment, an aim shared by the vanguard of designers, they were particularly appropriate sources.

Elsewhere, in Europe and America, there was a similar revival of interest in each country's traditional vernacular styles. Many artists like C R Mackintosh, Gaudí, Horta and Hoffman would look beyond the more 'international' Gothic or neoclassical styles towards forms that were influenced by their own country's tradition, population, materials and building techniques and requirements. Many believed that a rejection of European historical prototypes would allow a new contemporary art and design to emerge, and that 'historicism' could be replaced by 'nationalism.'

Where Celtic or early Christian art forms influenced the rectilinear style of Art Nouveau, the curvilinear style was to be affected by the art of Japan. According to many historians, the Impressionist painter Félix Bracquemond (1833-1914) was the first European artist to discover Japanese prints when, in 1856, he bought a series of woodcuts by Katsushika Hokusai (1760-1849) in a Paris print shop. Bracquemond's find was presumably made possible by Commodore Perry's opening of Japan in 1854, which was followed by a commercial treaty between Japan and America in 1859. Until that time, Japan had remained firmly closed to international trade, but now a steady flow of prints, ceramics, textiles and other articles were found in fashionable shops in all the major European and American cities. One such store, 'La Porte Chinoise' in the Rue de Rivoli in Paris, was opened in 1862

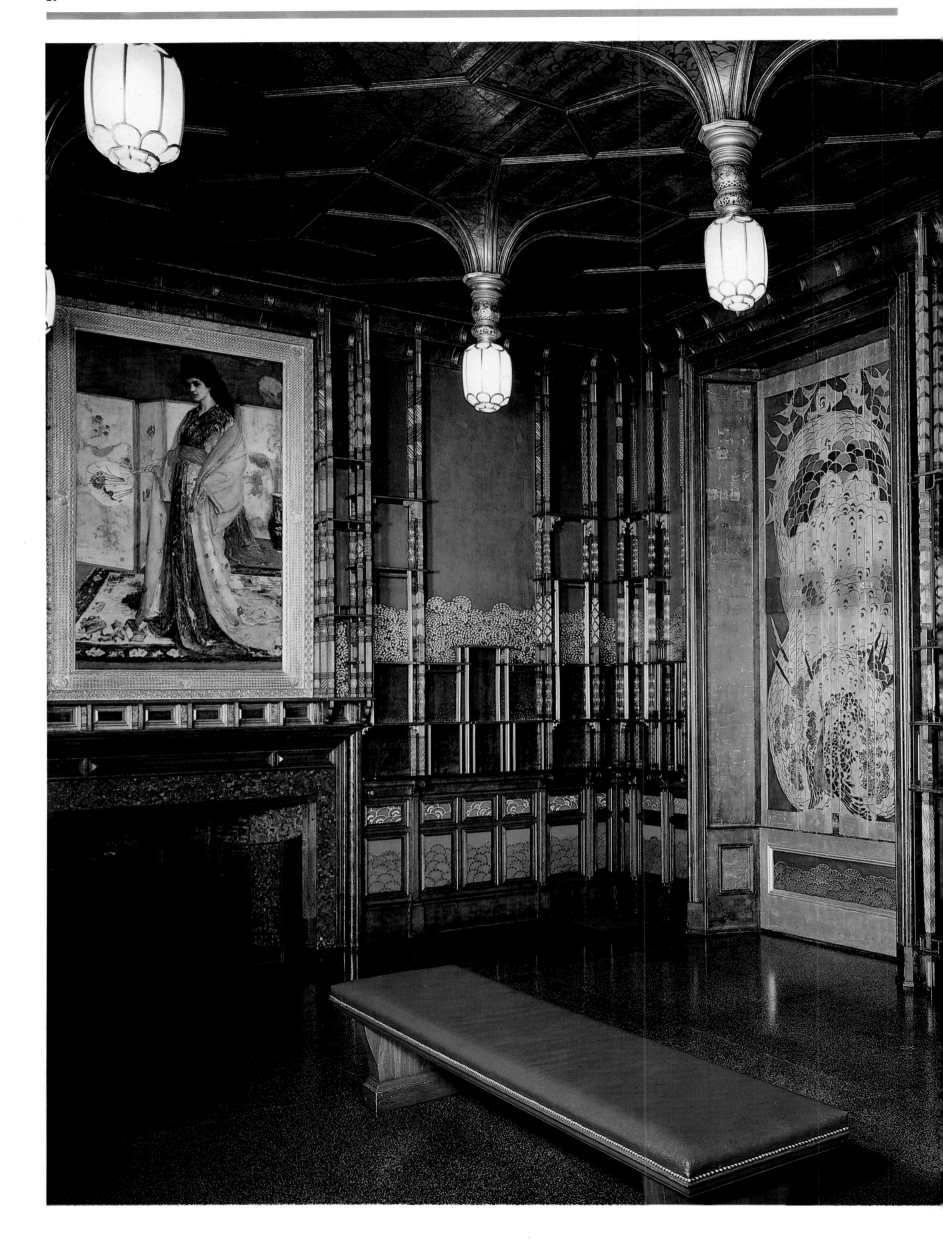

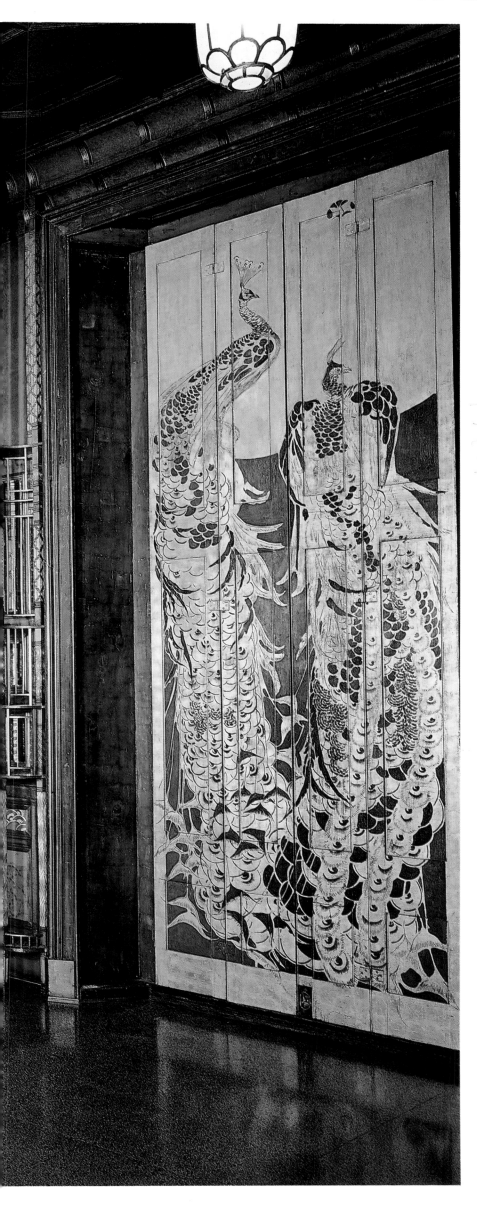

by Madame de Soye. Here Eduard Manet and the American painter James McNeill Whistler bought ceramics, kimonos, fans and prints that would dramatically affect their painting by replacing the traditional Western concept of perspective with a more ambiguous, flattened treatment of space and introducing linear patterns whose rhythms would eventually be incorporated into Art Nouveau. Japanese prints would become well known to many artists: Hiroshige's (1797-1858) *A Heavy Shower on the Ohashi Bridge* led Van Gogh paint a copy complete with phony calligraphy; in 1889, Gauguin painted his *Still Life with a Japanese Print*. Where Manet used Japanese art to advance to Impressionist approaches and techniques in painting. Whistler tended to incorporate the actual objects in his works, rather like stage props. In the *Princesse du Pays de la Porcelaine* (1864), Christina Spartali, the daughter of the Greek Consul General in London, is depicted kimono-clad with fan against a folding screen. Whistler's enthusiasm for the oriental was to produce one of the most enduring of the curvilinear Art Nouveau symbols, the peacock, which would find its way onto fabrics, glass and illustrations as well as into the famous Peacock Room, designed by Thomas Jeckyll and decorated from 1876-77 by Whistler in blue and gold for shipping magnate F R Leyland's collection of porcelain.

Machine production satisfied the demands of a growing middle class intent on acquiring the symbols of success and achievement that had previously been the prerequisite of the nobility, reproducing in large quantities the hand-crafted decorative items such as wallpaper, textiles, glass and ceramics. Caught in a vicious circle was the working-class consumer forced, by lack of money and the need to maintain a precarious gentility, to buy the shoddiest factory products.

LEFT: *The Peacock Room, showing Whistler's painting* La Princesse du Pays de la Porcelaine *(1864).*

BELOW: A Heavy Shower on the Ohashi Bridge, *by the Japanese artist Ichiryusai Hiroshige.*

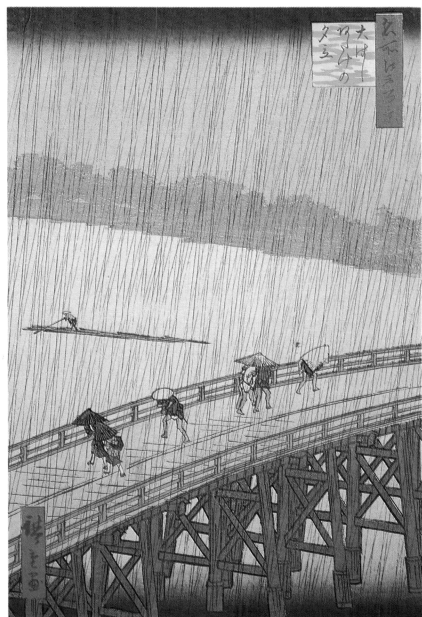

The problems that accompanied industrialization contributed to the social protests of the age. Central to many such protests was the dichotomy that God made the country and thus it was good, and man made the city which was therefore evil. Variations on this theme expounded the virtues of handwork alongside condemnations of the labor-saving machines. As industrialization was responsible for technological unemployment, long working hours, dangerous conditions, child labor and slum housing, moralists like William Morris argued for the suppression of industry and a return to the handcraft tradition. Accompanying the social objections were those made on the grounds of aesthetics against the products themselves, objections which would be the catalyst in developing theories of design.

William Morris (1834-1896) was essentially the first artist to raise his voice in disapproval of Victorian industrial design. Although his ideas had been anticipated by those of the critic John Ruskin, Morris went a step further by initiating practical projects to improve the situation. The son of a stockbroker, Morris was born in Walthamstow on the outskirts of London and educated at one of the new Victorian public schools, Marlborough. He went on to study for the clergy at Exeter College, Oxford, where he struck up an enduring friendship with Edward Burne-Jones. The two friends were taken on as assistants by Dante Gabriel Rossetti (1828-1882), a founder member of the Pre-Raphaelite Brotherhood who had agreed to paint a series of frescoes for the newly constructed Oxford Union debating halls. Jones and Morris were captivated by Rossetti and, after visiting Amiens, Beauvais and Chartres, they abandoned their earlier studies and left Oxford to commit themselves to art – Burne-Jones to painting, Morris to architecture.

BELOW: *William Morris (1834-1896), from an original photograph by Fredrick Hollyer. Morris was the first artist to protest against Victorian industrial design.*

RIGHT: The Pelican, *a cartoon by Edward Burne-Jones for a stained glass window to be made by the firm of Morris and Co.*

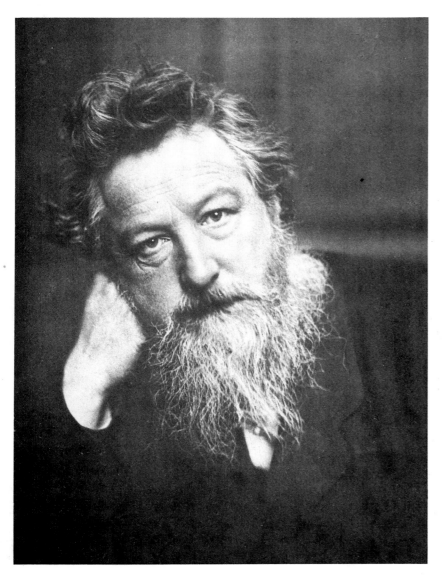

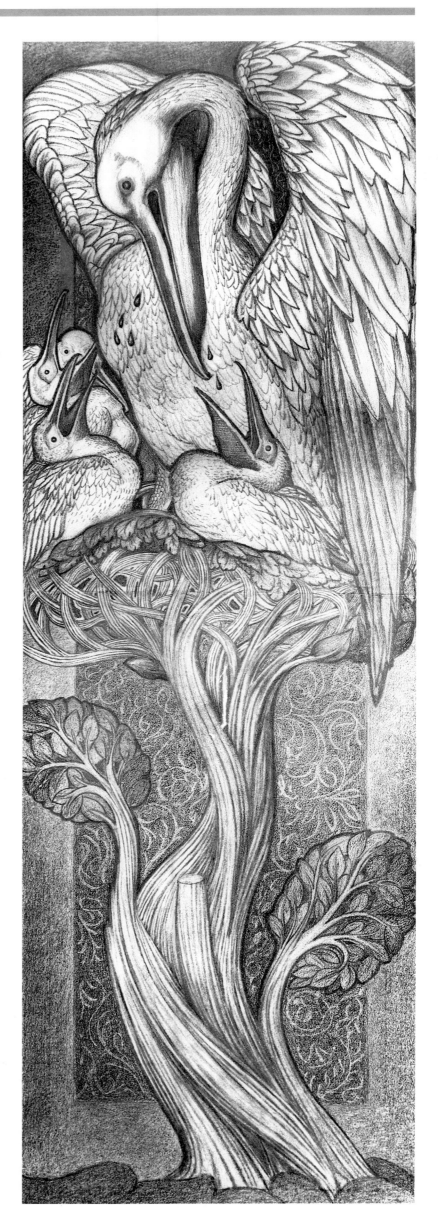

RIGHT: *The fashion for the orient is evident in* La Princesse du Pays de la Porcelaine *(1864), James McNeill Whistler's portrait of Christina Spartali. Until 1854, Japan had remained firmly closed to the west, but in 1856, Félix Bracquemond discovered Japanese prints in Paris. The treatment of space and the rhythmic linear patterns in Japanese art had a dramatic effect on European painting and would eventually be incorporated into Art Nouveau.*

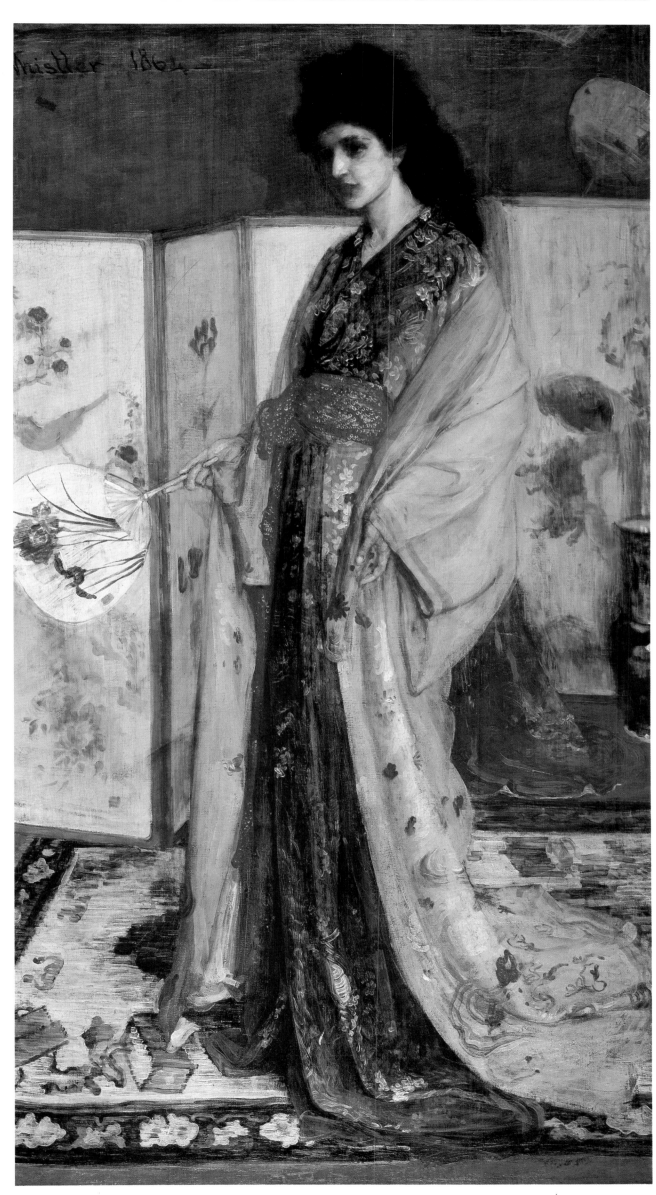

DGR
March 1850

Morris then found himself a position in the offices of G E Street, where Philip Webb was employed as senior clerk: Webb later designed the Red House for Morris at Bexleyheath in 1859. Morris's only easel painting to survive from the year he spent as a disciple of Rossetti is *La Belle Iseult* (1858), which betrays the Pre-Raphaelite obsession with detail alongside Morris's own love of patterns and textures. The subject, taken from Thomas Mallory's *Le Morte d'Arthur*, of the beautiful Iseult who was adored by one knight but loved another, is

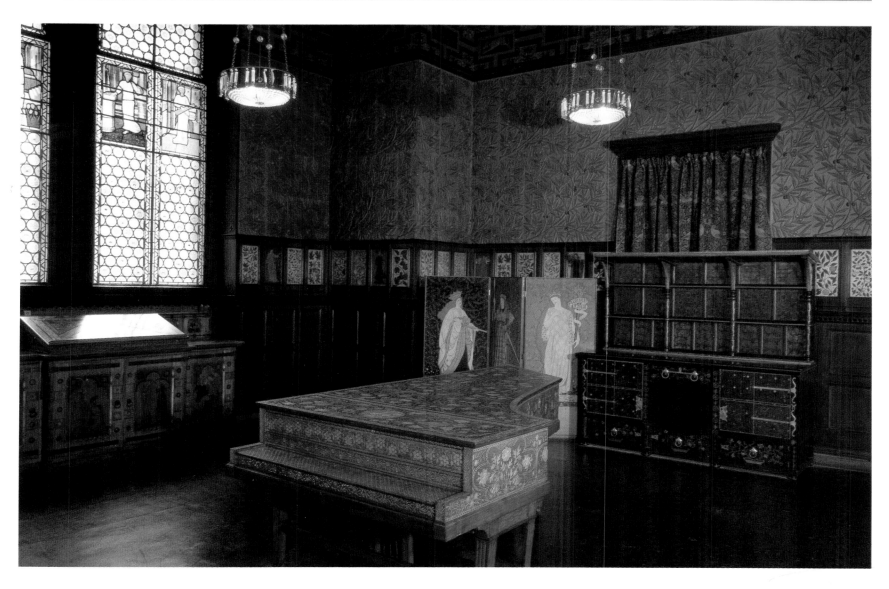

strangely coincidental. The model, Jane Burden, was discovered by Morris and Rossetti at Oxford and both fell in love with her. Though Rossetti's work is haunted by her image, Morris would marry Jane in April 1859.

In searching for a suitable home, Morris came to the conclusion that the fixtures and furnishing that were readily available were unsatisfactory: how could he produce beautiful art when surrounded by such ugliness? Therefore Webb designed the Red House and, abandoning painting, Morris devoted his time and energy to creating the living areas he felt were in tune with his principles. The resulting home was the Red House, was so called because of its construction in red brick at a time when stone and stucco were fashionable. The Red House was an original home: functional, practical and comfortable, it marked a break with slavish architectural imitations of the past. Where a regular classical façade conceals the layout of the interior space behind it, Webb allowed the function of each room to influence the entire design of the house. Views of the Red House show a great deal of what can be described as 'irregularity': there are circular, pointed and flat-topped windows alongside arches and turrets.

The collective effort by Morris and his friends in furnishing the Red House eventually led Morris to consider the possibilities of producing their designs for sale to a discerning public. Calling themselves 'Fine Art Workmen in Painting, Carving, Furniture and the Metals,' the firm of Morris, Marshall and Faulkner was established in 1861. The firm's partners were Morris, the painter Ford Madox Brown, Burne-Jones and Rossetti, architect Philip Webb, Brown's friend P P Marshall and an accountant C J Faulkner, a close friend of Morris and former mathematics don at Oxford.

LEFT: *'Bird,' a double woven wool cloth by William Morris (1878), illustrates his belief that patterns should not be imitative or historical reproductions, but recreations of natural forms.*

RIGHT: *This chair by William Morris, in ebonized wood with turned decoration, is still upholstered in its original 'Bird' design wool cloth. The quality of Morris's dyes and craftsmanship is apparent in its good condition after a hundred years of use.*

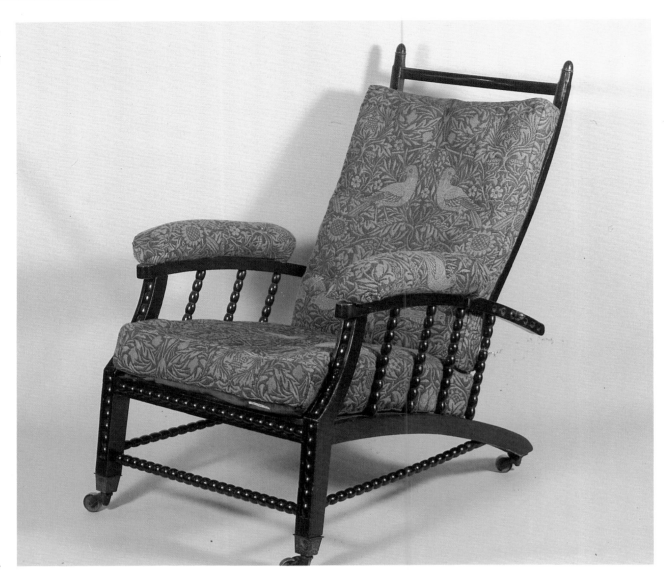

BELOW: The Works of Geoffrey Chaucer *published by Morris's Kelmscott Press. Burne-Jones provided the illustrations, Morris provided the decorative borders and designed the typeface, aptly called 'Chaucer.'*

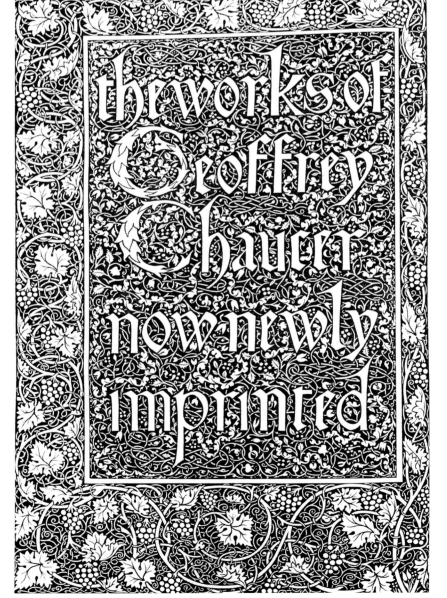

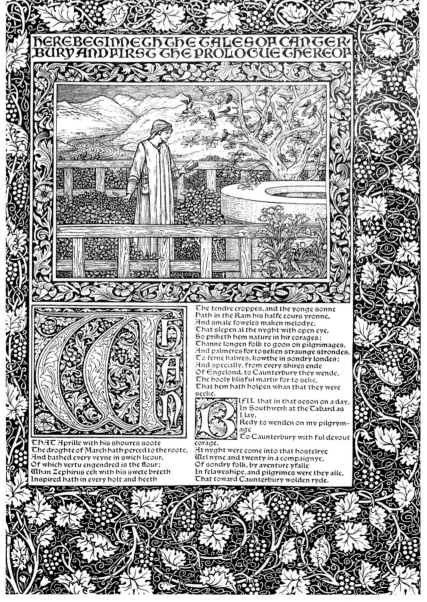

The firm first came to public attention with their exhibits at the International Exhibition at South Kensington in 1862, where they won praise and prizes for their work. Increased orders followed, and the firm expanded, moving in 1865 to Queen's Square near the British Museum.

Throughout the 1860s Morris was busy producing the needle-works he had started while working on the Red House, as well as the first of his many wallpaper designs. The basis for Morris's wallpaper designs and chintzes lay in knowledge of natural forms and historical precedents. Within these designs are contained the prototypical symbols and motifs, such as flowers and vines, of Art Nouveau.

For many years Morris had helped Henry Cole build up a collection of tapestries, carpets and embroideries from all over the world, and particularly from the Middle East, for the new museum at South Kensington. But Morris was adamant that patterns should not be imitative or historical, but should be re-creations of nature, and that the designs should be true to the surfaces they ornamented. Morris made extensive studies into suitable dyes to satisfy his demands for permanent colors that were not like the acid colors derived from newly developed chemicals. Many of Morris's patterns were produced using an indigo dye discharge technique, whereby the cloth was dyed completely in an indigo vat and then printed with a bleaching agent which would reduce or remove the indigo as the design required. His experiments and techniques resembled those of an alchemist rather than a designer, but the quality and the strength of color after a hundred years bears testament to his skill.

RIGHT: *Crane's poster for his* Floral & Fanciful Books in Colour.

BELOW: *Walter Crane's cover design for an exhibition catalog of his own works shows him continuing Morris's attempts to reform design.*

BELOW RIGHT: *This fretwork-backed chair was designed by Arthur Heygate Mackmurdo for the Century Guild around 1880.*

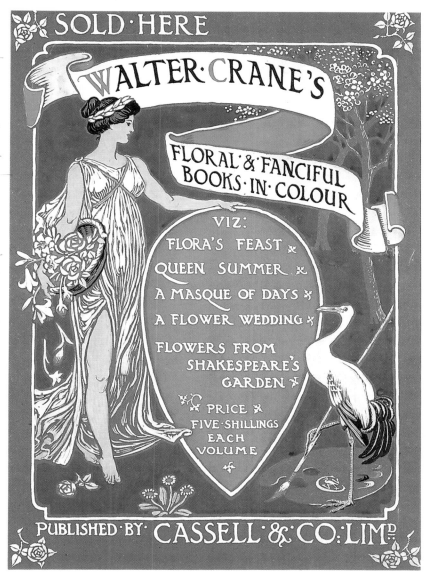

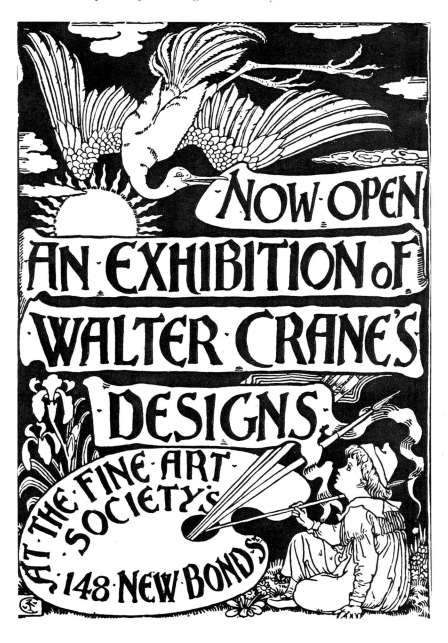

In 1871, Morris found Kelmscott Manor in the Thames Valley, about twenty miles west of Oxford. It was here that he developed his poetry, especially the works he derived from old Norse legends he had discovered on visits to Iceland. As his reputation grew, Morris was also drawn into official art education: he started lecturing on his fledgling socialist views on art and its role in society. These views would have an enormous impact in Europe and America as well as in England. In 1880, in an address to Birmingham School of Art, Morris delivered one of his most often cited maxims: 'Have nothing in your houses that you do not know to be useful or believe to be beautiful.'

By 1875, however, the firm was in financial trouble. The partnership was dissolved, and the firm was re-created as Morris and Co. Morris was now firmly in charge, and new showrooms were opened on Oxford Street in 1877. The following year Morris moved his base to Hammersmith. In the new house, called Kelmscott House, Morris established carpet looms and the Kelmscott Press.

After his studies of oriental carpets, Morris began to experiment and design for his own looms. The so called 'Hammersmith' rugs show his work in the continued hand knotted technique. Although machines remained his arch enemy, Morris felt he ought to become the master of them. After the carpet making was transferred to Merton Abbey, Morris tried a range of designs, such as 'Lily,' for machine production by approved manufacturers.

Like many of his efforts to revive lost crafts and skills, Morris's revival of interest in typography and printing would have a great influence on book and periodical design. For the famous Kelmscott Chaucer, Burne-Jones made drawings for eighty-seven illustrations; Morris added decorative borders and designed a typeface, called appropriately 'Chaucer,' which was more like Gothic hand lettering than anything designed for a modern press. In his desire to produce

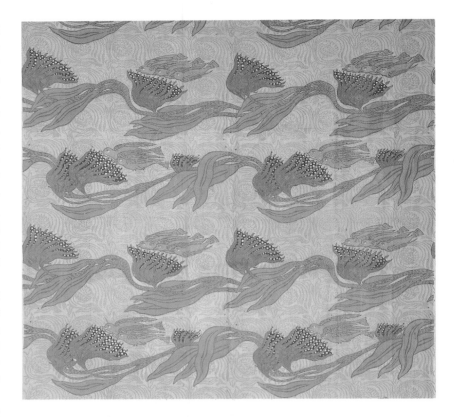

ABOVE: *'Cromer Bird,' a printed fabric designed* c *1882 by A H Mackmurdo for the Century Guild.*

BELOW: *Gauguin's* The Vision After the Sermon *(1888) depicts Breton religious experiences.*

BELOW RIGHT: *The architect Henri van de Velde's house at Uccle. Here van de Velde entertained Toulouse-Lautrec with a dinner where food, drinks and decor were all black.*

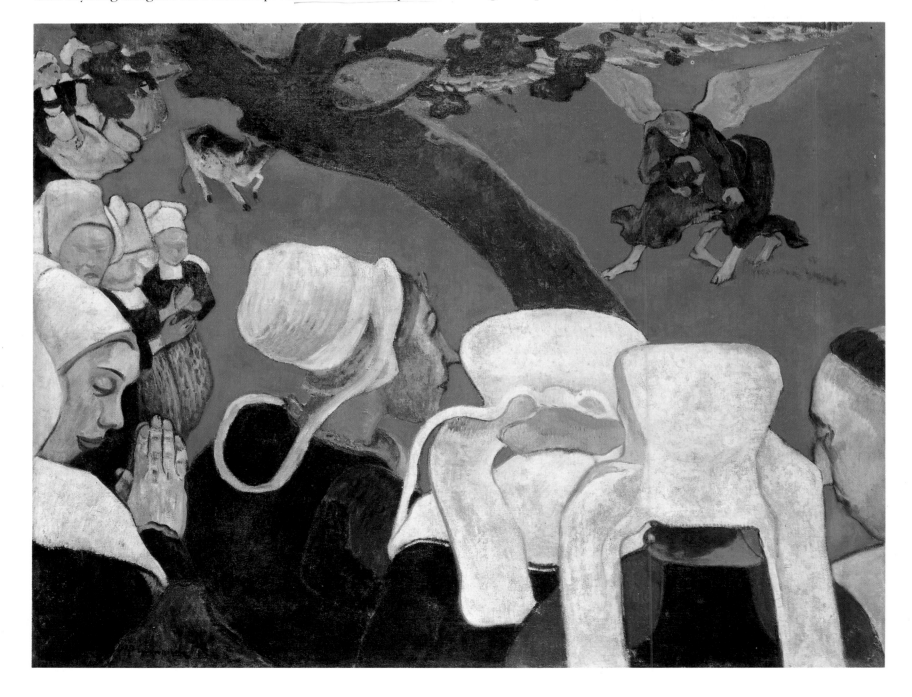

books that were easy to read as well as being things of beauty, Morris really only succeeded in the latter. Of the fifty-three books he designed and published at the Kelmscott Press, each was beautiful and precious, but none easy to read.

Nevertheless, Morris's attempts to improve the quality of printed material was carried on by his followers in the Century Guild in England who produced their magazine *The Hobby Horse*, and abroad in Boston, Massachusetts, by a similar magazine, *The Knight Errant*.

Despite criticism that Morris's artistic achievements were at odds with his socialism – since he as far as possible refused to employ machine methods his products were expensive, bought by only a narrow circle of educated and wealthy patrons – the effects of his teachings were such that many of the following generation of artists, architects and designers would devote themselves to improving design. Of particular importance were disciples such as Walter Crane, C R Ashbee and Arthur Heygate Mackmurdo, and groups formed to further design like the Century Guild, the Art Workers Guild and the Guild and School of Handicrafts.

After Morris's death, however, England's part in preparing the world for the Modern Movement came to an end, and the pioneering of design passed to the United States and to Europe, where an admiration for the achievements of the Industrial Revolution had fostered a greater understanding of the consequences of industrialization in the relationship between architecture and design and the use of ornament. Among the first to acknowledge this were the Austrians Otto Wagner and Adolf Loos, Americans Louis Sullivan and Frank Lloyd Wright and the Belgian Henri van der Velde, all of whom at some stage in their careers used the forms of Art Nouveau.

Dissatisfaction with the state of art and civilization in the newly industrialized world, however, was not peculiar to Morris nor confined solely to England. Throughout Europe in literature, art and philosophy there appeared a rejection of the scientism, materialism and moralism of the 1880s.

One form that this reaction took was a drive towards mysticism, decadence and even the occult. This was to have an influence on Art Nouveau: Beardsley and Wilde would reconvert to orthodox religion on their deathbeds; Sar Péladan headed the Rosicrucians, a group of religious and mystical symbolists whose influence reached its height under Alphonse Mucha; Paul Gauguin, from 1886, led the Synthesists at Pont-Aven in his use of symbolic forms and colors in his representations of the primitive religiosity of Breton peasants; and Maurice Denis, the principal theorist of the *Nabis*, would be inspired in his dictum that the painting was a flat surface covered in colors assembled in a particular order – an approach that would herald the simplified patterns of Art Nouveau.

In France the protests against the spirit of the age often came in the form of a provocative stance that was determined to shock conventional bourgeois society. Inspired in part by the cult of 'Dandyism' and artificiality promoted by the poet Charles Baudelaire, the most exotic of characters, Count Robert de Montesquieu, emerged to serve as the model for des Esseintes, the principal character in Huysmans' novel *À Rebours*.

À Rebours describes des Esseintes' search for sensual pleasure in a private world, his house, which is decorated and filled with rare and luxurious objects. Here des Esseintes spends his evenings preparing drinks in colors to match his moods and giving a supper where the decor, table and food are all black. To demonstrate the closeness of the Symbolists to the Art Nouveau artists and designers, it is worth noting that Henri van der Velde gave a similar dinner at his house in Uccle in Belgium for Toulouse-Lautrec.

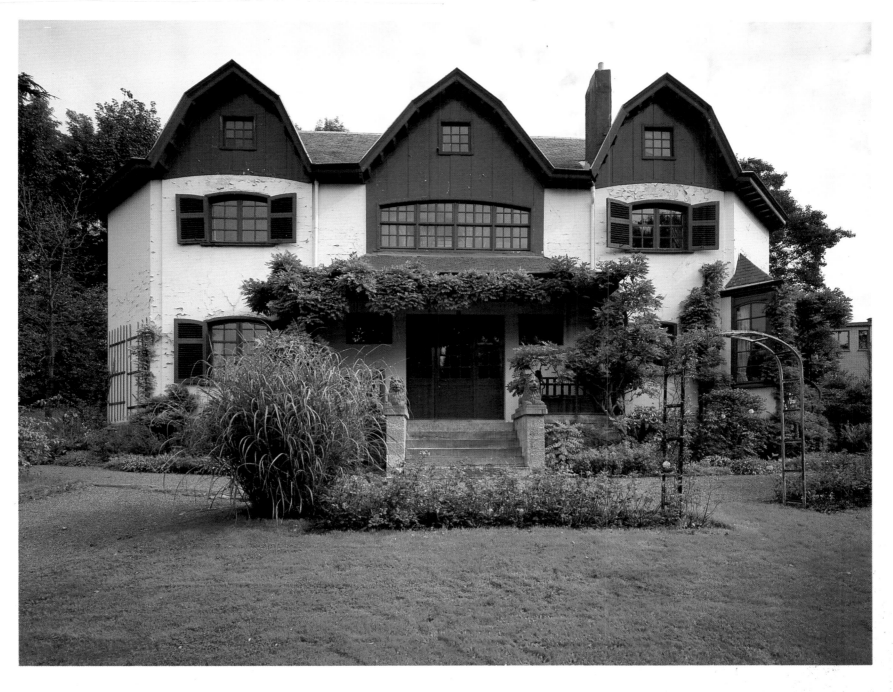

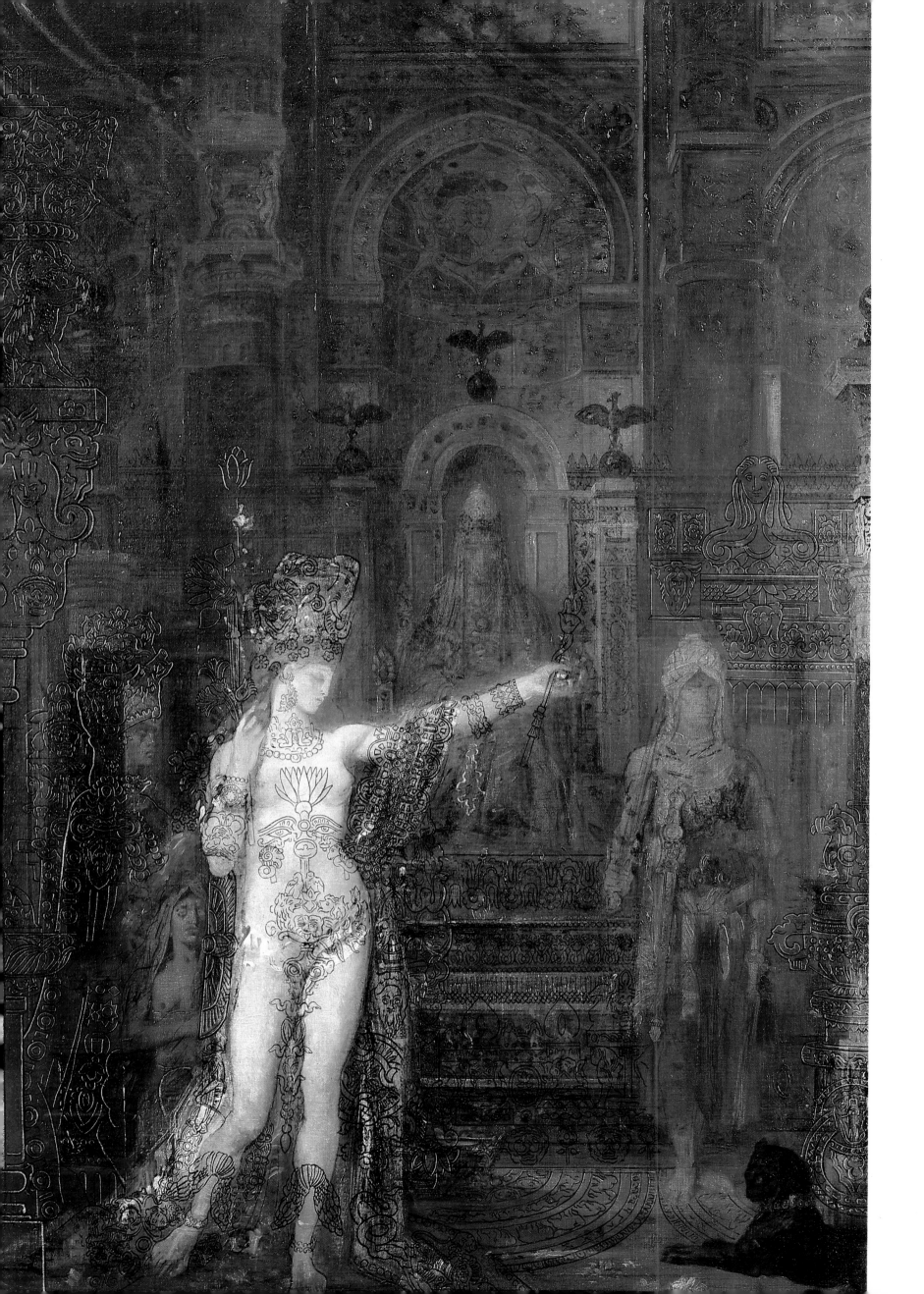

LEFT: *Gustave Moreau's* Salomé Dancing *(1874-76) was a landmark in Symbolist painting, its fevered eroticism balanced by an almost heiratic formalism. Moreau was brought to the attention of the French public through the publication of Huysmans' novel* À Rebours. *Huysmans' description of the archetypal femme fatale subsequently appeared in various guises throughout Symbolist and Art Nouveau art.*

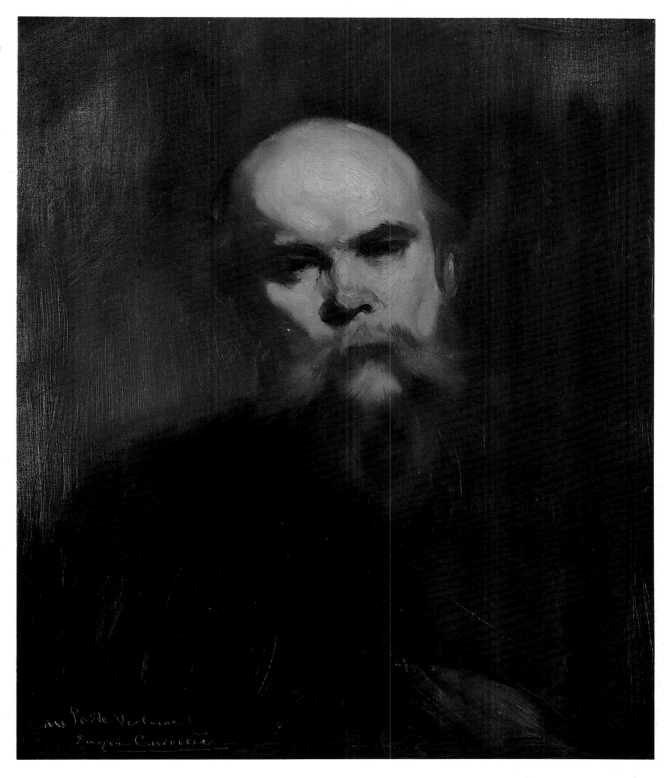

RIGHT: *The poet Paul Verlaine, shown here in an 1890 portrait by Eugène Carrière, was of great importance to the Symbolist movement. His picturesque lifestyle and his imprisonment in Belgium following the scandal of his homosexual liaison with Rimbaud made him a cult figure among the artistic milieu of Paris.*

When Huysmans' novel was published in 1884, it brought to public attention the Symbolist painters Puvis de Chevannes, Odilon Redon and Gustave Moreau, with its sensational descriptions of their works. Moreau's *Salomé Dancing* (1875-76) popularized the theme of the 'femme fatale' which subsequently appeared in much Symbolist art and literature, and became a predominant symbol in Art Nouveau. The sources for *Salomé Dancing* were undoubtedly Flaubert's *Salammbô*, published in 1862, and the Salomé of Baudelaire's poems *Les Fleurs du Mal*.

The Symbolist poetry of Mallarmé and Verlaine (and in England that of Swinburne), which was labeled 'Decadent' after a denunciation of *À Rebours*, not only provided the symbols for Art Nouveau but the theory that the barriers between one art form and another should be torn down. The interplay between poets, painters, designers and musicians led to verses being inscribed on table tops and to symbolic pictures being executed in jewelry and glass, and encouraged easel painters to leave their studios to enter workshops to design posters, fabrics and furniture. It was this idea that led Claude Debussy to set to music Mallarmé's *L'Après-Midi d'un Faune* and Richard Strauss to set Wilde's *Salomé* in the form of an opera. The visual, the sensual and the imaginative were synthesized in an approximation of Wagner's 'Gesamtkunstwerk' ('combined art work') where music, poetry and drama were blended with ancient myth and the cult of an idealized figure into a unified artistic whole.

Although the visual artists never formed a cohesive 'school' like the literary Symbolists, they tended to group and regroup. What did unite them was their condemnation of purely representational art that attempted a scientific examination of natural appearances. Gustav Khan expressed the desires of both artists and writers when he wrote that as a group they had tired of the contemporary and wanted to use symbols derived from any period, and even from dreams. Moreau went further, saying that he believed only in what he *didn't* see and solely in what he felt. Symbolism was concerned with emotions rather than with factual reality, and greater emphasis was placed on shape and color than on 'verisimilitude.'

The influence of Symbolism spread beyond France to Belgium and *Les Vignt*, to Holland, Switzerland and the Salon of Sar Péladan. In the art of Ensor and Munch, the Symbolist influences extended to Expressionism while in the works of Gustav Klimt and the artists of the Munich and Vienna Secessions, Symbolism embraced Art Nouveau.

The Art Nouveau style was not then, as Walter Crane once called it, a short-lived 'decorative disease', but part of a larger continuing trend in European art and design. Born on the one hand out of a belief that art could be spiritually and morally uplifting as well as beautiful, and seen on the other as the logical outcome of the degeneracy of the age, Art Nouveau is a style that varies widely, depending on the country in which it appeared as well as on the techniques and materials employed.

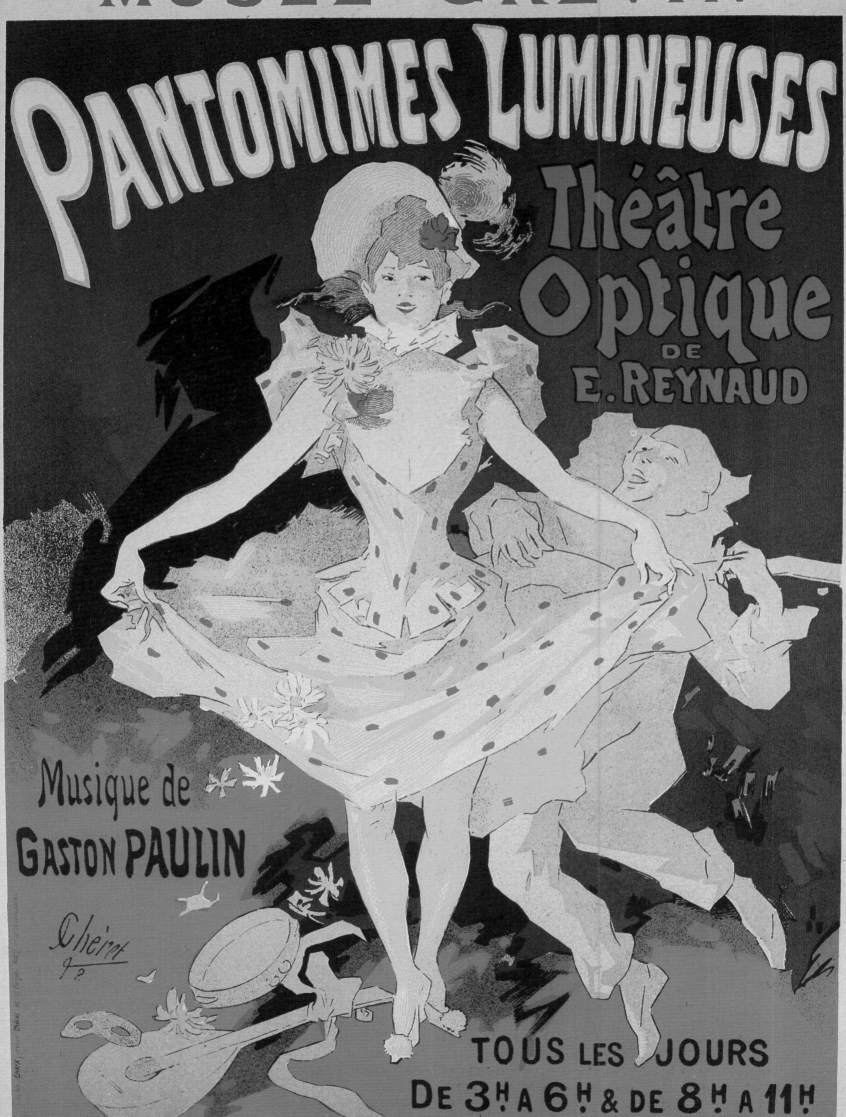

Graphic Design and Photography

The shift from the Victorian style to the Art Nouveau style is strikingly apparent in the field of graphic design. Victorian posters employed busy, crowded layouts with a mass of typography and illustrations; the designers' preference for large, rounded and heavily ornate styles formed a graphic parallel with Victorian furniture and products. For most Victorian typographers legibility counted for less than display and, under the influence of historicism, Gothic and Egyptian typefaces flourished. Even Morris's own Kelmscott Chaucer, luxuriant in decoration and often called the 'most beautiful book in the world,' was difficult to read.

Hand in hand with changes in typography and graphic design came new printing methods revolutionized by steam power. Koenig's flatbed press printed *The Times* of London in November 1814, the first time the newspaper was produced by a steam-powered press. In 1869 *The Times* followed with a second advance, the Walter Press, which was the forerunner of modern newspaper presses which print continuously from curved cast plates. These developments were soon to be followed by the American Richard Hoe's Web Press which produced folded paper and more impressions per hour than the flatbed press. In 1884 and 1885 respectively, Linotype and Monotype improved print technology and when Frederick Ives of Philadelphia patented the crossline screen, or halftone, the printing of photographs in newspapers became possible.

As newspapers became more and more a part of daily life, posters that advertised newspapers and their stories appeared on the walls of city streets throughout Europe and America and, among the urban population, the habit of buying a daily newspaper grew. As illiteracy decreased, new reading habits started: in France the 1882 laws made elementary education free and compulsory as well as removing education from the rule of the Church.

In Victorian graphic design every inch of space was filled; in Art Nouveau, especially in posters and illustrations, white space became a positive design element and pattern was restricted to particular areas. Realistic figures became abstracted, replacing the portraits of manufacturers and their wives or the firms' founding fathers.

In terms of typography, Eugene Grasset (1841-1917) is credited with having designed the first Art Nouveau typeface. Following on from Grasset's experiments for the Art Nouveau magazines *Pan* and *Jugend*, Otto Eckmann was commissioned to design a typeface in the Art Nouveau style. Called *Fette Eckmann*, the face is based on the Roman alphabet but with irregularly curved letters. Areas that are normally enclosed, as in the letters A and D, were opened up to link them with the white space of the page. Henri van de Velde was another typographer who experimented with letter forms, turning them into almost illegible squiggles.

In 1883 the earliest woodcut of the Art Nouveau period was produced. The young architect and designer Arthur Heygate Mackmurdo (1851-1942) wrote a book about Christopher Wren's churches in the City of London. With its abstracted tulips that appear like flames and its elongated birds (some say they are cranes, other cockerels), Mackmurdo's cover departed from its Victorian predecessors in its flattening of shapes and its use of negative space. As Art Nouveau developed, the flowing lines first introduced in Mackmurdo's work became more widespread.

BELOW LEFT: *This poster for the* Salon des Cent *by Eugène Grasset displays the Art Nouveau interest in flowing lines and the flattening of space. Grasset is credited as having designed the first Art Nouveau typeface in 1898.*

BELOW RIGHT: *In Henri van de Velde's poster for* Tropon, *the curvilinear Art Nouveau style is fully developed.*

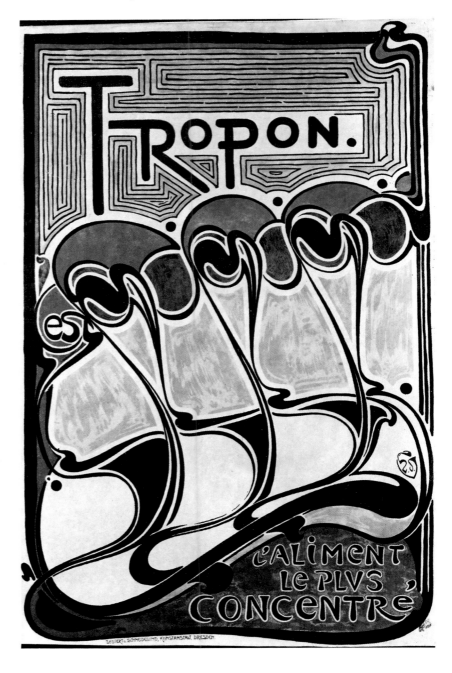

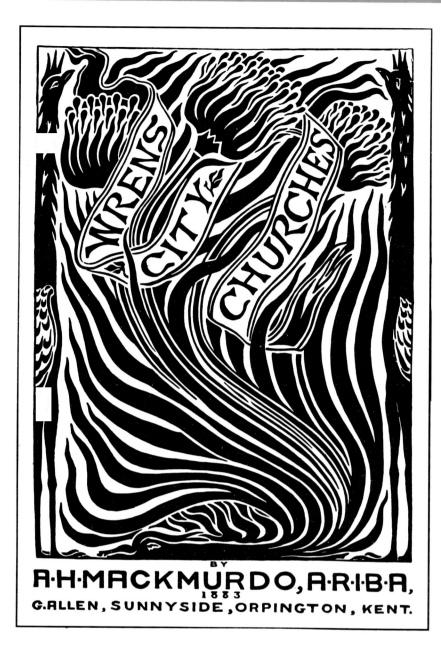

LEFT: *One of the earliest Art Nouveau woodcuts is A H Mackmurdo's title page for his* Wren's City Churches *(1883). Its effect, reminiscent of the fretwork on the back of a Century Guild chair, is one of undulating movement.*

BELOW: *Carlos Schwabe's 1892 exhibition poster for* The Salon de la Rose + Croix *reflects the Salon's peculiar brand of Symbolism, and is celebrated as a forerunner of the Art Nouveau style in posters.*

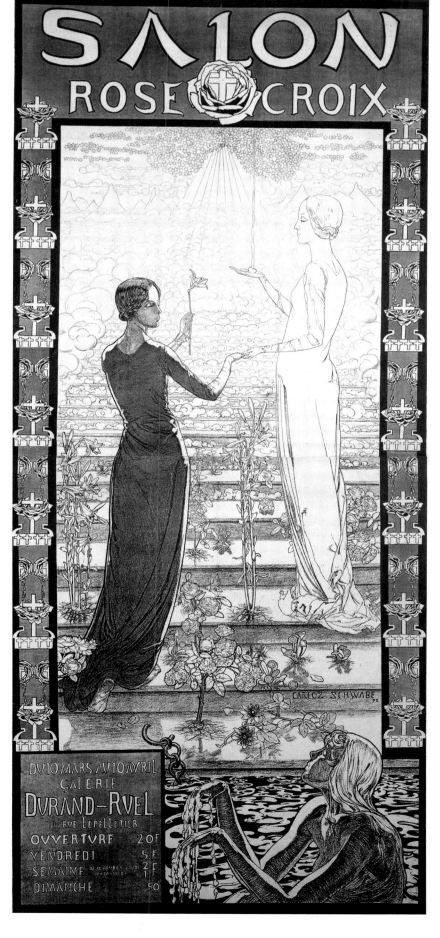

In 1882 Mackmurdo and Selwyn Image (1849-1930) founded the Century Guild, which produced the first Art Nouveau book and fabric designs. These designs used patterns that abruptly switched direction, and played strong patterns against delicate ones. The whole effect is rather like undulating seaweed and has its roots in Japanese art, which provided the simplified, flattened forms, and in the work of William Blake. Mackmurdo reproduced Blake's illustrations to the *Songs of Innocence* in the magazine the *Hobby Horse*, which first appeared in 1884. One of the first art-oriented literary magazines of the 1880s and 1890s, it had a formidable if rather eclectic team of contributors which included John Ruskin, Ford Maddox Brown, Rossetti, Burne-Jones and Oscar Wilde.

Jointly edited by Mackmurdo and Herbert Horne, the first issue had a line block cover designed by Selwyn Image and printed on handmade paper. The aim of the magazine was to promote the ideals of the Century Guild, which hoped to encourage high standards in design. The *Hobby Horse* was also the first magazine to treat printing – especially modern printing – as an art form, as well as being the first journal to introduce British design and theory to Europe. Although disbanded in 1888, the Guild's work in print was followed in 1891 by an exhibition in Belgium. This helped to propagate their visual ideas; Victor Horta, for example, is reported to have used Century Guild wallpapers for his Tassel House.

Apart from their primary aim of selling, advertising posters also reflected the new social attitudes and tastes. One poster which has acquired a certain degree of celebrity as a forerunner of the Art Nouveau style was designed by Carlos Schwabe (1866-1926) for the exhibition of 1892 by the *Salon de la Rose + Croix*, which would later have a great influence on the work of Alphonse Mucha. The *Salon de la Rose + Croix* was launched by Josephin Péladin in opposition to the official art salon, and promoted his own brand of Symbolism. For his salon, Péladin drew up a set of rules which listed the subjects that

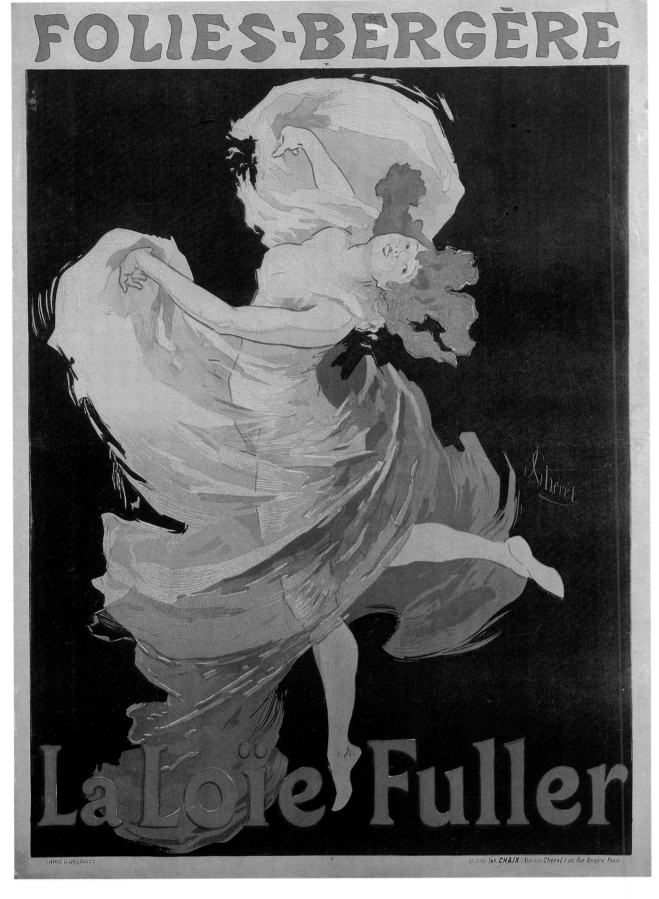

FOLIES-BERGÈRE
La Loïe Fuller

he would reject no matter how well they had been executed. The re-
jected subjects included history, military and patriotic paintings, all
representations of modern life, rustic scenes, landscapes (except for
those painted in the style of the great master Poussin), seascapes and
sailors, anything humorous or domestic, sporting animals, flower
studies and still lifes. It is not surprising that Schwabe, who himself
painted in a manner akin to the Pre-Raphaelites like many of the
other artists associated with Péladin's salon, never appeared with the
Rose + Croix again.

Jules Chéret (1836-1932), who was among the first to introduce Art
Nouveau elements into poster design, was awarded the Légion
d'Honneur for creating a new 'branch' of art, an art that was applied
to commercial and industrial printing. The subject matter of Chéret's
posters consisted almost invariably of pretty girls swathed in skirts
and petticoats, and stemmed from a long tradition in French painting
exemplified by the work of Rococo artists such as Boucher, Watteau

and Fragonard. What is different is Chéret's use of color, which he de-
veloped as a result of a visit to England in 1850. While in England he
studied Turner's work and mastered the techniques of mass produc-
ing color designs using four or five colored blocks. Chéret later
introduced this technique to Paris and, backed by the perfumier Rim-
mel, founded his own printing firm. The simplified outline and flat
design modelled without traditional chiaroscuro Chéret took from
the Japanese. This simple treatment had both artistic and commercial
advantages; as well as being practical in a technical sense, it also
proved to be more effective for advertising since its large areas of
bold color attracted the eye.

Though Chéret was the pioneer of color lithography, it is fair to say
he was not the master. Chéret's posters would be a source of in-
spiration for many artists who were demanding a new kind of art, but
the greatest exponent of poster art must surely be Henri de
Toulouse-Lautrec (1864-1901).

RIGHT: *This French poster for Rajah Tea by Privat-Livemont (1900) neatly exploits the turn-of-the-century vogue for all things oriental. Tea drinking, long associated with England, was never very popular on the continent, where coffee or chocolate was preferred. In rural areas of France and Belgium tea was often considered a drug, to be drunk only for its medical properties. In this poster the mysterious powers of the gypsy woman are called upon to glamorize the product.*

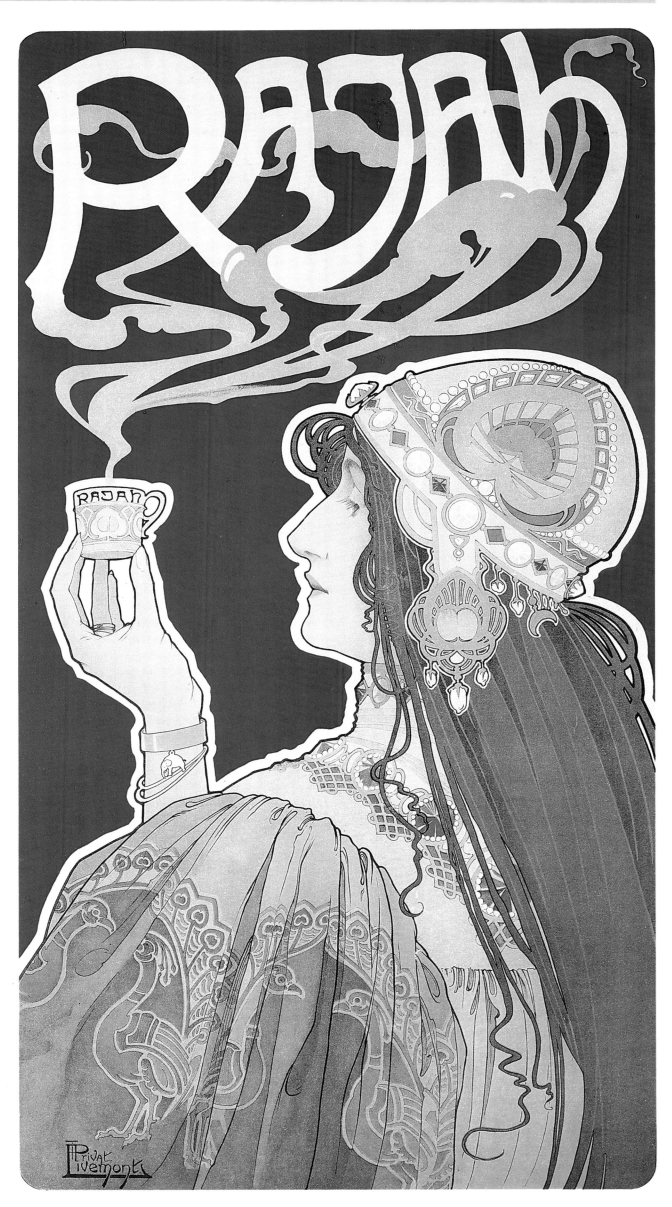

Reine de Joie

par

Victor Joze

chez tous les libraires

Imp. Edw. ANCOURT & Cie PARIS

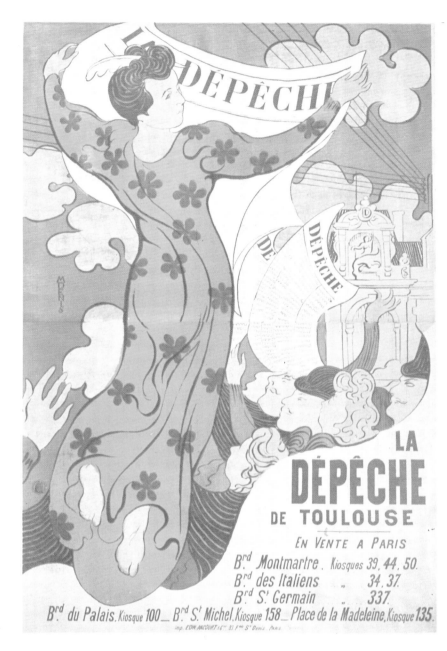

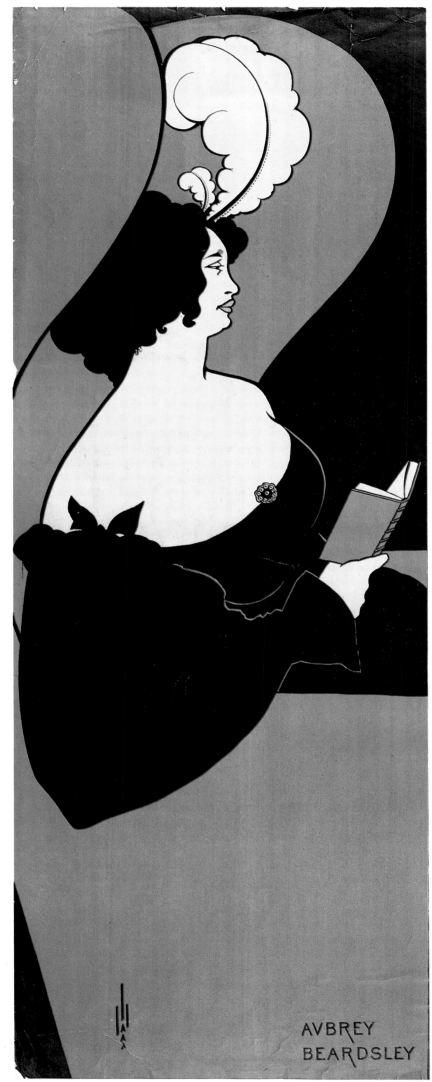

LEFT: *Toulouse-Lautrec's poster for the novel* Reine de Joie, *by Victor Joze. Scandalous novels featuring femmes fatales proved immensely popular in France at the end of the century.*

ABOVE: *Maurice Denis' poster for* La Dépêche de Toulouse *employs a flat decorative pattern contained within bold outlines and combined with an explicit symbolism to create one of the finest examples of Art Nouveau advertising posters.*

RIGHT: *The work of Aubrey Beardsley epitomizes curvilinear Art Nouveau graphic design in its rhythmic lines, its lack of pictorial depth, and its intense preoccupation with images of women.*

bodies and in particular their hair formed part of the rhythmic lines. In addition, there is the lack of pictorial depth, as epitomized by the *enfant terrible* of Art Nouveau graphic design, Aubrey Beardsley (1872-1898). In his work everything appears to occur within the same plane; in the counterplay of black and white, he employed tone in a way far removed from its usual naturalistic aims.

In 1891 Beardsley was introduced to Oscar Wilde at Edward Burne-Jones's house. When, in 1894, Wilde's play *Salomé* was translated by Lord Alfred Douglas and published in England, Beardsley provided the illustrations. For many of Beardsley's illustrations he chose the popular Symbolist themes of the 'femme fatale,' Arthurian legend and ancient tales, but he also liked to depict everyday life, as his poster for the *Pseudonym and Autonym Libraries* testifies. Only 600 of the special and ordinary editions of *Salomé* were printed, and reviews were few and far between. But Beardsley's drawings brought him into contact with many important writers. His next venture was to be the *Yellow Book*. Many periodicals would be produced in these years and many would disappear as quickly as they had appeared.

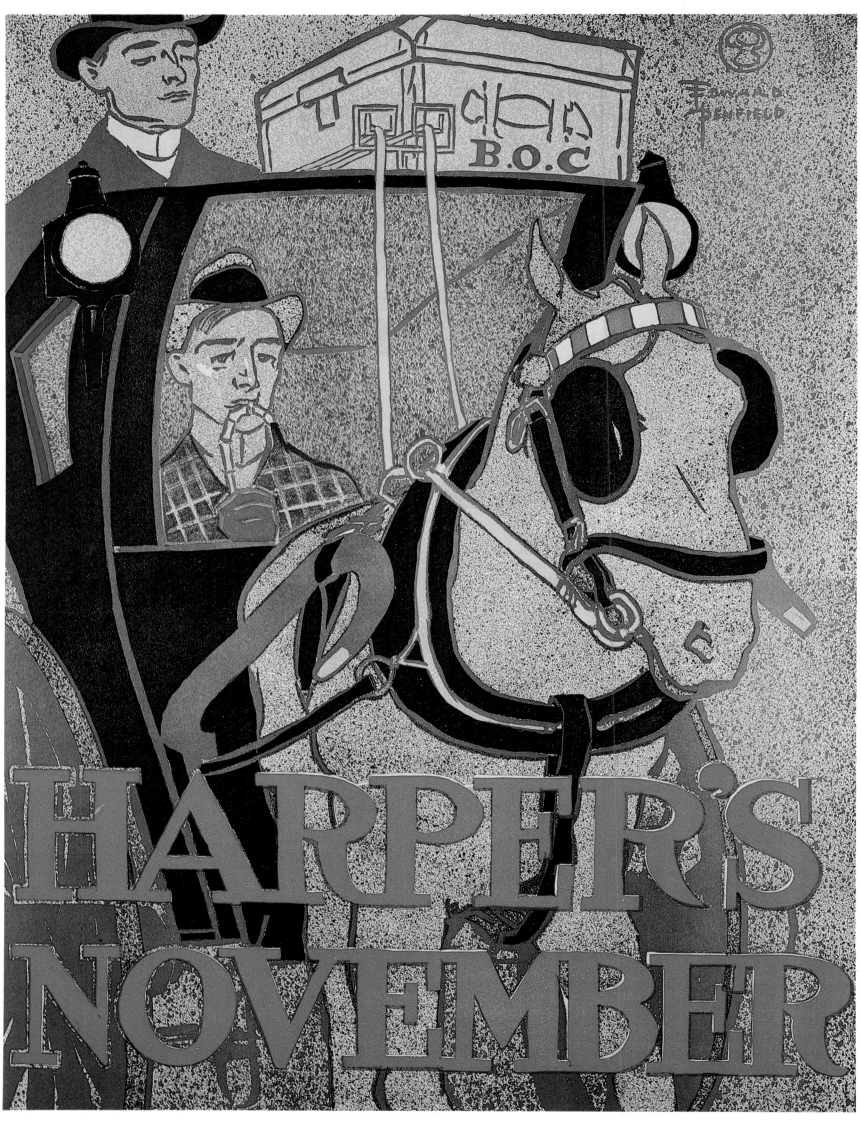

ABOVE: *Edward Penfield's poster for* Harper's Magazine *demonstrates his ability to translate a mundane scene into a stylish design.*

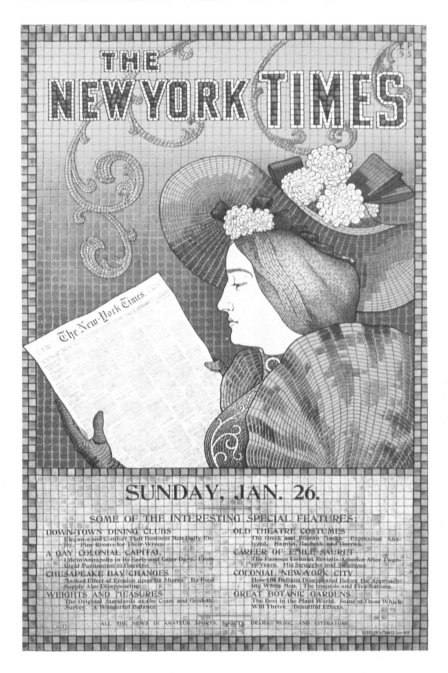

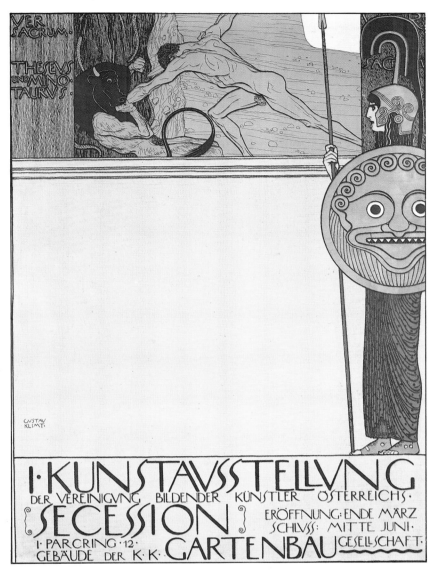

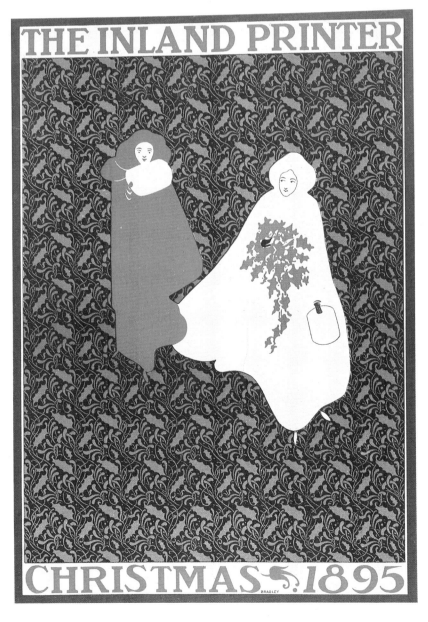

ABOVE: *This 1895 poster advertising the* New York Times *is initialed at the top right 'E P' and believed to be by Edward Penfield. His work reflected the new reading habits in America, depicting readers of all professions and classes.*

ABOVE RIGHT: *Gustav Klimt's controversial 1898 poster for* Ver Sacrum, *depicting Theseus and the Minotaur, offended critics and public so much that Klimt later had to add a tree to the design, obliterating Theseus's genitalia.*

BELOW RIGHT: *Will Bradley's poster for* The Inland Printer *mixes Beardsley's bold use of space with Morris's love of patterns.*

There were other changes afoot in society and its attitudes, which were marked by the use of nude figures on posters. Although there was a long and continuous tradition of nude painting and sculpture, never had nudes been used for advertising purposes. Many figures would appear draped and in traditional settings: the first poster of the *Sezession*, designed at the beginning of 1898 by Gustav Klimt, was an advert for the *Sezession*'s review *Ver Sacrum* which used the mythological theme of Theseus and the Minotaur. Although Klimt's original nude figure offended the critics and public, forcing him to add a tree to the design, the nude and draped figure would continue to be used in advertising posters. Klimt's poster employed an elaborate symbolism, and its effect lies in the contrast created by the surface pattern and the pictorial space. The upper portion of the poster, depicting Theseus delivering the final blow to the minotaur, was designed to symbolize the fight between the *Sezession* and the official art salon, while Athene, long chosen as the protector of artists' groups, was a popular motif in exhibition posters.

English poster art at this period was, with the exception of a handful of artists such as Beardsley, not terribly striking. In an effort to establish higher standards for English graphic design, the Beggerstaff Brothers (actually brothers-in-law James Pryde and William Nicholson) would have an influence that is still evident today. The Beggarstaffs joined forces to produce four poster designs for an exhibition at the Westminster Aquarium in 1894 for 'Nobody's' candles and pianos: the 'Nobody' could be converted into a named manufacturer of the products advertised. For these posters – some of which were twelve feet high – the Beggarstaffs used a silhouette treatment, using flat tones cut from colored paper and pasted onto boards. The first of their posters to appear on the streets was for a production of *Hamlet* and depicted the actor Gordon Craig in profile holding a skull; each copy was hand-stenciled. But not all of the Beggarstaffs' posters were successful, for some of their finest works were never used. One such poster was for Henry Irving's one act play *Don Quixote* and showed Don Quixote on a white horse against the background of a windmill. Although Irving bought the poster, it never appeared, as the play flopped and was withdrawn. A subsequent design for another Irving play, *Robespierre*, was produced at the request of the English actress, Ellen Terry. When Terry told Irving of her request, Irving refused to see the designs. Despite these setbacks, before the end of 1895 the Beggarstaffs had finished several posters including *The Beefeater*, the design for Rowntree's Cocoa and for *Cinderella* at the Drury Lane Theatre in London.

Comparing the Beggarstaffs' work with their contemporaries on the continent, we see a similar boldness of line and flat tone. Yet the English treatment is more subtle and less colorful, limited to muted tones of gray and brown. In the 1960s, a decade which witnessed a revival of interest in posters and poster art, the Beggarstaffs' lettering style, with its rounded serifs, was seen once more.

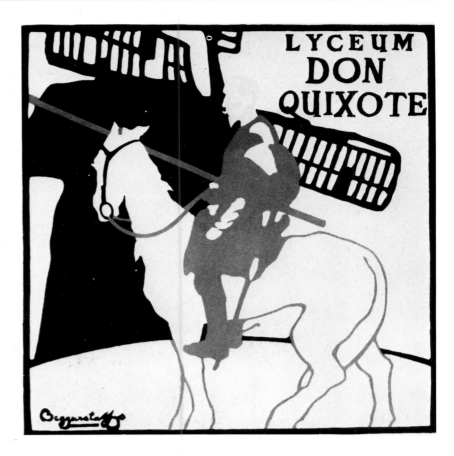

ABOVE: *Although the work of the Beggarstaff Brothers was less colorful and flamboyant than that of their European and American contemporaries, their use of flat tones and silhouettes proved widely influential.*

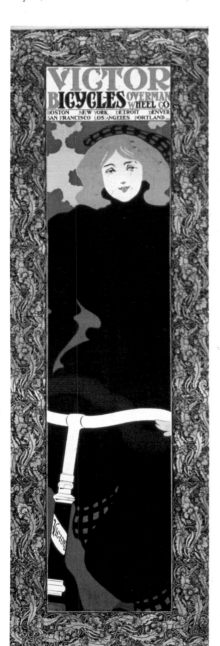

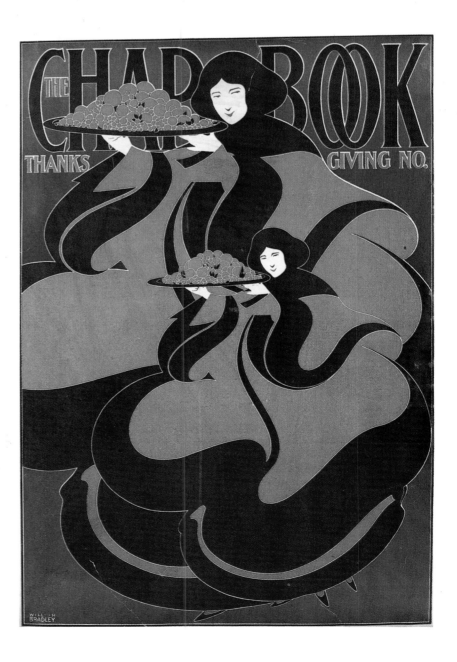

LEFT: *In this poster for* Victor Bicycles (c 1900) *by Will Bradley, the Art Nouveau style is used to advertise the products of a new industry and reflect the new independence of women.*

RIGHT: *Possibly the best known posters by Bradley are the five in color for* The Chapbook.

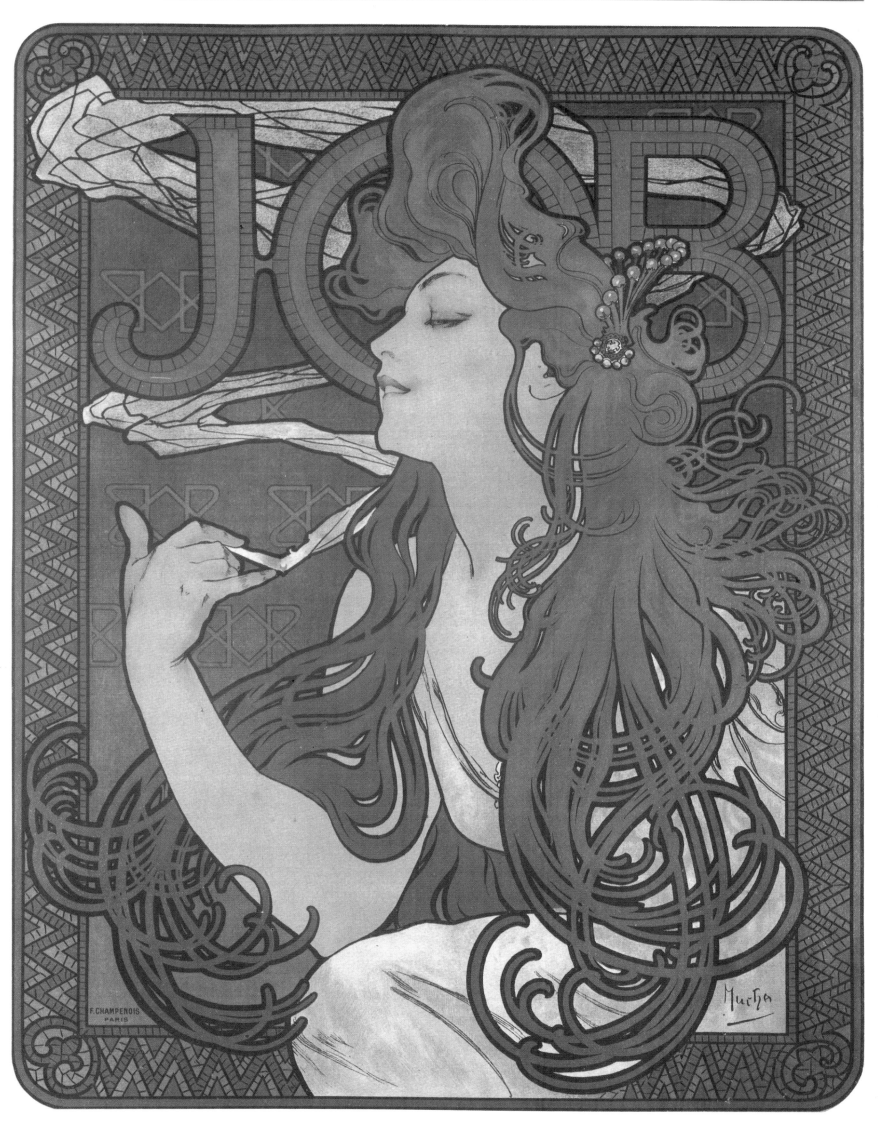

ABOVE: *Mucha's poster for* Job
Cigarette Papers *(1896) illustrates*
the flowing style that influenced
American posterist Will Bradley.

ABOVE: *Art Nouveau style affected the covers as well as the contents of books; René Weiner made this magnificent binding for Flaubert's* Salammbô *in 1893.*

BELOW: *This tooled leather binding, designed by Camille Martine and made by René Weiner at the Nancy School, shows the subtlety that could be achieved in the medium.*

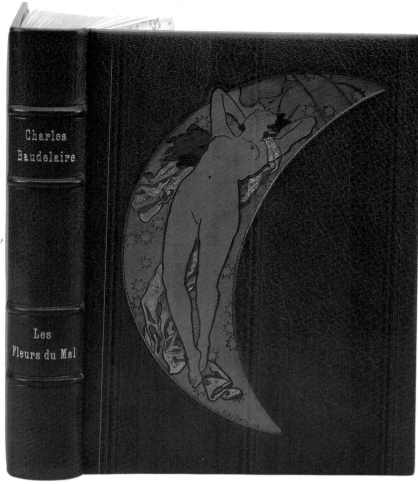

During these years it was not only the contents of books that became subject to the Art Nouveau style; so did their covers. Possibly the most remarkable and beautiful bindings are the work of René Weiner (1856-1939) of Nancy. Weiner used the process of 'pyrograveur' – applying a heated stylus to the leather and burning or scorching in the color – and often collaborated with other artists, notably Toulouse-Lautrec and Victor Prouvé (1858-1943), who had also worked with Emile Gallé. Weiner's bindings are more like jewels than book covers. Their intricate lines display the Art Nouveau fascination with the stylized rendering of natural forms, while the subject matter is suggestive of the books' contents. The cover for Flaubert's *Salammbô* (1893) depicts the moon-goddess Tanit, Moloch the fire god of the Ammonites, whose worship required the sacrifice of children, and Salammbô herself, draped by a python.

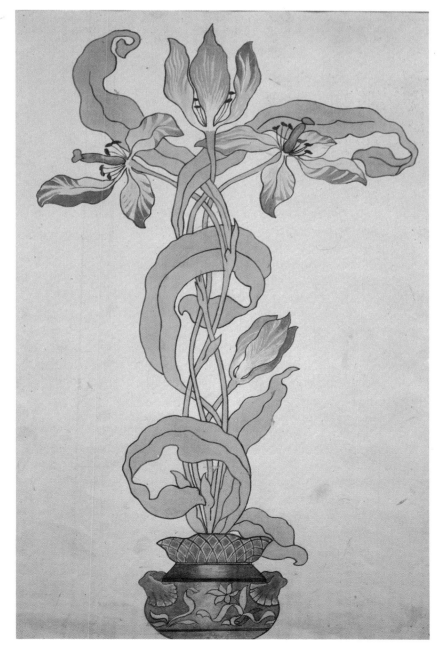

ABOVE LEFT: *Bookbinding for Huysmans' novel* À Rebours.

ABOVE RIGHT: *Bookbinding for Charles Baudelaire's collection of Symbolist poems* Les Fleurs du Mal.

RIGHT: *A watercolor sketch by Koloman Moser for an illustration of* Tulips in a Plant Pot.

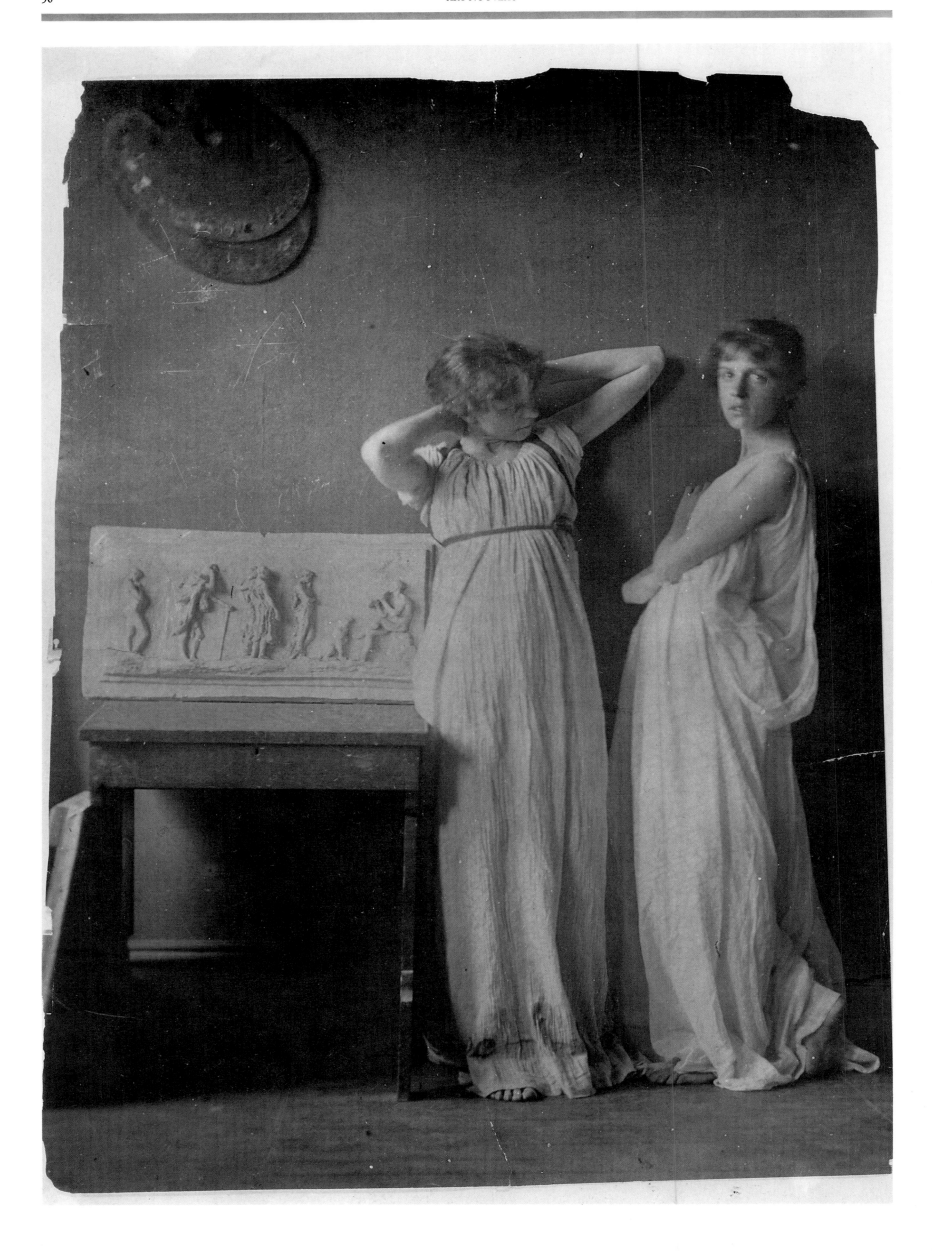

LEFT: *Two pupils in Greek dress pose beside a plaster cast of* Arcadia *in this print by Thomas Eakins. One of America's greatest painters, Eakins regarded photography as equal to the other graphic arts, and printed his works on high-quality platinum papers.*

RIGHT: The Pond in Winter *(1888), by Peter Henry Emerson. An American-born doctor living in England, Emerson photographed the scenery and people around the Norfolk Broads. Emerson's compositions were not simply records of the visible world, but showed the influence of Japanese prints and Whistler's paintings.*

BELOW: Gathering Waterlilies *(1886), by P H Emerson.*

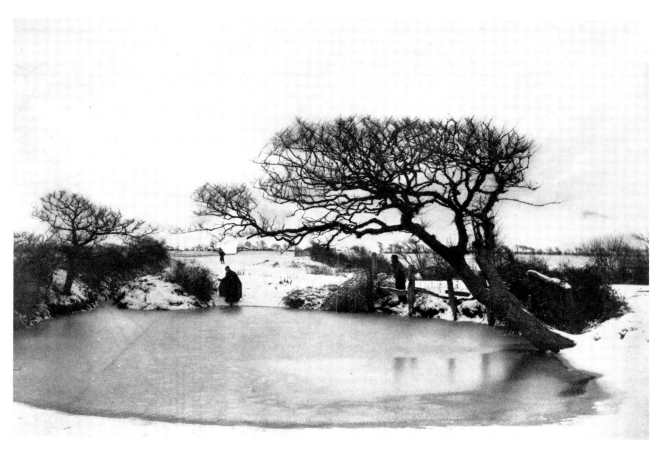

Eakins's own technique differed from that of Muybridge in his use of a single camera equipped with a revolving, pierced disk fitted in front of the lens. This allowed Eakins to take a series of superimposed, yet still distinguishable images on one plate. Once he had succeeded, Eakins gave up his experiments, but he continued to use photography as an aid to his painting. He believed that the photograph should be regarded as the equivalent of an etching or lithograph, and printed his work on the most expensive platinum papers.

From its origins as a useful source of information, photography developed into something much more, inspiring the compositions, forms and conceptions of reality. Degas, himself an amateur photographer like Manet and Courbet, used a soft, out-of-focus treatment in the background of his paintings, used space in a compressed way as though seen through a camera and cut details of his work at the edges like a snapshot. After his death, the secretive Khnopff was found to have made extensive use of photography in his painting.

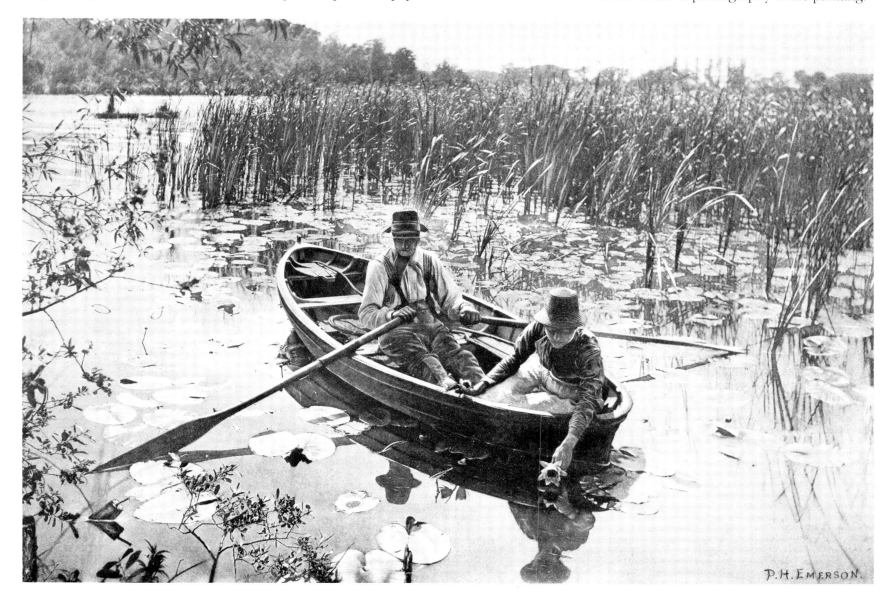

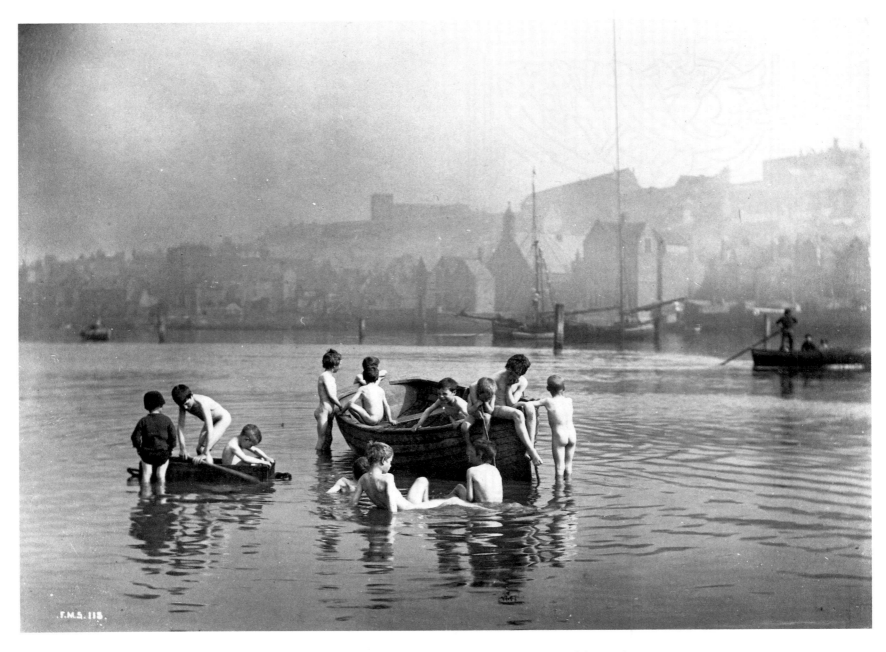

ABOVE: *Frank Sutcliffe was a member of the* Linked Ring, *an international group of amateur photographers dedicated to the idea of photography as art. In contrast to Emerson's studies of rural life, Sutcliffe's photographs, such as* Water Rats (1896), *depicted urban, industrial life.*

The major influence on a new way of seeing that would transform painting came from Michel-Eugène Chevreul (1786-1889). Chevreul, whose discoveries as a chemist included margarine, was also a director of the Gobelins tapestry manufacturers. His work there led him to undertake research into color and the way in which the eye perceives particles of juxtaposed color; this would become the theoretical basis of French Impressionism, and through its 'new vision' would encourage the development of photography as an art form.

A new spirit entered photography in the 1880s following the development of the dry-plate process, invented by Richard Leach Maddox in 1871, and the introduction of the Kodak camera in 1886 by George Eastman. The first development was a process that made the commercial manufacture of plates possible, freeing photographers from having to make their own, and the second was a simplified camera for the amateur at a low price – $25 including leather case. By 1891 nearly 100,000 Kodak cameras had been sold: Degas owned one and so did George Bernard Shaw. The conservative professionals who followed Robinson in his ideas of art photography were now faced with a growing army of enthusiastic, experimental amateurs. Turning their backs on academicism, the new photographers found kinship with Impressionism, the major art movement of the 1890s.

Peter Henry Emerson (1856-1936), an American-born doctor living in England, was among the first to reject the art photography of the Victorians. Believing that the camera had its own peculiar qualities, he looked around him for patterns and structures that evoked stillness and peace. Simplicity was Emerson's goal; he avoided the use of props, costumes and theatrical poses, and he condemned the retouching of photos. In his pictures taken on the Norfolk Broads it is possible to see the way photography had advanced. From merely reproducing the visible world it had developed an art whose influence came from Whistler's Japanese print-inspired arrangements of hazy nocturne paintings.

RIGHT: *Alfred Stieglitz,* Paula (1889) *Silver print. Around 1900 the center of photographic activity moved from Europe to America. Steiglitz, the leading figure in American photography, founded the Photo-Secession Group.*

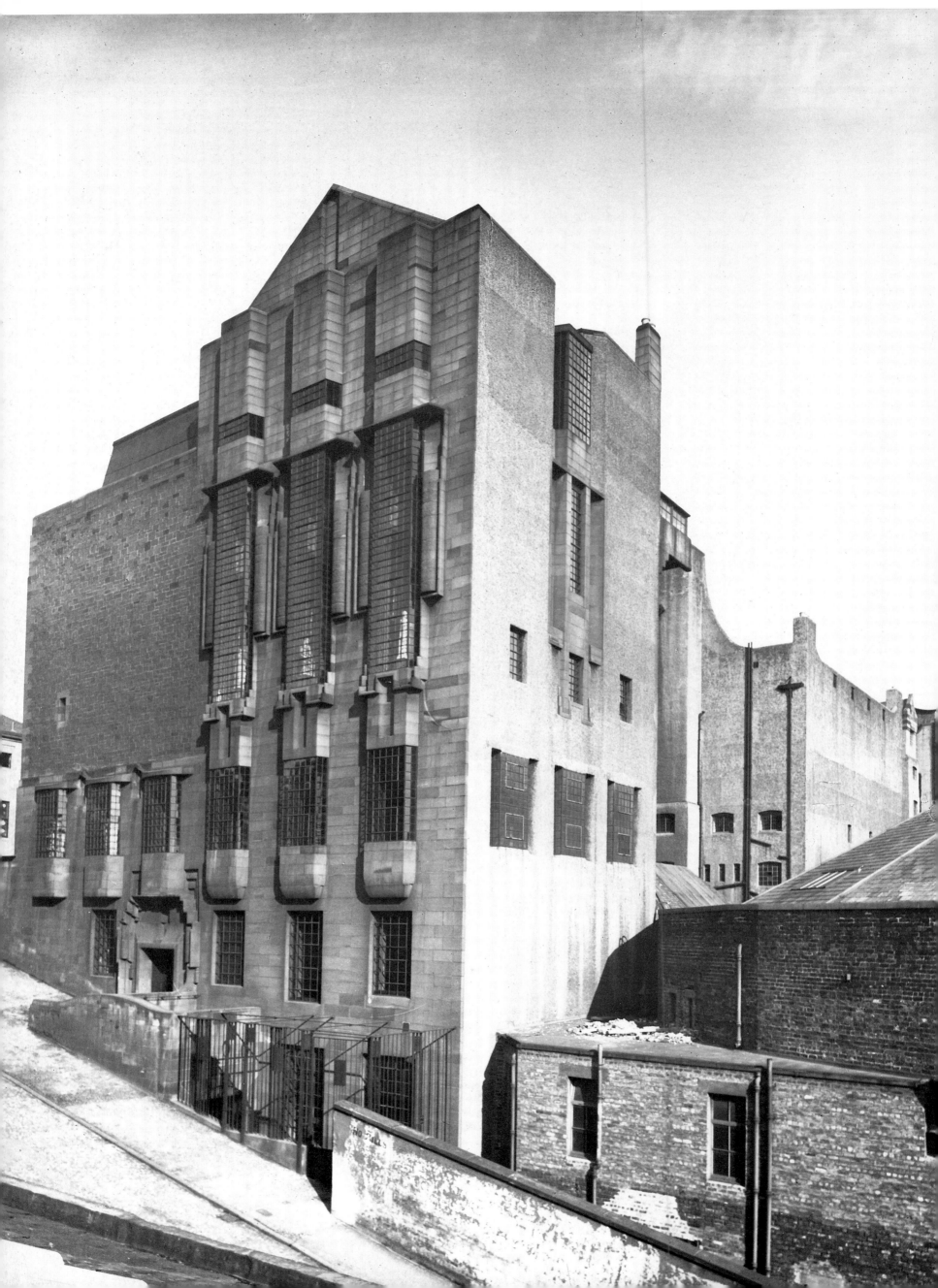

Architecture and Interior Design

Where the Arts and Crafts purists were distrustful of a conscious preoccupation with style and concerned themselves with ideological matters, the European Art Nouveau designers were concerned with the visual, and aimed to discover a new style for the twentieth century. And where the Arts and Crafts Movement aimed for honesty, simplicity and good craftsmanship, the Art Nouveau aimed for a sophisticated elegance which was often tinged with decadence.

The dictates of the Arts and Crafts movement allowed for a certain degree of flexibility when it came to the manufacturing of low-cost goods with little hand crafting, as long as the forms chosen were suitable for machine production. In architecture there was the question of how to use new materials like plate glass, steel and reinforced concrete. The problem was not so much how to build with these materials: the English and French engineers had successfully experimented in the construction of factories and exhibition halls. The real challenge was coming to terms with their use, deciding how the materials should be displayed, internally and externally, and how far the new materials should suggest new architectural forms.

Art Nouveau has been credited with changing the tradition of adapting new materials to existing styles, freeing steel and glass from their secondary role as well as exploring and exploiting their decorative possibilities.

In most cases, a building is called Art Nouveau because of its ornaments, yet Art Nouveau architecture can be found without Art Nouveau decoration. Some of the qualities of Art Nouveau decoration, such as curving lines and a lack of symmetry, are less suited to architecture simply because buildings, on the whole, have to be functional and their construction requirements make it difficult to create curving whiplash forms as exteriors.

Despite these considerations, some of the most potent examples of Art Nouveau that remain today are buildings. In some, many of their original interior fittings survive: others have lost their original interiors but their exteriors for the most part remain with their character intact.

As in the other fields of design, the Art Nouveau style permeated buildings with a wide variety of functions: public houses and churches, underground stations, art galleries and theaters as well as commercial buildings and private houses. Some reflect the curvilinear mode of Art Nouveau in their decorative details and biomorphic forms, others the rectilinear mode in their clear lines and straight edges. *Punch*, always aware of the latest fashions and movements in art, was quick to lampoon the new style. R C Carter's cartoon *The Home Made Beautiful* (1903) made an unfavorable comparison between the austere nature of Art Nouveau furnishings and their cosily

TOP: *Art Nouveau lettering in the London underground station at Edgware Road.*

ABOVE: *This tiled ticket office window at Edgware Road underground station offers a more restrained English answer to Guimard's Métro station entrances.*

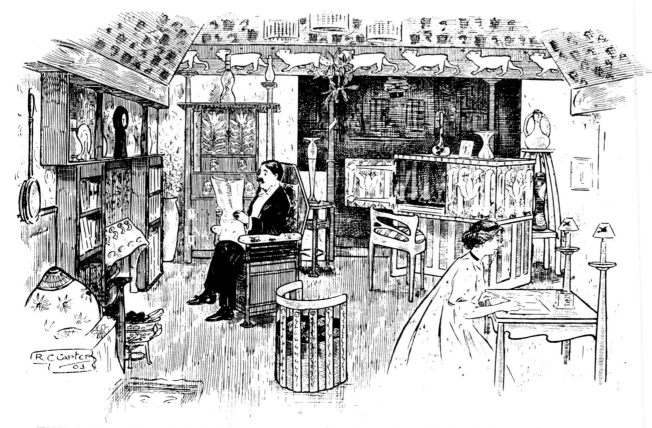

THE LATEST STYLE OF ROOM DECORATION. THE HOME MADE BEAUTIFUL.

According to the " Arts and Crafts."

LEFT: *Although* The Home made Beautiful *by R C Carter, from a 1903 issue of* Punch, *is clearly intended as a lampoon, the cartoon is nevertheless an accurate description of Art Nouveau furnishings.*

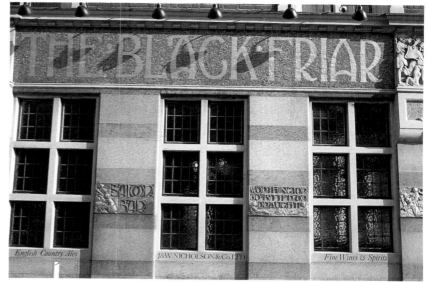

ABOVE: *'The Black Friar,' a public house in the Art Nouveau style, is one of the finest examples of a commercial building in the style in London. The Black Friar takes its name from the former Dominican Friary whose site it occupies.*

ABOVE RIGHT: *The colors of 'The Black Friar's' external decorations – greens, blues and golds – are found again inside, enriched by some of the most remarkable Art Nouveau stained glass outside of religious buildings.*

RIGHT: *Mosaic decoration over entrance to the saloon of 'The Black Friar'. The façade, stained glass, interiors and marble slabs carved in low relief were all the work of Henry Poole.*

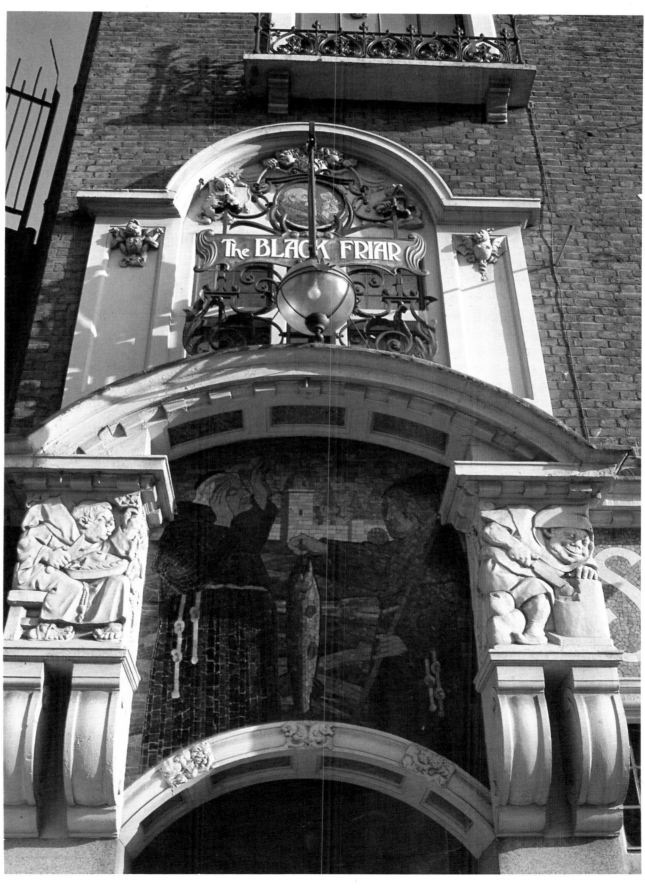

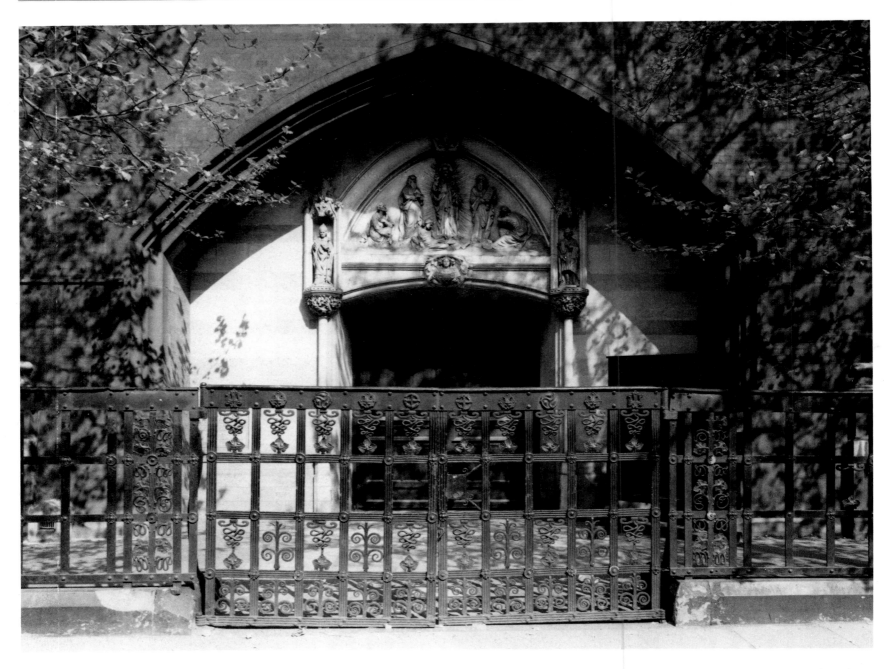

stuffed Victorian equivalents. At the same time, the cartoon made a subtle comment on the new-found status of women; the Art Nouveau furnishings clearly reflect her taste and not that of her husband.

ABOVE: *Holy Trinity Church in Sloane Street, London was designed by J D Sedding; his assistant Henry Wilson designed the railings. Inside, the great east window was designed by Burne-Jones and made by William Morris.*

Possibly one of the most comfortable views of the new style is from inside 'The Black Friar,' a public house at Blackfriars on the site of a Dominican Friary dissolved by Henry VIII. The marble slabs,

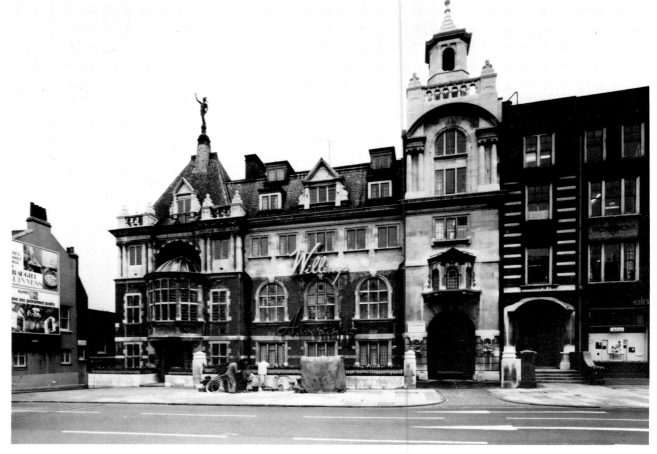

RIGHT: *As the twentieth century advanced, the Art Nouveau style in England became mixed with a variety of others. The Willing House in Grays Inn Road, London, designed by Hart and Waterhouse, is a fine example of this eclectic approach.*

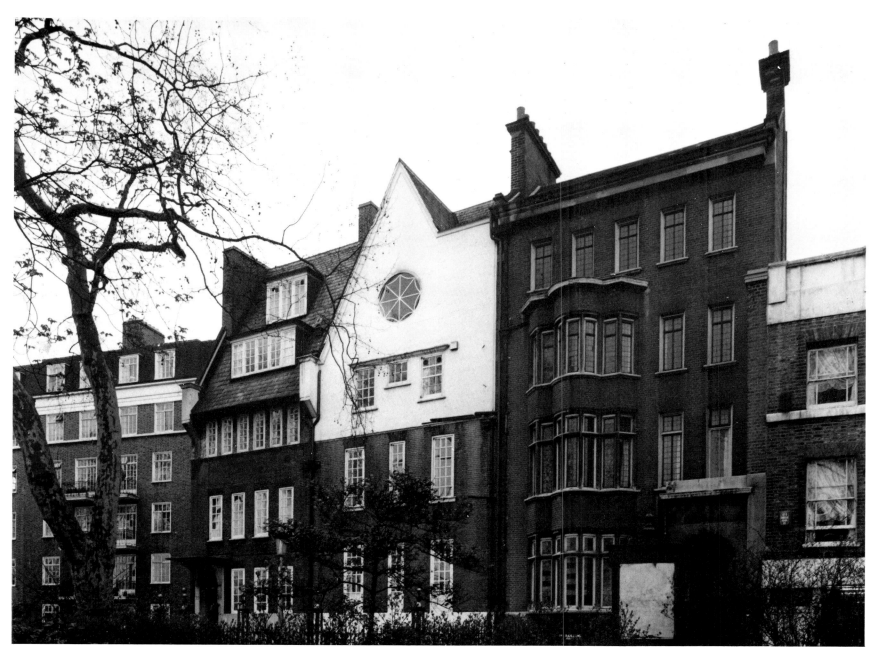

decorated with low relief bronze figures by Henry Poole, would not look out of place in a church, but the color scheme of the stained glass, predominantly green, blue and gold, gives an effect more sub-marine than celestial. For that quality of light, one need only visit Holy Trinity Church in Sloane Street, London, where it is provided by the great east window designed by Edward Burne-Jones and made by William Morris. Holy Trinity was designed by J D Sedding and com-pleted after his death by his assistant Henry Wilson (1864-1934), who also designed the iron railings that separate the forecourt of the church from the street. Inside, enclosing the choir stalls are cast-bronze panels, designed by F W Pomeroy, of angels carrying scrolls.

Number 37 Harley Street, London, is another interesting example of Art Nouveau in England. It was rebuilt in 1899 in Monk Park stone by Beresford Pite with decorative panels by the sculptor F E Schenck, portraying the arts and sciences. As the twentieth century advanced, the Art Nouveau style in England would become mixed with a variety of other styles: the Willing House in Grays Inn Road, London, is a good example of the mix. Designed by architects Hart and Water-house, many traces of Art Nouveau have nevertheless survived.

Jeweler and silversmith Charles Robert Ashbee (1863-1942) was also responsible for the design of buildings and interiors. His own house at 39 Cheyne Walk, London, displayed the Art Nouveau style – even if the familiar curves are absent – particularly in the relationship between the horizontal, small-paned windows and the 'negative' spaces between them. The interiors were decorated throughout by the Guild of Handicrafts, using tooled leather wall coverings in some areas, and became the subject of illustrated articles in *The Studio* in 1895, and by Hermann Muthesias in *Dekorative Kunst* in 1898.

In 1897 the Grand Duke of Hesse had sent a special envoy from Darmstadt to see Ashbee's work. The result of these enquiries would lead to W H Baillie Scott's commission to decorate and furnish the

ABOVE: *Number 39, Cheyne Walk, Chelsea was designed by silversmith and jeweler Charles Robert Ashbee, and is a showpiece of Guild of Handicraft workmanship.*

BELOW: *Number 37, Harley Street, designed by Beresford Pite, has decorative panels by F E Schenk.*

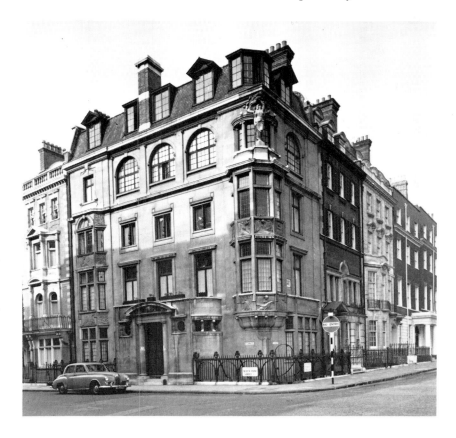

Grand Duke's Palace with pieces like the Music Cabinet (1898). Further commissions followed and through these, the magazines and European exhibitions, Ashbee and the Guild of Handicrafts would inspire Josef Hoffmann's workshops in Vienna, thereby spreading the Art Nouveau style abroad.

With the passing of time, the effects of war and the rebuilding of exteriors, many fine examples of Art Nouveau buildings have been lost. But often, by looking at the upper parts of buildings, we can still find fine examples of the style. The Apollo Theatre on Shaftesbury Avenue, London, was designed in 1900, the year of the Paris exhibition where, under the *Porte Monumental*, lit by incandescent lamps, artists would meet. Designed by Lewin Sharp and opened in 1901 with an appropriate production, *The Belle of Bohemia*, the façade shows the 'belles' of the turn of the century as well as angled windows set into cartouches.

The most remarkable building designs in England during the Art Nouveau period belong to C Harrison Townsend (1852-1928) whose principal works are the Whitechapel Art Gallery dating from 1897-99 and the Horniman Museum of 1900-02. In the first, the building betrays a variety of sources: the asymmetry of the ground floor in relation to the upper floor and the leaf ornamentation belong to H H Richardson (1838-1886), who helped the United States to make its claim for the lead in the vanguard of architecture. In the second building, a mural decorates the façade, in front of which stands the square clock tower with its straight edges rounded off.

In spite of these outstanding examples, the main British – as opposed to the purely English – achievements in Art Nouveau are the buildings and furnishings of the Scotsman Charles Rennie Mackintosh (1868-1928), one of the new generation of European architects who sought to establish a national architecture.

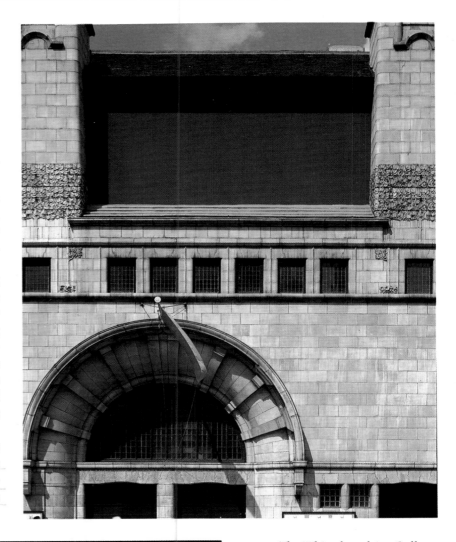

ABOVE: *The Whitechapel Art Gallery, by C Harrison Townsend, dates from 1897 to 1899.*

LEFT: *The interiors of Townsend's church at Great Warley were designed by Sir William Reynolds-Stephens. The vaulting is traversed by ribbons of aluminum, with plates of aluminum decorated with embossed lilies inserted into the walls. The entire vaulting of the apse is clad in aluminum sheets decorated with bright red bunches of grapes. Great Warley Church is one of England's rare extant examples of Art Nouveau architecture and interior design.*

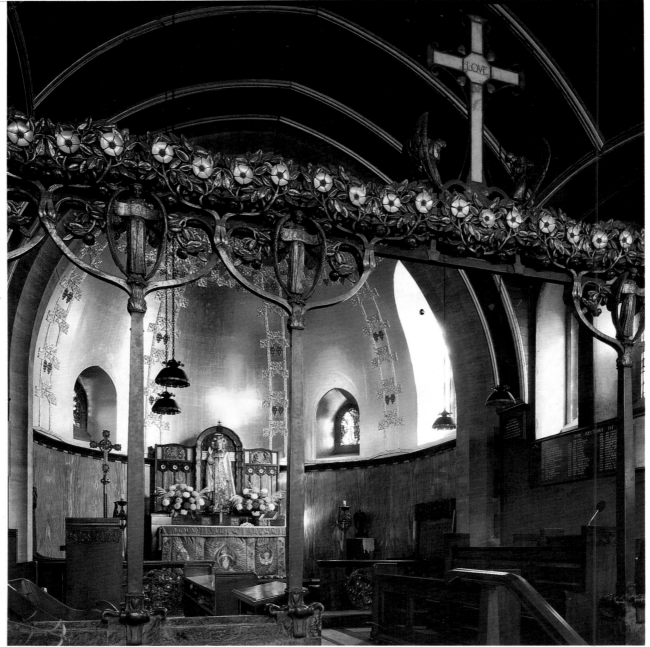

RIGHT: *The Horniman Museum, with its distinctive clock tower, was built by Townsend between 1900 and 1902. The museum was designed to contain the collection of the Horniman family, whose wealth had been amassed through tea shipping.*

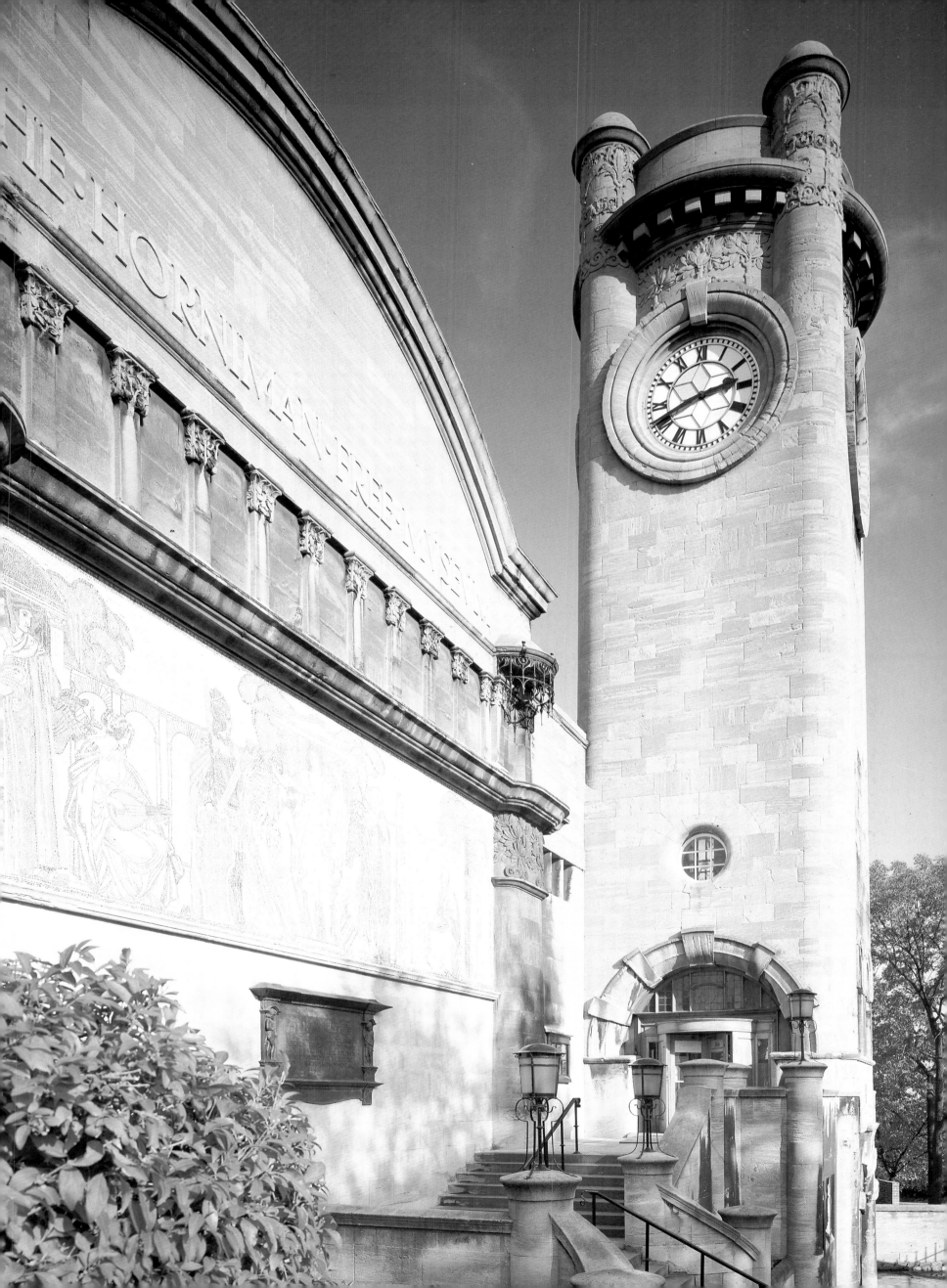

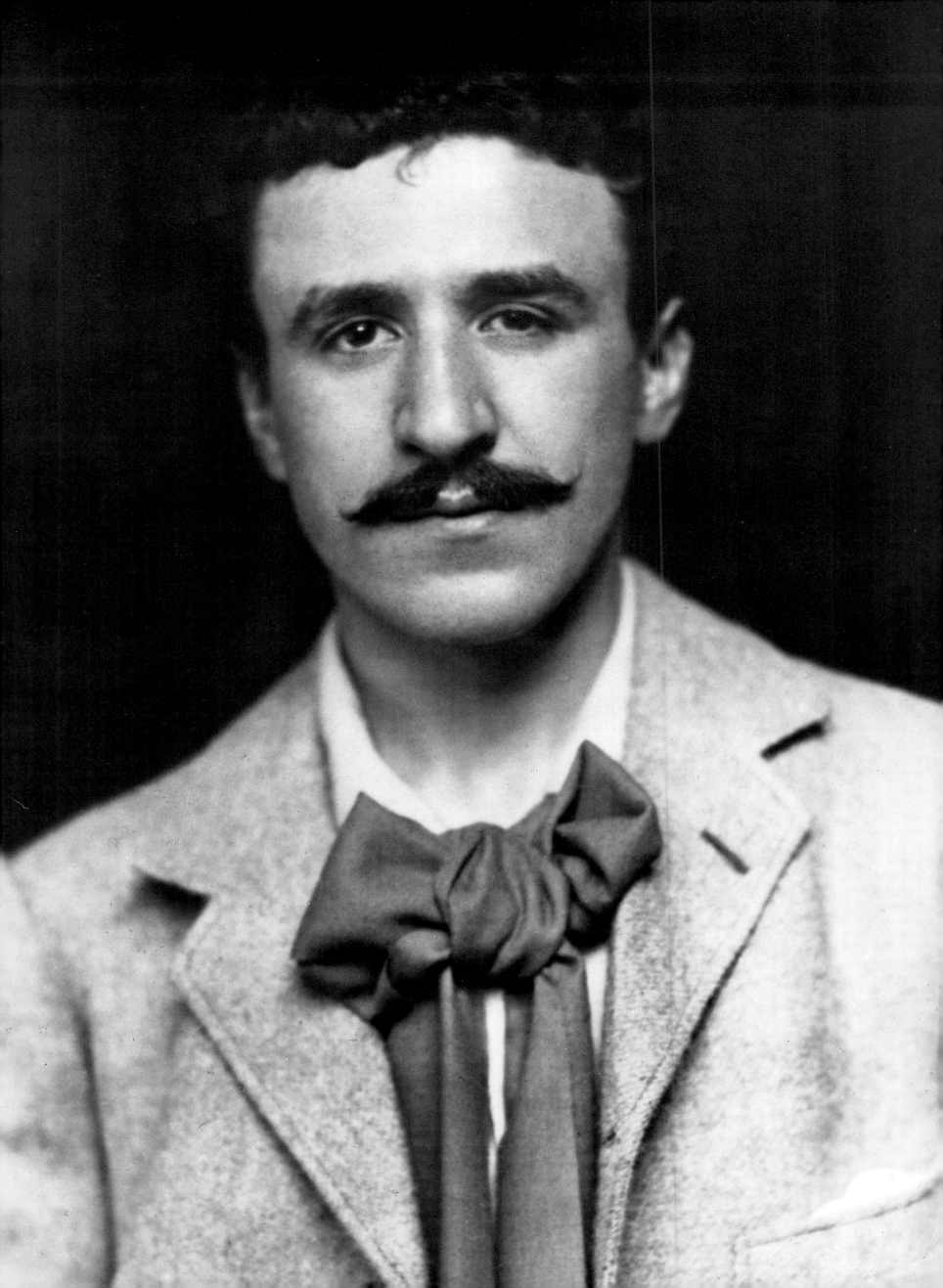

LEFT: *Charles Rennie Mackintosh (1868-1928).*

BELOW: *An 1896 poster for the Scottish Musical Review by C R Mackintosh.*

RIGHT: *The north entrance of the Glasgow School of Art, designed by C R Mackintosh.*

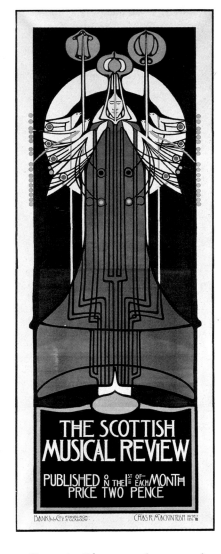

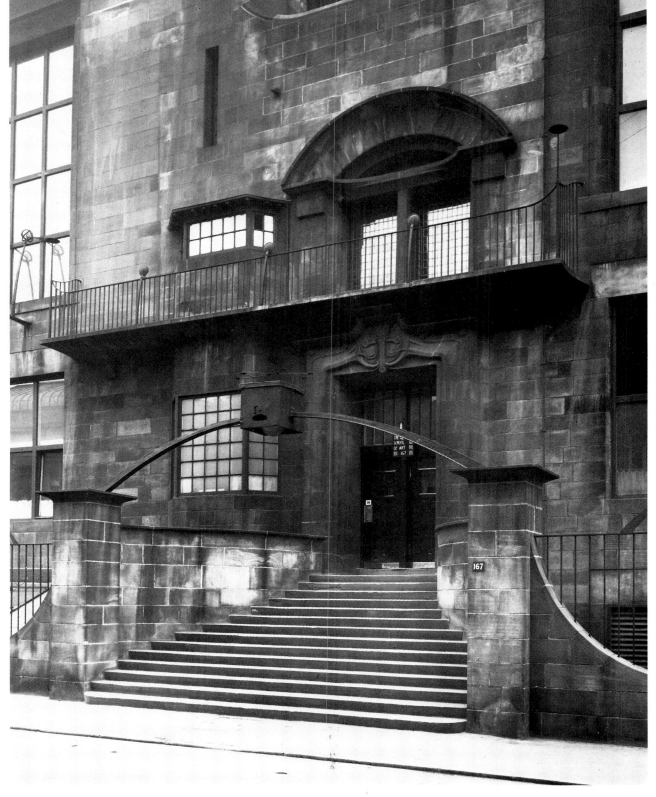

Born in Glasgow, the son of a police superintendent, Mackintosh began his career in 1884 as an apprentice to local architect John Hutchinson and enrolled in evening classes at the Glagow School of Art where, in line with the rest of British architectural education, the belief was that architecture was an art of adornment. But since the 1870s there had been a great interest in Glasgow in the arts, focused on a group of young painters who became known as the Glasgow School. And when Francis Newbery became head of the Glasgow School of Art, bringing with him a direct knowledge of artistic developments in London, the school became one of the finest in Britain and attracted much attention from the rest of Europe.

After completing his articles, Mackintosh joined the firm of Honeyman and Keppie where he became friendly with fellow draftsman H J MacNair. By 1892 Mackintosh had developed a fully Art Nouveau decorative style which utilized aspects of elongation and abstraction, a style much influenced by the appearance in 1893 of the magazine *The Studio* which contained illustrations of the works by Voysey, Beardsley's illustrations for Wilde's play *Salomé* and the Java-born Dutch symbolist Jan Toorop's painting called *The Three Brides*. Around the same time, Newbery had noticed a similarity of style in the work of Mackintosh and MacNair to that of two sisters, Margaret and Frances

Macdonald, and the four designers were brought together. The Four, as they became known, developed a common style, designing metalwork and posters such as Mackintosh's severely rectilinear poster for the *Scottish Musical Review* which attracted criticism for its abstraction when it was shown in 1896 at the Arts and Crafts Exhibition.

Having become a partner at Honeyman and Keppie in 1894, Mackintosh received his first important commission as a freelance designer in 1897: the new Art School in Glasgow, which was built between 1898 and 1899 and extended between 1907 and 1909. This commission would be followed closely by the first of the tea rooms for Miss Cranston.

Through his education within the mainstream of the Gothic Revival, Mackintosh learned a craft approach to building. This and Lethaby's book *Architecture, Mysticism and Myth* (1892) helped to bridge the distance between Celtic mysticism and the Arts and Crafts' approach to form. Mackintosh had always taken the more traditional approach, derived from Ruskin, which argued that modern materials like iron and glass could not replace stone because they lacked 'mass.' In the new Glasgow School of Art, despite the wealth of local gray granite and roughcast brick, iron and glass would be present in large quantities. The school, the result of a competition, was built in

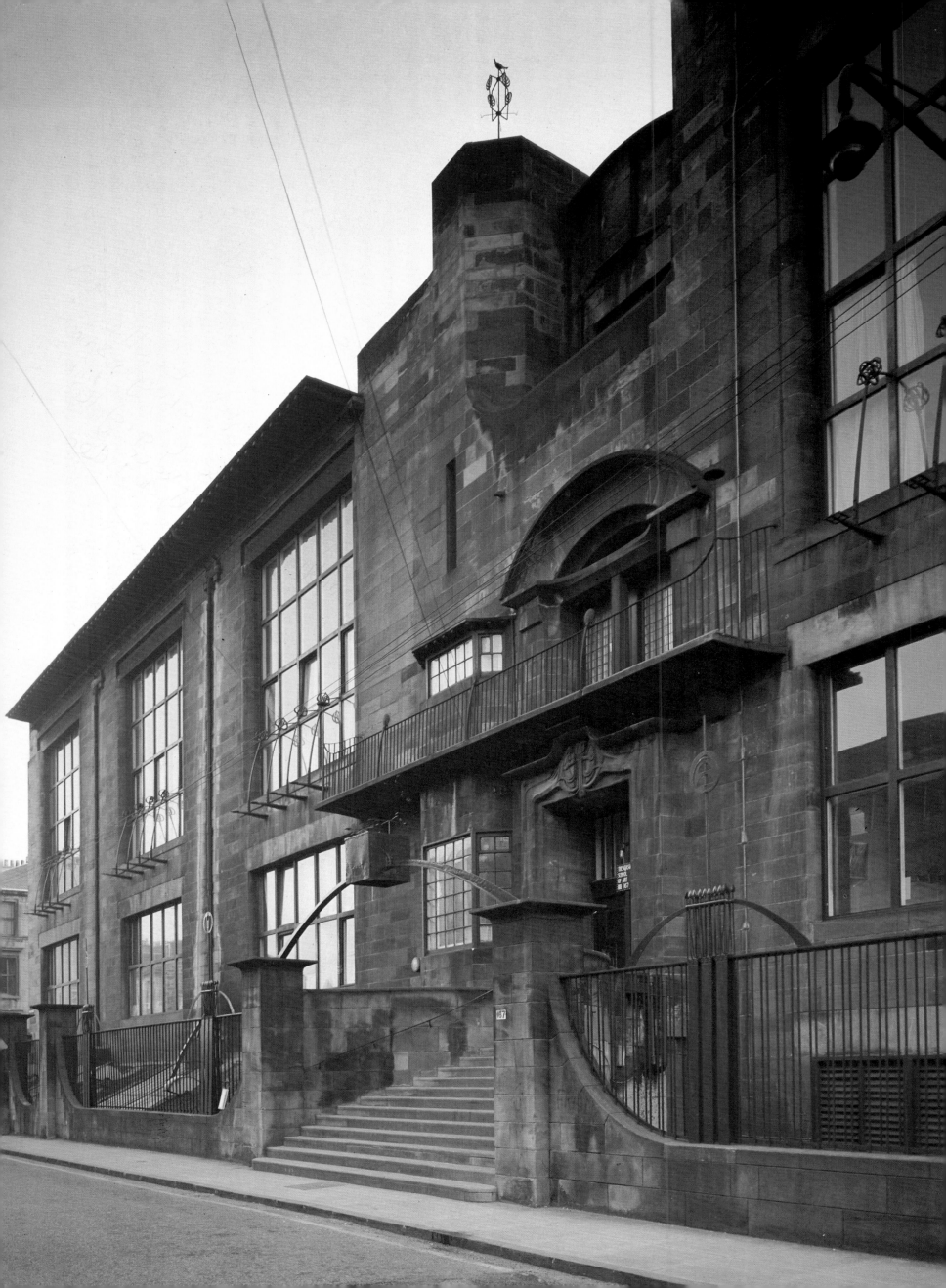

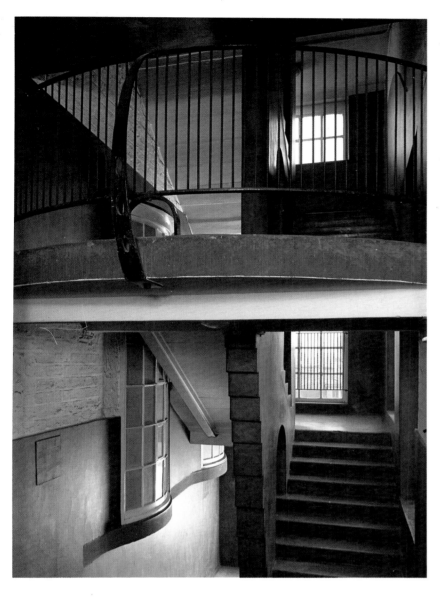

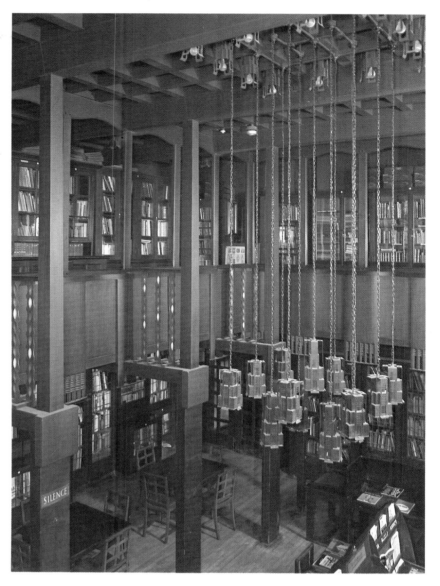

LEFT: *The north façade of the Glasgow School of Art. The projecting iron brackets, bent back against the windows like stylized flowers, are both decorative and functional as they provide support for window cleaners' planks.*

ABOVE: *The east staircase of the Glasgow School of Art, at the first floor level.*

ABOVE RIGHT: *The Library at the Glasgow School of Art belongs to the second phase of building, from 1907 to 1909.*

two stages and is a record of Mackintosh's stylistic development from 1896 to 1909.

The competition was initiated by Mackintosh's friend, tutor and patron Francis Newbery. His schedule proved too demanding for the budget of £14,000, so the competitors were asked to design a two-stage building, with the first stage to be constructed under the specified sum. The design that Mackintosh submitted on behalf of Honeyman and Keppie was not a fixed or final plan, but served Mackintosh as an 'intention' which was subject to refinements and improvements during the course of the building program. But in the first place it was the actual site that determined many of the characteristics of the building. This was a long, narrow rectangle of land lying east to west on the south side of the main, highly sloping access road. Newbery's demands for the school consisted of functional specifications such as large studios with uninterrupted north light and adequate heating.

The result was a plan rather like the letter E, with a series of studios connected by corridors. Despite the logical symmetry offered by the plan, Mackintosh utilized deliberately asymmetrical aspects: the huge studio windows reflect the various sizes of the rooms behind them, resulting in a non-uniform exterior bay spacing. The asymmetrical balance is continued further in the treatment of the entrance bay with the offset door and small window. But the railings, precisely symmetrical to the front entrance, show that the entrance door, despite its initial off-set appearance, is in fact at the physical center of the façade. The entrance door and surround were altered later to give them a more Art Nouveau form along with the gate pillars, topped by stylized clumps of tulips and an ironwork arch. One feature of the exterior which never escapes mention is the use of projecting iron brackets on the studio windows. Characteristic of Mackintosh's later decorative work, they are also a functional necessity: they support window cleaners' planks. The decorative heads of the brackets give relief to the expanses of glass and appear rather like flowers bent against the windows.

A more conventional use of ornament, however, is illustrated by the sculpted motif over the main entrance, whose curves blend into the molding around the doorway. While the exterior walls of the school are in local granite, the internal structure is based on brick piers with steel girders for the widest spans and cast-iron beams for smaller ones. The size of the interior spaces could be changed by removing the wooden partitions separating each studio. In the sub-basement Mackintosh incorporated an effective ducted heating and ventilation system, served by a large fan-room next to the boiler room and fed by fresh-air grilles beside and below the main entrance. The main heating duct supplied the vertical branches built into the corridor walls; these branches opened into the studios themselves by a series of grilles.

In the first phase of the building from 1897 to 1899, two rooms indicate the direction in which Mackintosh's style was moving: the original Board Room in the east wing (which now houses a permanent exhibition of the School's collection of Mackintosh's furniture, drawings, paintings and models) and the Directors' Office. Every detail of the rooms – every chair, table, clock and each piece of cutlery – was designed in relation to its setting. Both rooms are 'white rooms': in the Board Room the steel beams spanning the ceiling are left exposed but painted white, and in the Directors' Room, the apartment is panelled all round to a height of eight feet with built-in cupboards and panels of decorative leaded glass.

RIGHT: *Detail of the mural by Mackintosh for the Buchanan Street Tea Rooms. The predominant colors of the scheme were reds and purples, fashionable in both interior and textile design.*

FAR RIGHT: *White furniture and lamp fittings designed by Mackintosh.*

BELOW: *Simple lines and dark stains rather than varnishes were the hallmarks of many of Mackintosh' designs such as this chair.*

BELOW RIGHT: *White chair designed by Mackintosh and exhibited at the Turin Exhibition in 1902.*

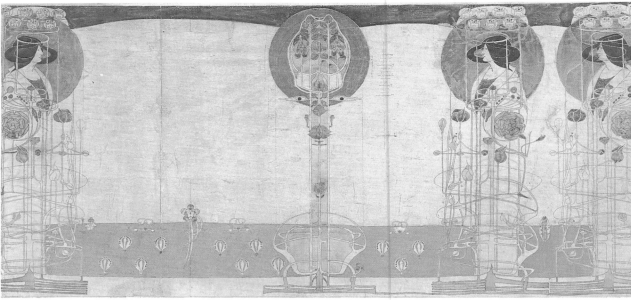

with George Walton (1867-1933), who designed the furniture, Mackintosh created the murals for the Buchanan Street rooms, in which he translated his poster technique into bold stencilled Art Nouveau patterns of peacocks, roses, lilies and women.

In the next project for the Argyle Street rooms, Mackintosh's contribution was limited once more, but this time to the design of the furniture. From 1894 Mackintosh was most active designing furniture. Several pieces were for the general market, while others were commissioned by the Glasgow firm of cabinetmakers Guthrie and Wells. The furniture was simple, the rectangularity relieved in places by a long sweeping curve, strap hinges and fittings. Avoiding the use of varnish, Mackintosh preferred dark green and brown stains which resulted in a quality that was close to the pieces produced by the Arts and Crafts designers. The difference, however, lay in Mackintosh's tendency to refine the structural pieces in his furniture, making them more slender and delicate in contrast to the homely chunkiness of the English pieces.

Mackintosh is known to have been concerned with the introduction of vertical elements within an interior: he disliked the idea of all the furniture being too much the same height. Some of the verticals of the chair backs would rise above the most elaborately dressed hair and feather hats, while other chairs had their back supports curtailed abruptly. These very low-backed chairs are said to have been used by Miss Cranston's waitresses during less busy periods in the tea rooms. By present-day standards, the chairs are uncomfortable after a long period, but it must be remembered that these chairs were not designed for relaxing in, but for sitting upright with the correct Edwardian deportment.

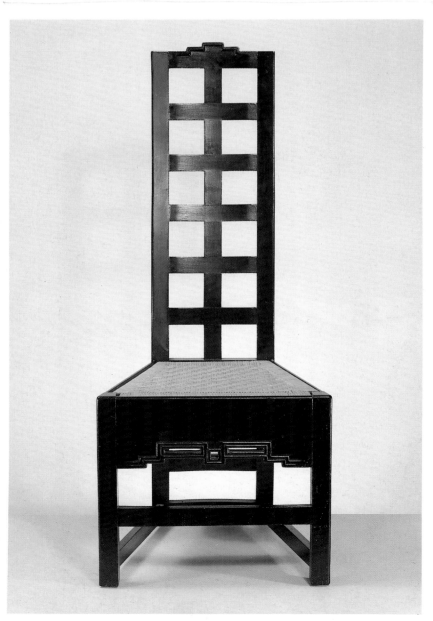

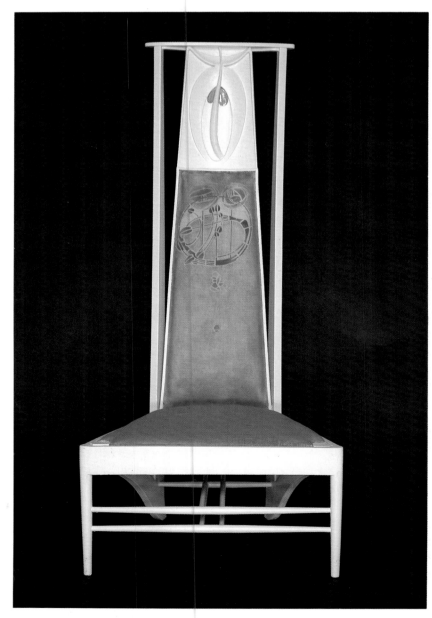

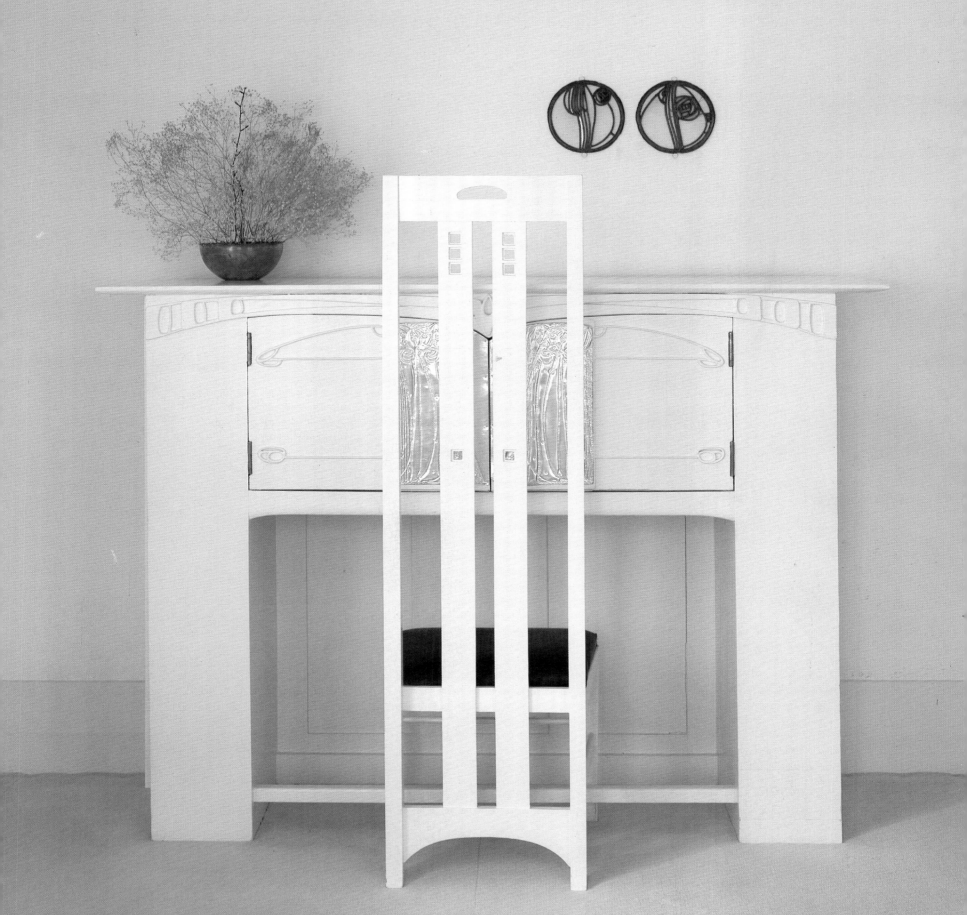

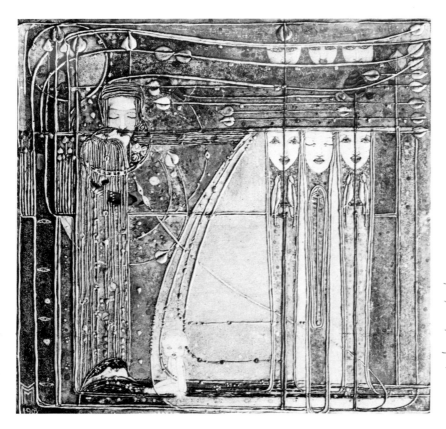

The Room de Luxe was painted white with a dado above which, on three sides, was a mural made of mirror-glass panels. On one wall, a gesso panel by Margaret Macdonald Mackintosh (the couple had married in 1900, a year after MacNair married Margaret's sister, Frances) based on Rossetti's Sonnet 'O all ye that walk in willow wood.' The Room de Luxe survives in part, though without Mackintosh's furniture, as the coffee room of Daly's Department Store. The doors and window were of leaded glass with the dominant colors of purple and rose, with a remarkable chandelier made of glass bubbles. The effect of the white interiors and furniture offset by the colors in the stained glass panels and doors captivated Mackintosh's European admirers: the Willow Tea Rooms were illustrated in 1905 in the German magazine *Dekorative Kunst* and followed the Four's exhibition of white rooms at the Vienna *Sezession* Exhibition in 1900 and the Turin Exhibition in 1902.

A main source of information regarding Mackintosh's work in domestic interiors and furnishings, since many of its contents have survived, is Hill House in Helensburgh, built for publisher W W Blackie. In Mackintosh's own writings and at Hill House itself, it is possible to see the legacy of the Scottish Baronial buildings which fascinated him and were to influence his designs. Built in local stone with traditional construction techniques, the building's elements are arranged according to their function, not their appearance. Externally, taking account of Scottish rains that are blown horizontally as well as falling vertically, the walls rise to protect the gable ends of the roof. Internally the irregularity of the rooms is derived from their use. The living room has two recesses, one a bay projecting from the face of the building, with a built-in seat and two doors which lead into the garden. At this, the 'summer' end of the room, there is a concentration of light which contrasts with the 'winter' end of the room with its fireplace and small window. The second recess was designed to hold the family's piano. The white walls of the room rise to the height of the bay window; above the picture rail, both walls and ceiling are painted dark, with the result that the main area of the room is established.

After 1901 Mackintosh had sole control of the design of Miss Cranston's tea rooms at new premises in Ingram Street, and from 1902 to 1904 at the Willow Tea Rooms in Sauchiehall Street. The Willow Tea Rooms were housed in a building also designed by Mackintosh, and featured five tea salons, a dining gallery and a billiard room. In these rooms, Mackintosh's use of symbolism is most apparent: the whole of the Willow Tea Rooms were decorated with a willow-leaf motif and abstracted forms in the plaster and ironwork relating to tree shapes. Both the name and the motif were appropriate as the street name, Sauchiehall, was itself derived from 'willow.'

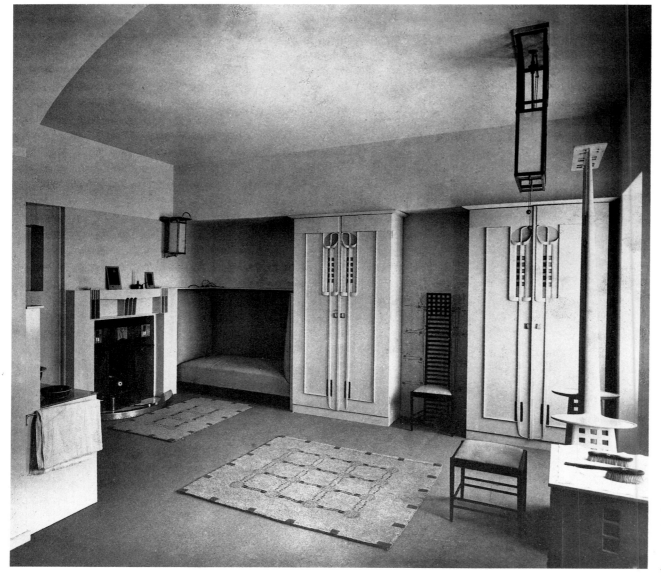

ABOVE LEFT: *The Opera of the Wind, a decorative panel for the Warndorfer Music Room in Vienna by Margaret Macdonald Mackintosh. Fritz Warndorfer would later become the financial backer of the* Wiener Werkstadt.

LEFT: *The main bedroom at Hill House in Helensburgh, designed by Mackintosh for the publisher W W Blackie. The main height of the room is established by the furniture set into recesses.*

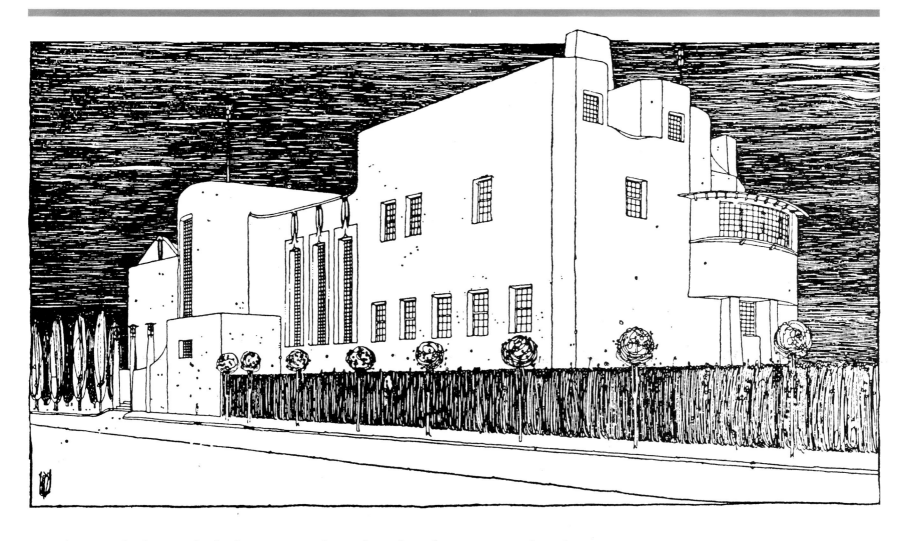

In the main bedroom, the bed is positioned in a large barrel-vaulted alcove off the main rectangle of the room. Again heights are established by the use of wardrobes, which are placed in recesses as deep as the furniture and which rise up as high as the top of the windows. Thus the arches and walls flow almost organically into each other, complemented by the varying verticals of the furniture.

After 1900 Mackintosh's name was widely celebrated abroad, though his work was little known in England. In Europe, he was fêted by Josef Hoffmann, and in 1901 the *Sezession* magazine *Ver Sacrum* was devoted to Mackintosh's work. This led Mackintosh to enter a competition organized by Alexander Koch's magazine *Zeitschrift für Innin-Dekoration* to design a house for an 'art lover.' Although Mackintosh strayed from the competition rules, he was considered important enough to merit a special award. In 1902, Mackintosh was commissioned to design a music room in Vienna for Fritz Warndorfer, who became the financial backer of the *Wiener Werkstadt* in the following year.

In 1903 Mackintosh's work became known in Russia: examples of his designs were illustrated in the avant-garde *Mir Iskusstva* (The World of Art) and in 1905, 35 illustrations of Hill House appeared in *Deutsche Kunst und Dekoration*.

But at home, Mackintosh's work received little publicity, and in 1914 he left Glasgow for good. After moving to London, he received no architectural commissions. Isolated from his strongest supporters in Austria and Germany by the war, Mackintosh found his career in decline. Coupled with his habitual heavy drinking, this lack of recognition led to his death in poverty in 1928.

Mackintosh occupies a unique position in the history of the modern movement: in his work he took what he needed from his Scottish background, from the Arts and Crafts movement and from Art Nouveau, and brought them together in his own personal style. While his buildings and furniture may appear forward looking, Mackintosh was entrenched in the nineteenth century: while he was denying the possibilities of steel and glass taking the place of stone in architecture, Louis Sullivan had completed his Carson, Pirie and Scott Store in Chicago. And despite the similarities between Mackintosh's work and the Viennese designers such as Hoffmann and Olbrich, by looking at the Scot's work alongside those of his contemporary French or Belgian Art Nouveau designers, the essential differences are apparent.

ABOVE: *Mackintosh's 'Art Lover's' House earned him an award in Koch's 1901 competition.*

BELOW: *Chairs designed for Hill House by Mackintosh. The severity of Mackintosh's rectilinear style has recently enjoyed a revival.*

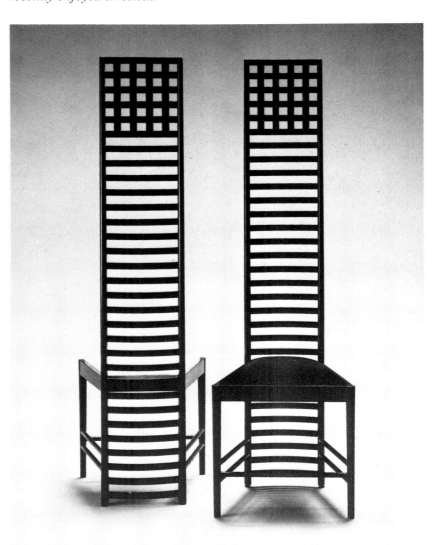

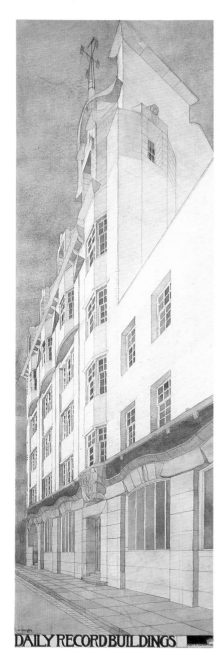

ABOVE: *Mackintosh's sketch for the* Daily Record *Buildings*.

RIGHT: *The* Castel Béranger *apartment building was designed by Hector Guimard for Madame Fournier. Separating the 'service' stairs at the rear from the main staircase inside is a wall of double curved glass tiles. The glass wall allows light to pass from the rear of the building through to the main stairs without the intrusion of servants or tradesmen.*

RIGHT: *Hector Guimard's Métro station entrances, such as this one at Abbesses, used prefabricated sections of cast iron. Between 1900 and 1904, 140 such entrances were built in Paris.*

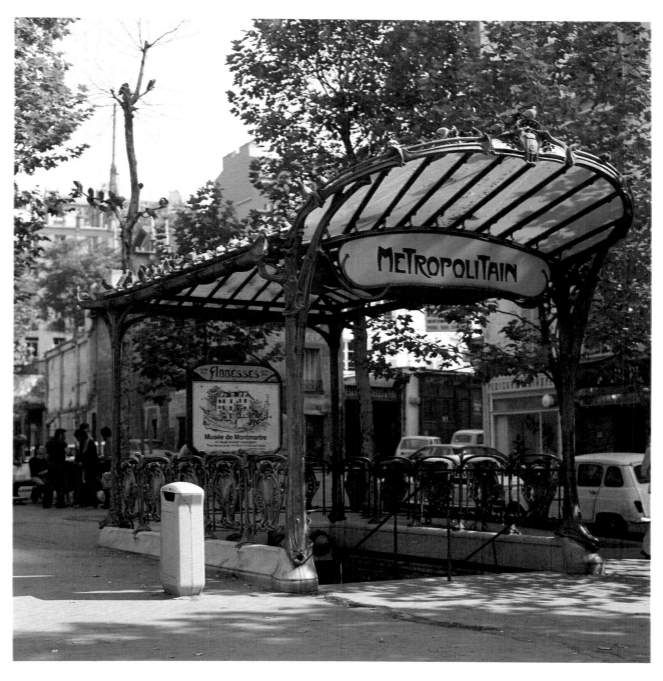

BELOW: *Guimard's cast-iron sections were painted green to resemble bronze. Despite their sinuous and delicate appearance the entrances have stood nearly a hundred years of constant use. Even the typography is treated in the same flowing style.*

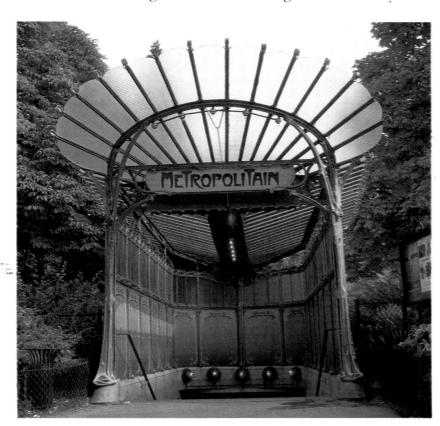

As the curvilinear mode of Art Nouveau developed, the features that had first been used by Mackmurdo in his title page for *Wren's City Churches* and again in his fretwork-backed chair and textile designs, became more apparent. The sinuous flowing lines were capable both of decorating solid forms and being used structurally. Thus the ideals of beauty and utility could be married, as they were by Hector Guimard (1867-1942) in his plant-like, arched cast-iron Paris Métro station entrances.

Guimard, one of the best-known French Art Nouveau architects, received a traditional academic education at the École des Beaux-Arts in Paris from 1885 to the early 1890s. While studying there he became acquainted with the theories of Eugène-Emmanuel Viollet-le-Duc (1814-1879) who, like the Arts and Crafts Movement, advocated the essential unity of the arts. Having won a scholarship, Guimard was able to visit England and Scotland to study the works he had read about in magazines. Although impressed by what he saw, he was more influenced by his visit to Belgium to see the architect Victor Horta (1861-1947), who had designed his *Hôtel Tassel* in 1892.

In 1894 Guimard was commissioned to design a block of apartments in Paris, the *Castel Béranger* for Madame Fournier. Guimard drew up plans in a neo-Gothic style in 1895, but in the year he met Horta, so the story goes, he was persuaded to forget the 'flower' and concentrate on the 'stem.' Returning to Paris, Guimard completely redesigned the *Castel Béranger*, introducing several new features. Each of the 38 apartments was to have an individual plan, making them varied and irregular. This same varied and irregular quality is evident once more in the façade. For this, Guimard used a variety of materials: brick, carved stone, wrought iron, cast terracotta, iron and bronze. In the façade, we see all the characteristics of the curvilinear mode of Art Nouveau: asymmetry, the predominance of line, and ornamentation that is structural and in certain cases functional. Many of the building's features were the result of Guimard's idea of being both artist and master of works; he undertook all aspects related to his architecture, including the ironwork, stained glass, ceramics, carpets and even the lettering.

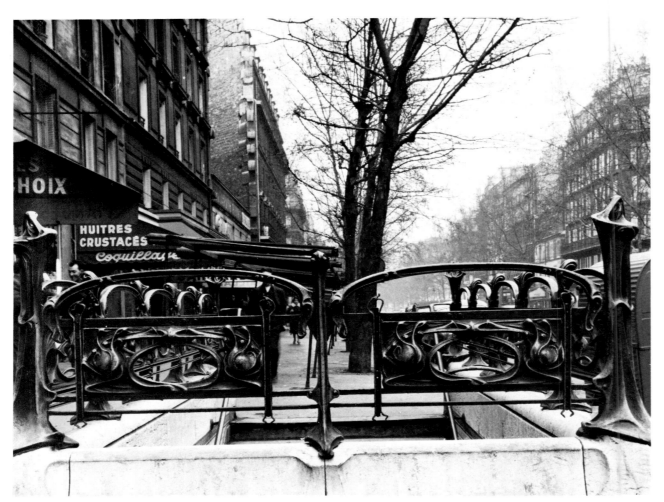

RIGHT: *The glass-topped dome of Horta's* Hôtel Van Eetvelde *is supported by steel stanchions and decorated with stained glass. The dome lights the central living space of the house.*

BELOW: *With the* Hôtel Tassel *(1892-93), Victor Horta became one of the first architects to make extensive use of iron in a domestic building.*

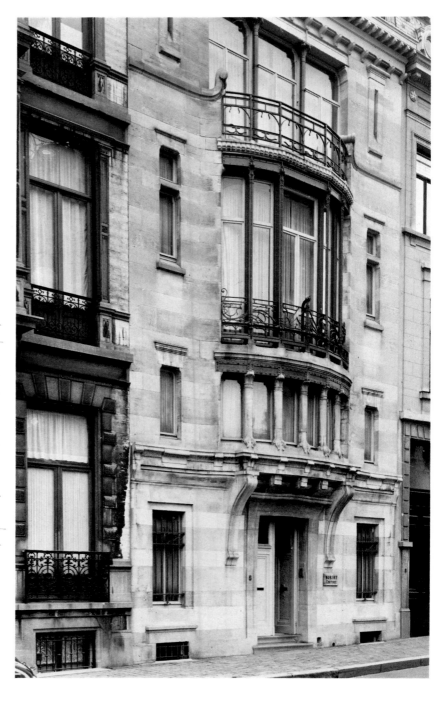

Like his mentor Victor Horta, Guimard was prepared to expose iron and glass where necessary. At the top of the building are rarely seen iron details that resemble sea horses, while at the back of the building, separating the main staircase from the service stairs, is a wall of double curved glass panels in alternating shapes. But it is the famous iron entrance gate that most clearly expresses the Art Nouveau style in its asymmetrical balance of swirls and straight lines.

Guimards' Métro station entrances date from 1900 to 1904. One hundred and forty entrances were built in Paris, many of which survive today. Important not only as examples of Art Nouveau, the station entrances are significant in their use of prefabricated cast-iron elements, for Guimard believed that modern machine methods should be used whenever possible. The cast iron was painted green to resemble bronze, and although they may appear intricate in design, the entrances have stood up well to the strain of three quarters of a century's heavy use. Guimard even treated the typography and lighting in the same sinuous way, all of which gave rise to the name 'Style Métro' as a synonym for Art Nouveau.

Guimard's contemporary in Belgium, Victor Horta, was a cobbler's son who had originally studied music before moving to Paris to work in the studio of an architect and decorator Debuysson. Between 1892 and 1893, Horta designed a house for the engineer and geometry professor Emile Tassel, a house that would be the first movement towards the fully developed Art Nouveau style.

In the *Hôtel Tassel* (the word 'hotel' here means a significant residence or mansion, rather than a hostelry) a narrow, three-storey town house in a traditional terrace, Horta became one of the first architects to make extensive use of iron in a domestic building. He exploited its strength in supporting columns and its decorative capabilities in the free-flowing lines which are most apparent in the staircase. Here the supporting iron column is embellished with a capital of iron tendrils, the separate lines of which are repeated throughout the rest of the ironwork as well as in the paintwork, the mosaics and the colored glass panels.

The professor's office and laboratory were placed on the street front in a mezzanine floor (between the ground and first floor). In order to do this without excessively high or low ceilings, Horta changed the level of the ground-floor rooms in the rest of the house by raising them up half a storey. Cast-iron columns carry the weight of the building through the center of the house and, combined with

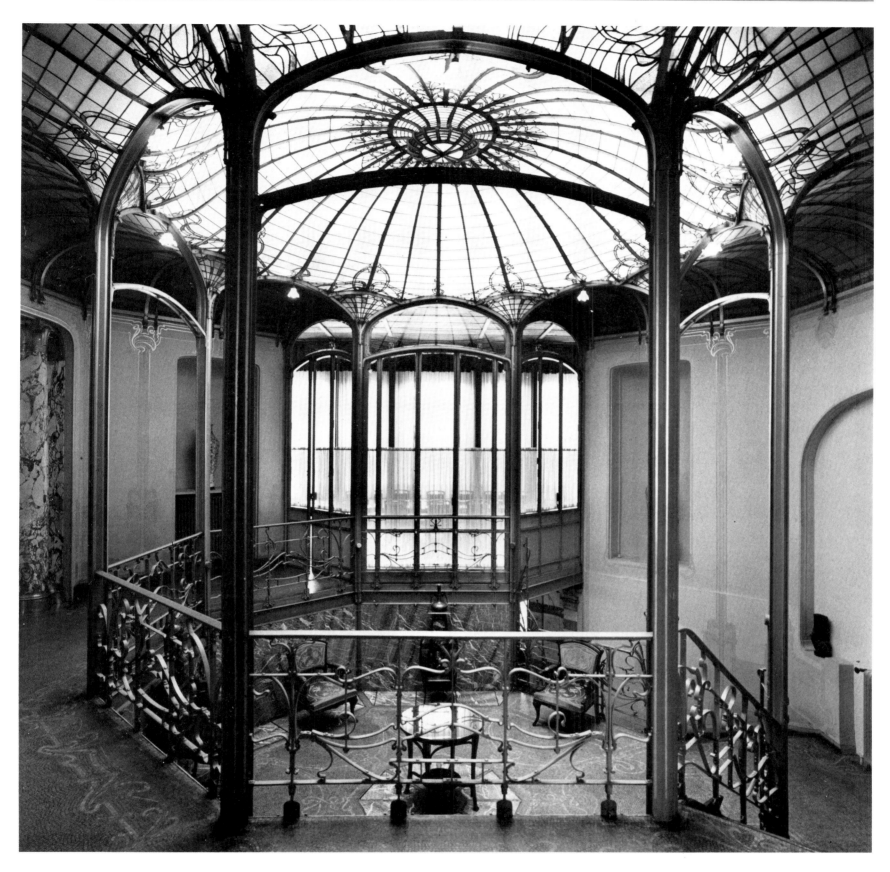

light wells, provide an open structure which is remarkably well lit for such a narrow building. The exterior of the *Hôtel Tassel* appears at first sight to be less remarkable than the interiors. Here however, Horta also used iron in columns and in an exposed beam between the first and second floor – something that had never been done in a private dwelling. The shallow curve of the bow window, though really only hinting at what is contained behind, harmonizes the *Hôtel Tassel*'s façade with the existing, neighboring architecture.

Over the next ten years, Horta continued to explore the potentials of both iron and stone in a number of other houses in Brussels. His own house, the *Hôtel Horta*, shows again his treatment of these materials: on the balcony, iron supports curl like flowers while supporting pillars leaf out in a manner akin to the earlier staircase. The *Hôtel Solvay* is on a much more magnificent scale. Built for a wealthy client, Armand Solvay, the building uses the same spindles of iron as supports and decoration. The façade of the *Hôtel Solvay* is made up of an arrangement of flat and curved surfaces, out of which the ornament seems to grow. The *Hôtel van Eetvelde* was again an extravagant and spectacular house designed for a wealthy client (in this case a Baron)

with exotic tastes. In the *Hôtel van Eetvelde*, the central living space and communication place for the rest of the house is topped by a glazed dome supported by steel stanchions and decorated with stained glass.

Between 1896 and 1899 Horta produced his most original work, though it was completely different in function and design from his previous projects. The *Maison du Peuple* in Brussels, (now demolished) was built as the headquarters of the Belgian Socialist Party. For this building, there were several requirements that Horta had to meet: two large public spaces were needed for daily meetings and rallies, and a large auditorium with seating for two thousand for party conventions and staged presentations. Much of the front of the *Maison du Peuple* was to contain income-producing shops, offices and some smaller meeting rooms. On the façade, the iron frame of the building was visible, mixed with brick, stone and glass, and the Art Nouveau details were apparent in the ironwork balustrades and the stone carvings across the curving front of the building.

Inside, the auditorium was one of the classic statements of Art Nouveau, in which decoration was combined with the curvilinear struc-

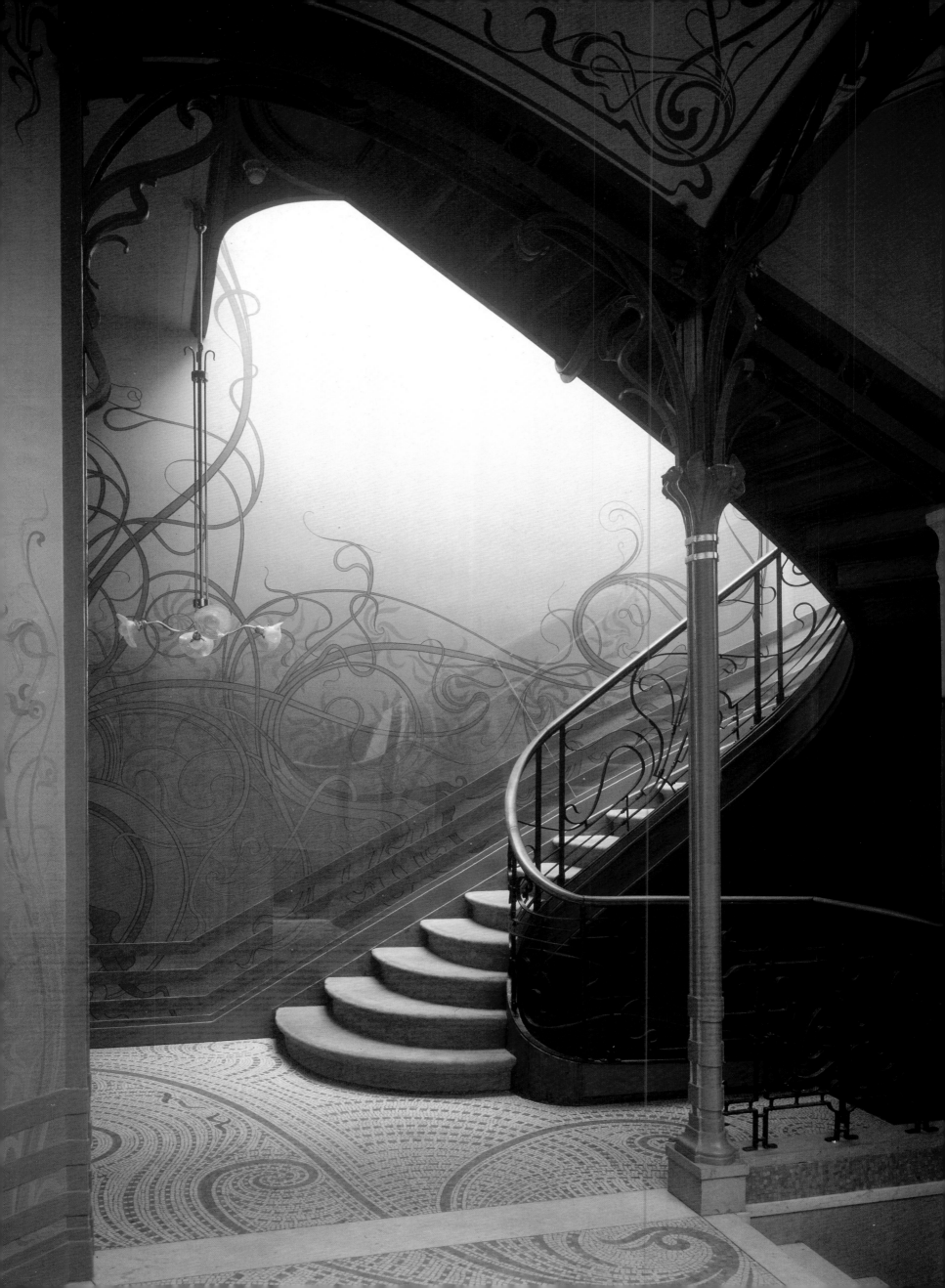

LEFT: *The famous staircase from the* Hôtel Tassel. *The iron tendrils of the capitol are repeated in painted and mosaic decoration.*

RIGHT: *The façade of the* Hôtel Horta *explores the potential of both iron and stone.*

BELOW: *Art Nouveau door furniture on the* Hôtel Horta, *now a museum.*

BOTTOM: *Stained glass windows from the* Hôtel Van Eetvelde.

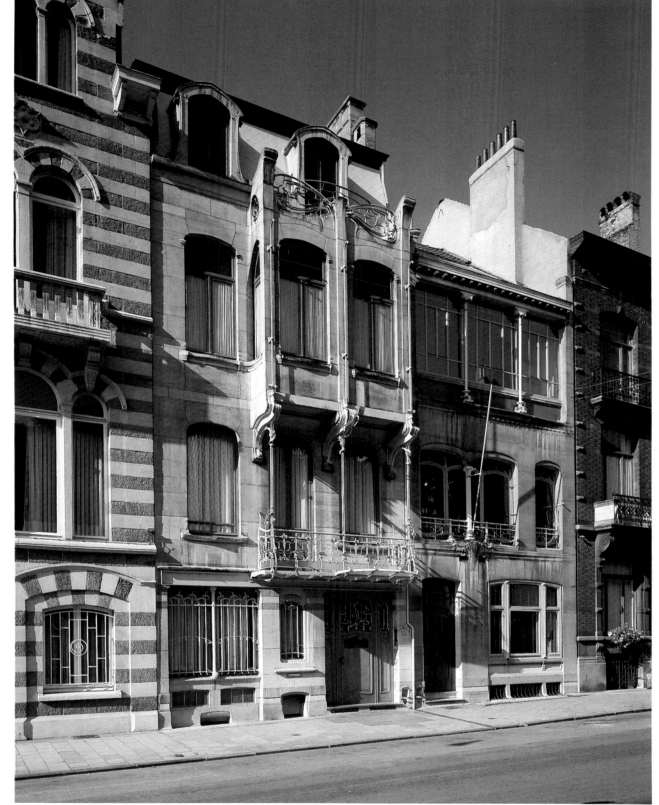

ture. The roof was carried on exposed curving steel girders, providing a lightweight yet rigid construction. Steel supports did away with the need for supporting columns (which usually restricted the views from the galleries); and over these supports, iron decorations climbed and twisted.

Horta's style grew out of the campaigns by architects in Belgium in the 1870s to develop a new, modern national style that was truthful and free from foreign influences. Such interests on the part of architects ran parallel with a general preoccupation with national identity that was aided by an accumulation of industrial wealth and by the political independence of Belgium.

In fact, the situation in Brussels at the end of the nineteenth century was in many respects similar to that in Barcelona, where in the 1860s a comparable Catalan revival had taken place when Madrid assumed sovereignty over the province, forbidding the use of the Catalan dialect. At first the revival was confined to social and political reforms, but it later took the form of a growing demand for Catalan independence. Despite support from the Church, Catalan independence was never granted and the claim would later emerge as a powerful factor in the Spanish Civil War.

partitions in the rooms allow the building to be adapted for any use.

The *Casa Mila* occupies a corner space in the Paseo de Gracia, the main promenade in the Ensanche, and in order to exploit the free plan of the building, Gaudí rounded off the angles of the building, so the façades follow a series of serpentine lines. In the rounded windows, irregular columns and in the ironwork of the balconies we again find the forms of nature. The roof also follows a serpentine line. This is not merely decorative, but is formed by the arched supporting structure; variations in the height of the parabolic arches in the attic cause the undulating line. Built in bricks 'edge on,' the arches give maximum rigidity with a minimum of thickness, which facilitated the conversion of the attics into further apartments in 1954. On the roof terrace of the *Casa Mila*, the same rhythmic lines are apparent. Ventilators are lined up like a helmeted army, while the steps placed close to the edge of the deep courtyard must have produced dizziness if not fear, for originally there were no banisters.

After stopping work on the *Casa Mila*, Gaudí devoted himself solely to religious architecture, of which the best-known example is undoubtedly the *Sagrada Familia*. The parts of the Temple of the Holy Family built by Gaudí include the crypt, the apse and the Nativity façade. The towers reach up 340 feet (100 meters), and a dome, which would have brought the structure to over 500 feet (150 meters), was planned but never executed.

The four towers over the eastern portal (the Nativity portal) are perhaps the most striking elements; instantly recognizable as the work of Gaudí, they have become a landmark of the city of Barcelona. The four towers were the first and only ones to be built out of a planned total of thirteen. The walls of the towers are pierced by openings, the sides of which are laced together by horizontal masonry. These function rather like louvres, protecting the interior from rain and deflecting sound. The towers above the portal are unmarked by sculptural elements in contrast with the lower section of the portal where the stone façade is clad with several large sculptures cast from cement in which are embedded fragments of glass.

Like all Gaudí's projects, the *Sagrada Familia* changed as building progressed. Constantly applying new theories and methods to the building, Gaudí developed a column based on a tilted tree structure which freed him from the need for flying buttresses to support the walls. Despite all his foresight, however, Gaudí was not an architect in the twentieth-century sense of the word: he was essentially still a

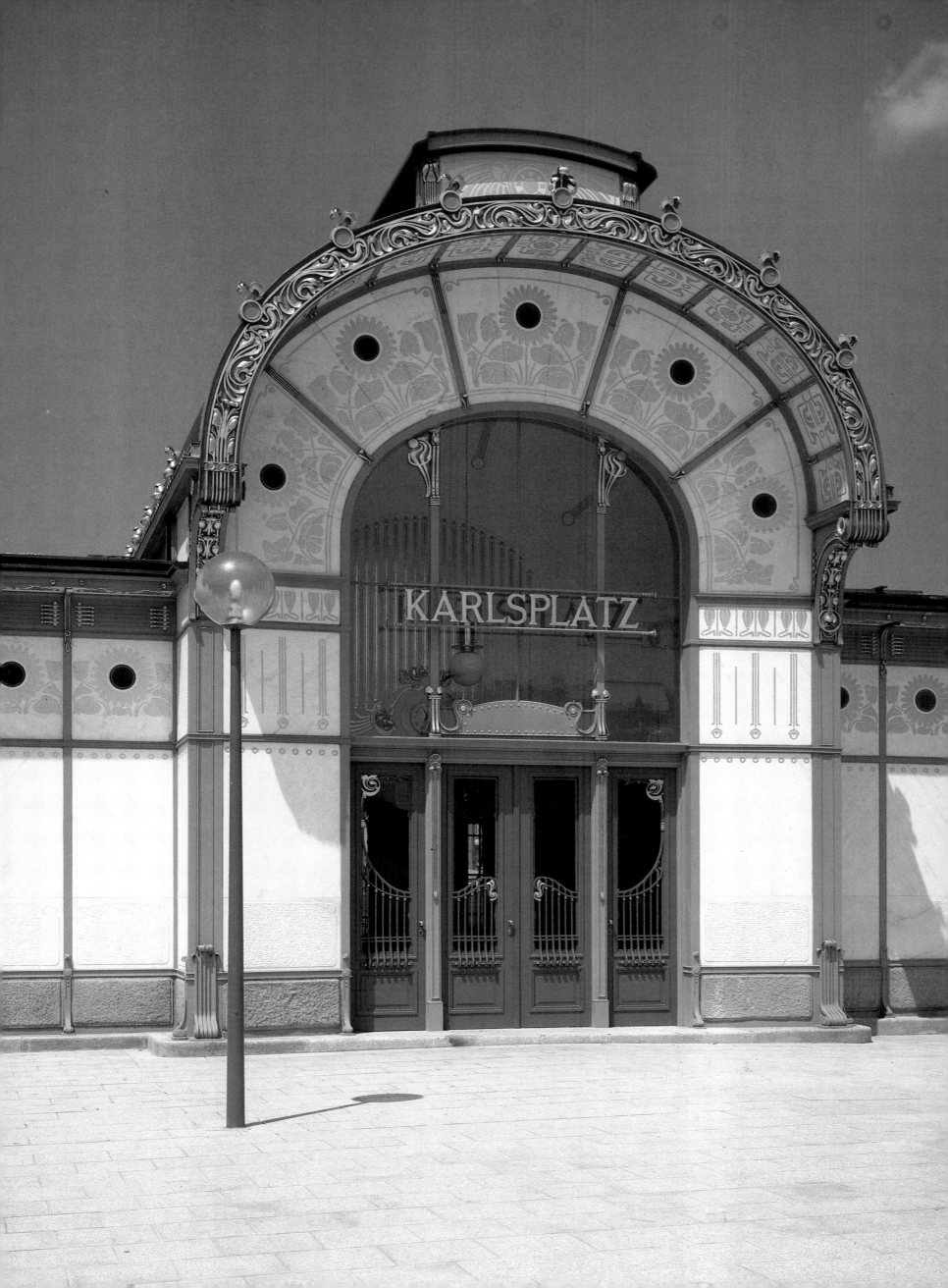

craftsman whose decisions were made in the course of construction rather than in definite paper plans. Even though a true Art Nouveau style only became apparent in his work after 1900, Gaudí has been hailed as a pioneer of twentieth-century structure and a forerunner of Nervi and Le Corbusier. In his refusal to continue the historicism of the nineteenth century, his interest in functional aspects of building, in his bold experimentation and in his individualism, Gaudí was truly a part of the Art Nouveau movement.

The various designs of European Art Nouveau were exhibited for the first time at the Universal Exposition in Paris in 1900, followed by a second exhibition in Turin in 1902. From these, artists on the continent became more acquainted with the English movement. A further understanding in Germany and Austria of Mackintosh's work in particular was aided by Hermann Muthesias (1861-1927), the cultural attaché at the German embassy in London from 1896 to 1903. In 1901 Muthesias published his book *Die Englische Baukunst der Gegenwart* and from 1904 to 1908 produced three volumes of articles and letters, *Das Englische Haus* which praised the work of Mackintosh and Baillie Scott.

The German Art Nouveau, or *Jugendstil* designers, like their British, Belgian and French contemporaries, began their careers as painters and graphic artists and later turned to design and architecture under the influence of Ruskin, Morris and the Arts and Crafts Movement. The *Jugendstil* only truly manifested itself after 1897 and, from the beginning, was split between ornate curvilinear forms derived from nature such as those of Horta and Guimard, and more rectilinear abstract forms like those of Mackintosh.

By 1900 German design was gripped by Art Nouveau ornamentation. The Elvira Studio by August Endell (1871-1925), built in 1897 and destroyed in 1944, had certain affinities with the work of Guimard and Gaudí in its deliberately asymmetrical walls and openings and in the curving ironwork of the windows. But the motif, like a breaking

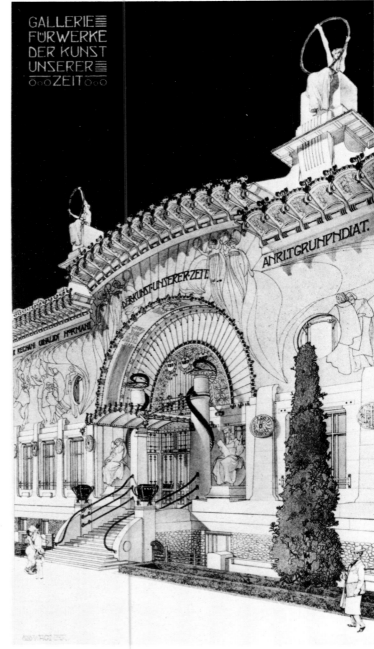

ABOVE: *Otto Wagner's design for an art gallery in Vienna.*

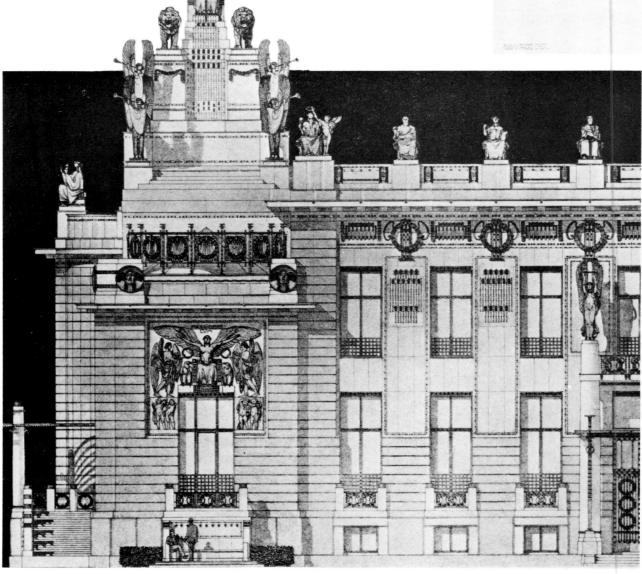

LEFT: *Otto Wagner's 1906 design for the* Friedenspalast *in the Hague.*

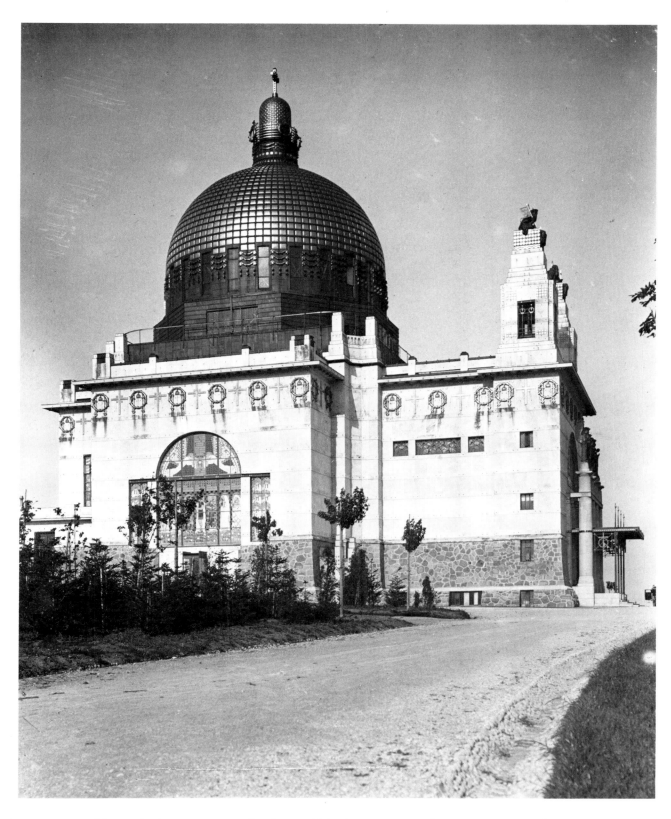

RIGHT: *The Steinhof Church (1906) in Vienna typifies Wagner's later style. Under the influence of Josef Olbrich, he moved further from classical architectural forms.*

wave, which dominated the façade is unique. Through the avant-garde review *Pan*, the taste for the Art Nouveau spread throughout the German-speaking countries, but soon afterwards the influence of the Vienna School began to be seen.

In 1895 Otto Wagner (1841-1918) published his book *Moderne Architektur*, in which he stated that architecture should concentrate on 'modern life' instead of imitating past styles. Wagner's ideas bore fruit in the form of the *Vereinigung Bildender Kunstler Österreichs* (The Austrian Fine Art Association), a breakaway group of artists who adopted the name *Sezession* and published the journal *Ver Sacrum*. Their motto was 'Der Zeit ihre Kunst – der Kunst ihre Freiheit' (to the age its art – to art its freedom), a concept similar to that expressed in Wagner's book. While Wagner's early commissions for projects such as the construction of the stations of the *Stadtbahn*, the transport system, betray a certain classicism; a building which shows his integration of the new decorative influences from the rest of Europe is the Maiolica House, a block of apartments over shops in a suburb developed outside the Ringstrasse in Vienna. (In 1857 Emperor Franz Joseph II had ordered the demolition of the fortifications surrounding the old city and the construction in their place of the Ringstrasse to link the old city with the rapidly developing new suburbs.)

In overall form the Maiolica House is similar to many other basic-

ally classical blocks in Vienna: the Art Nouveau influence is apparent in the treatment of the surface with colored maiolica tiles, with a sunflower motif repeated on the balconies. Wagner's later style, as exemplified in the Steinhof Church (1906), came about through his contact with the experiments of younger architects, in particular Josef Olbrich (1869-1908), who worked in Wagner's studio from 1894 to 1898. Olbrich abandoned almost all conventional decoration and replaced it with plant and tree forms, using a wide variety of materials and a range of color effects. In the *Ernst Ludwig Haus* designed for Ernst Ludwig of Hesse and his archduchess in Darmstadt in 1901, the mosaic in gold which frames the entrance and the blue-green mosaics of the terraces are typical of Art Nouveau.

Joining Olbrich in the *Sezession* and in Wagner's office was Josef Hoffmann (1870-1955). Hoffmann and his colleague Kolomon Moser (1868-1918) had organized an exhibition in Vienna in 1901 in which they displayed a series of furnished rooms. Some of the rooms they designed themselves, others were the work of Ashbee and Mackintosh, but all were met with great approval by the Viennese public and much of the furniture on exhibition was sold. After visiting England and Ashbee, Hoffmann met with Mackintosh in Glasgow. On their return to Vienna, both Hoffmann and Moser decided to try and bridge the gap between artist and craftsman to provide good-quality unified

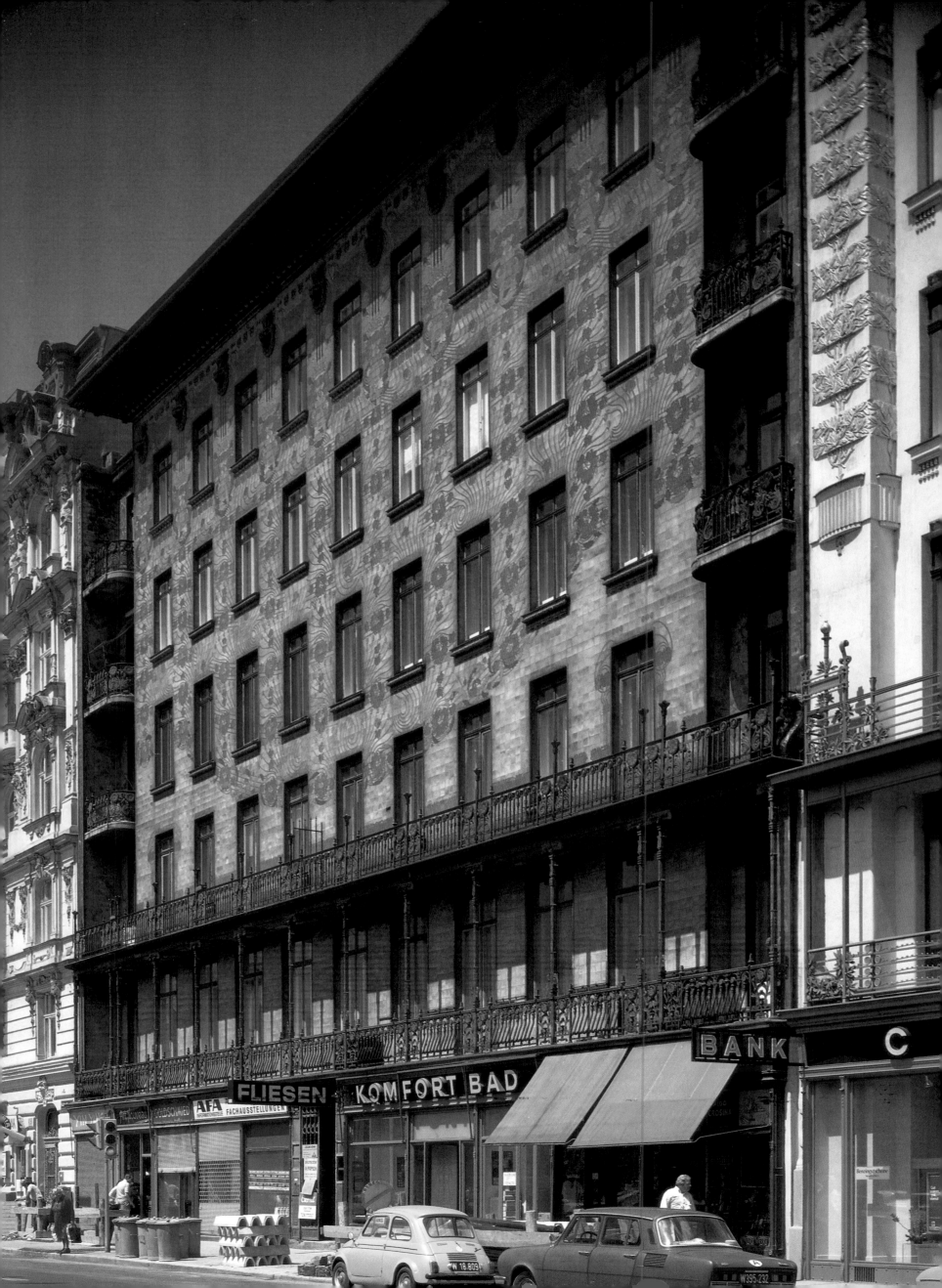

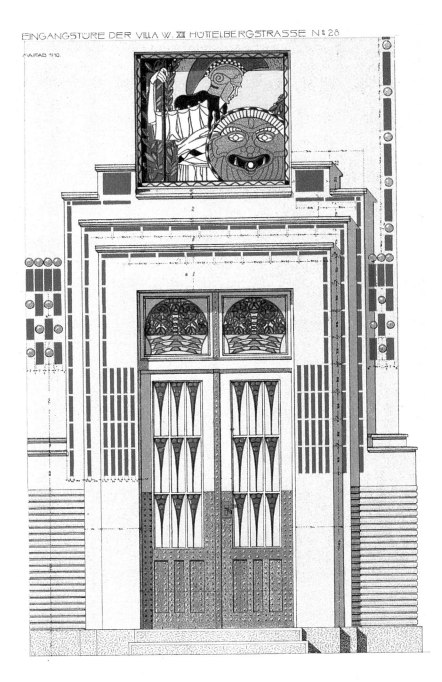

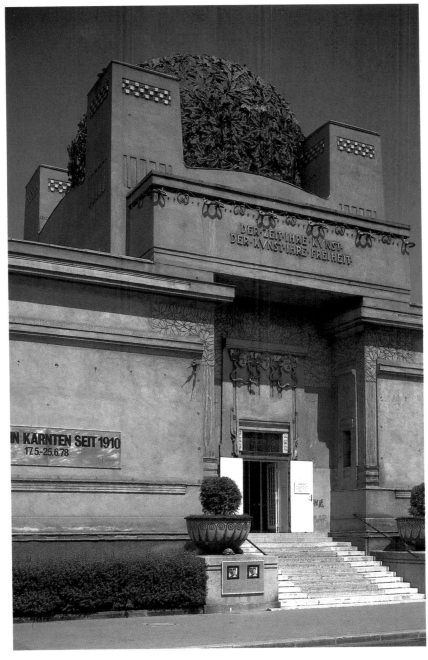

design. With Ruskin and Morris as their spiritual guides, they founded the *Wiener Werkstadt* in 1903 with financial backing from Fritz Warndofer, who had also been a patron of Mackintosh. The *Werkstätte* established the fashion in Vienna for clear lines and pure forms; they made few attempts to approach the needs of machine production, however, for the *Werkstadt* was still essentially a craft-based organization.

Overshadowing all of Hoffmann's commissions is his magnum

ABOVE LEFT: *Otto Wagner's design for a villa on the Ringstrasse shows the development of his style, particularly in comparison with the Karlsplatz station.*

ABOVE RIGHT: *The Vienna Secession Building (1897-98) by Josef Olbrich differs little in plan and general arrangement from the customary exhibition halls; in the treatment of the façade, however, Olbrich abandoned classical ornamentation in favor of tree forms.*

LEFT: *One of a pair of apartment blocks with shops below, Otto Wagner's Maiolica House has its façade clad in colored tiles with a weaving sunflower motif repeated in the balconies.*

RIGHT: *Peter Behrens' own house in the artists' colony at Darmstadt uses bands of green terracotta to create a rippling effect.*

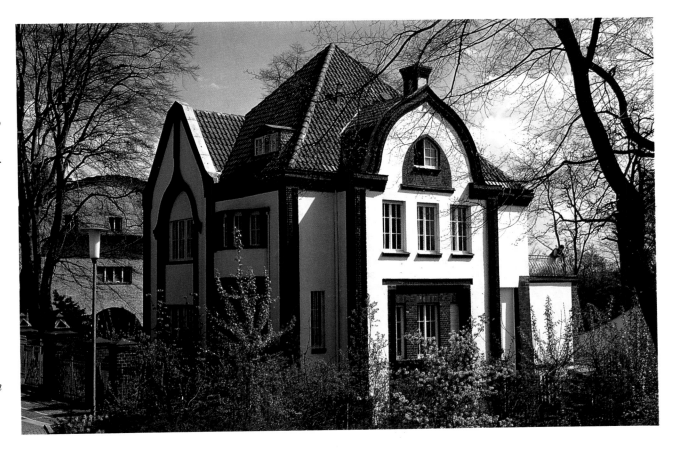

Peter Behrens (1868-1940). Behrens' contribution to the 1901 ex- placing the walls. Heavy stonework is still employed, but it has been

Eugène Vallin perhaps came closest to the heavy curving and molded forms that we saw in Guimard's Métro station entrances. Where English interiors normally consisted of separate pieces which harmonized, Vallin's furniture was designed from the outset as an integral part of a homogenous room. This approach, coupled with Vallin's tendency to choose dark woods, tended to result in a very formal and often forbidding impression; one feels that one is intruding on the room itself.

Alexandre Charpentier (1856-1909), a sculptor who later became a decorator, was part of the Parisian group *Les Cinq* which was at the center of the crafts revival in Paris. Charpentier took the Art Nouveau curve to its extreme, an approach that is particularly evident in the Rotating Music Stand, the base of which is more like melting wax than wood. Like many designers of the Art Nouveau period, Gallé, Majorelle and Charpentier did not confine themselves to designing and producing furniture. Given the Art Nouveau insistence on the unity of the arts, it is not surprising that the figures we associate with architecture, such as Guimard, Gaudí, Mackintosh and van de Velde, should have designed furniture, or that those we associate with furniture should have designed glass, silver and jewelry.

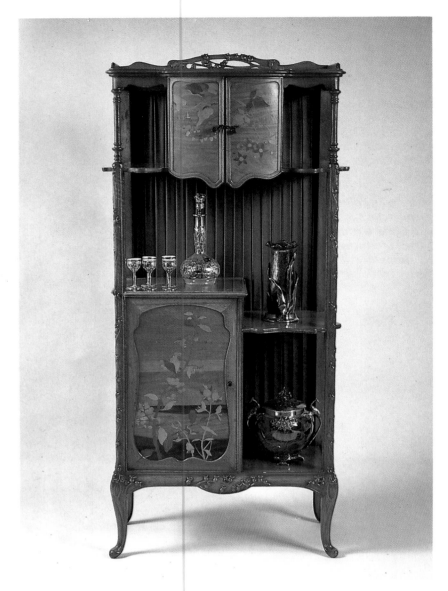

BELOW LEFT: *Much of Eugène Vallin's furniture such as this sellette (c 1900) was designed to be featured in a particular room. His frequent choice of dark woods tend to give his rooms a somewhat somber appearance.*

BELOW RIGHT: *Alexandre Charpentier began his career as a sculptor. Often ignoring the natural grain of the wood, Charpentier took the Art Nouveau curve to its extreme in furniture such as this music stand (1901).*

RIGHT: *Display cabinet (c 1900) with a marquetry design of plants, berries and flowers, possibly by Majorelle. On the shelves are a Bohemeian vase in iridiscent glass and silver, decanter and glasses of c 1900 and a bowl and cover made by* Wurttembergische Metallwarenfabrik.

FAR RIGHT: *This dining room furnished by Eugène Vallin is a fine example of Nancy School furniture in its Art Nouveau setting.*

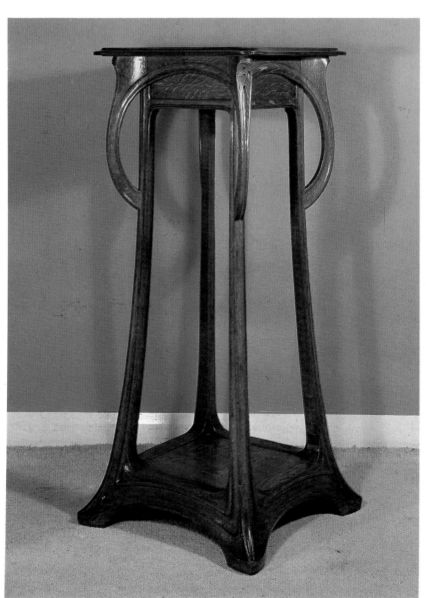

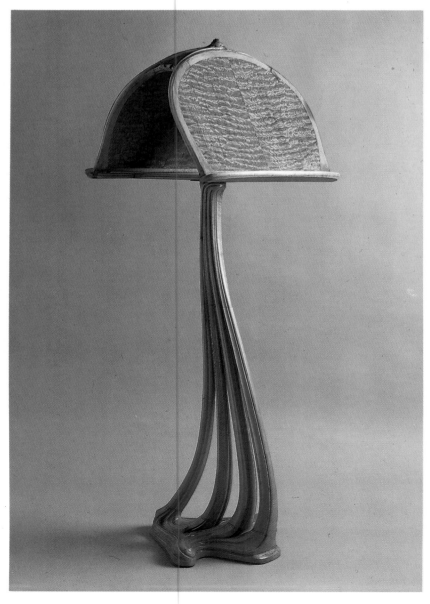

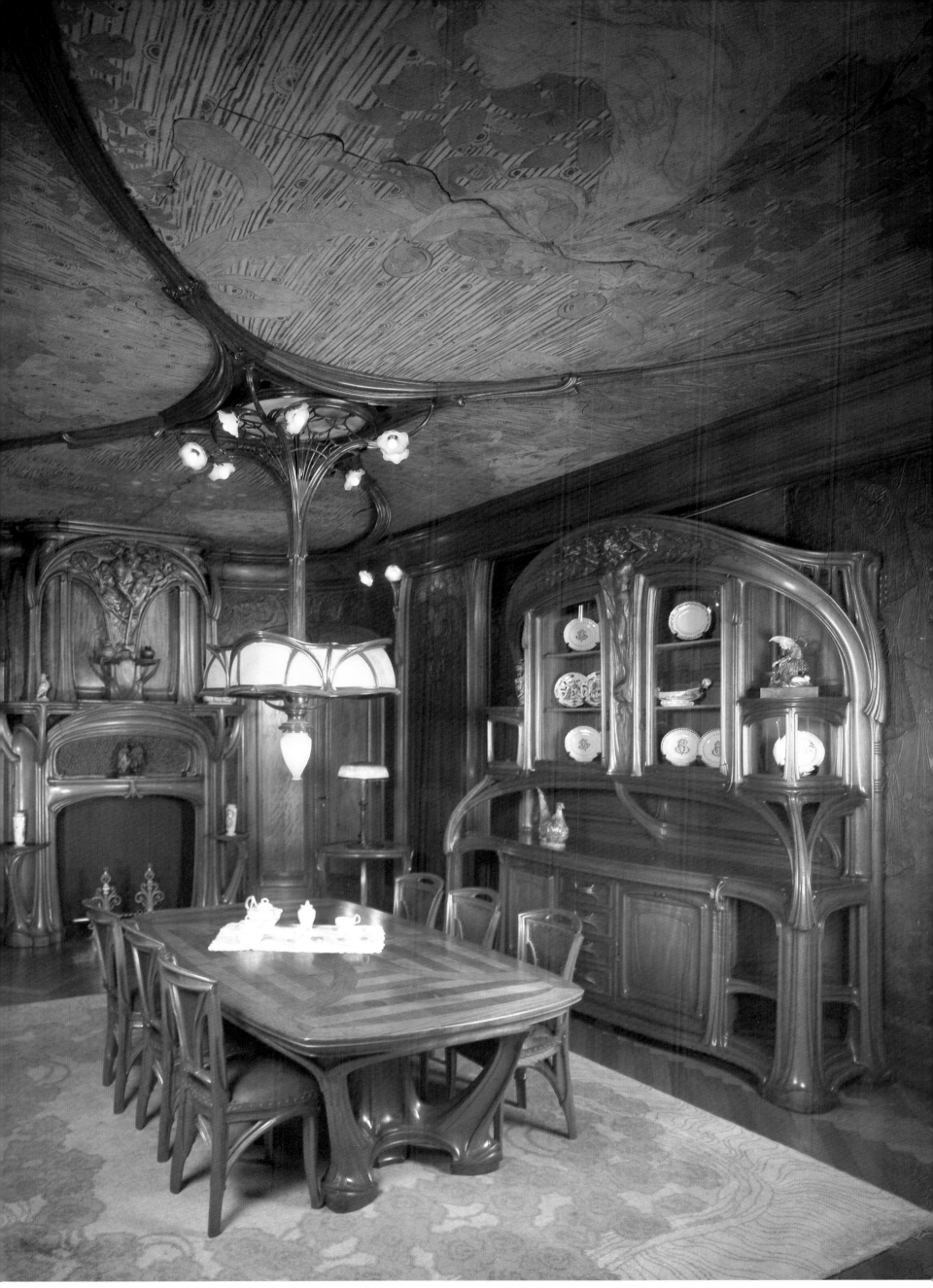

RIGHT: *Henri van de Velde designed this walnut sidechair for the dining room of his own house in Uccle.*

RIGHT: *This four-fold screen by Alphonse Mucha is decorated with panels depicting* Les Temps du Jour. *Mucha, like many other artists of this period, successfully crossed the boundaries from one art form to another.*

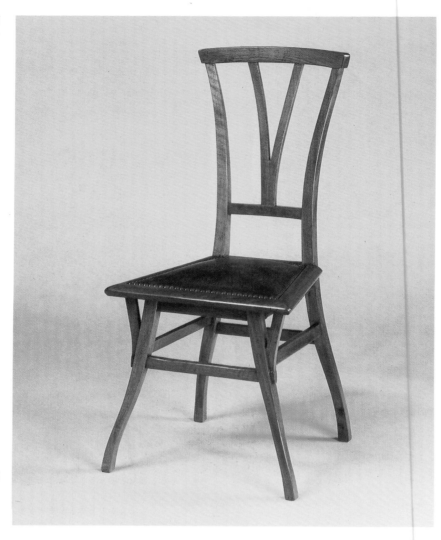

BELOW: *Austrian Art Nouveau furniture. From left: chair by Thonet (c 1905); cabinet by Koloman Moser (c 1903); three-fold screen by Josef Hoffmann (c 1899); square-shaped chair by Koloman Moser (c 1903).*

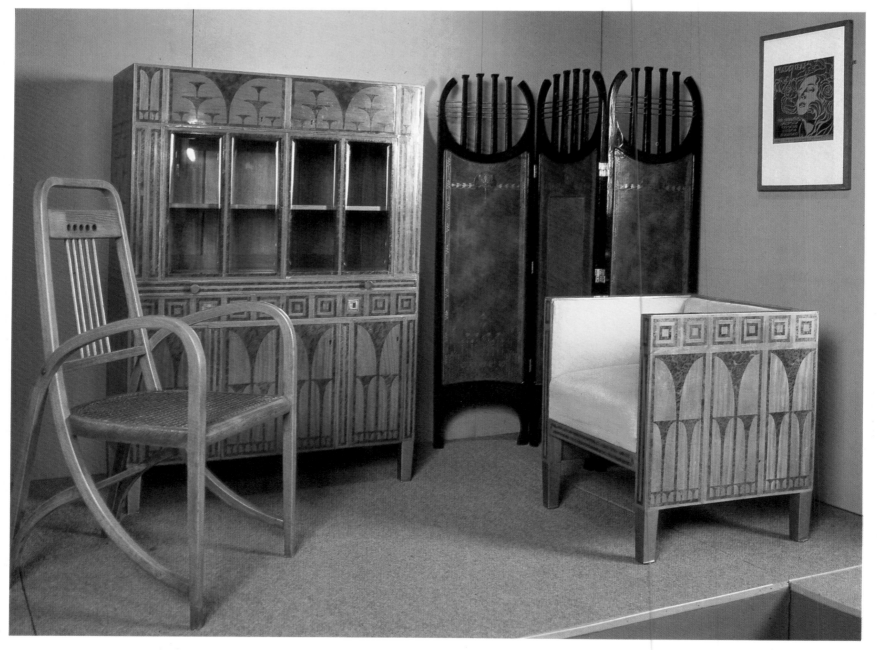

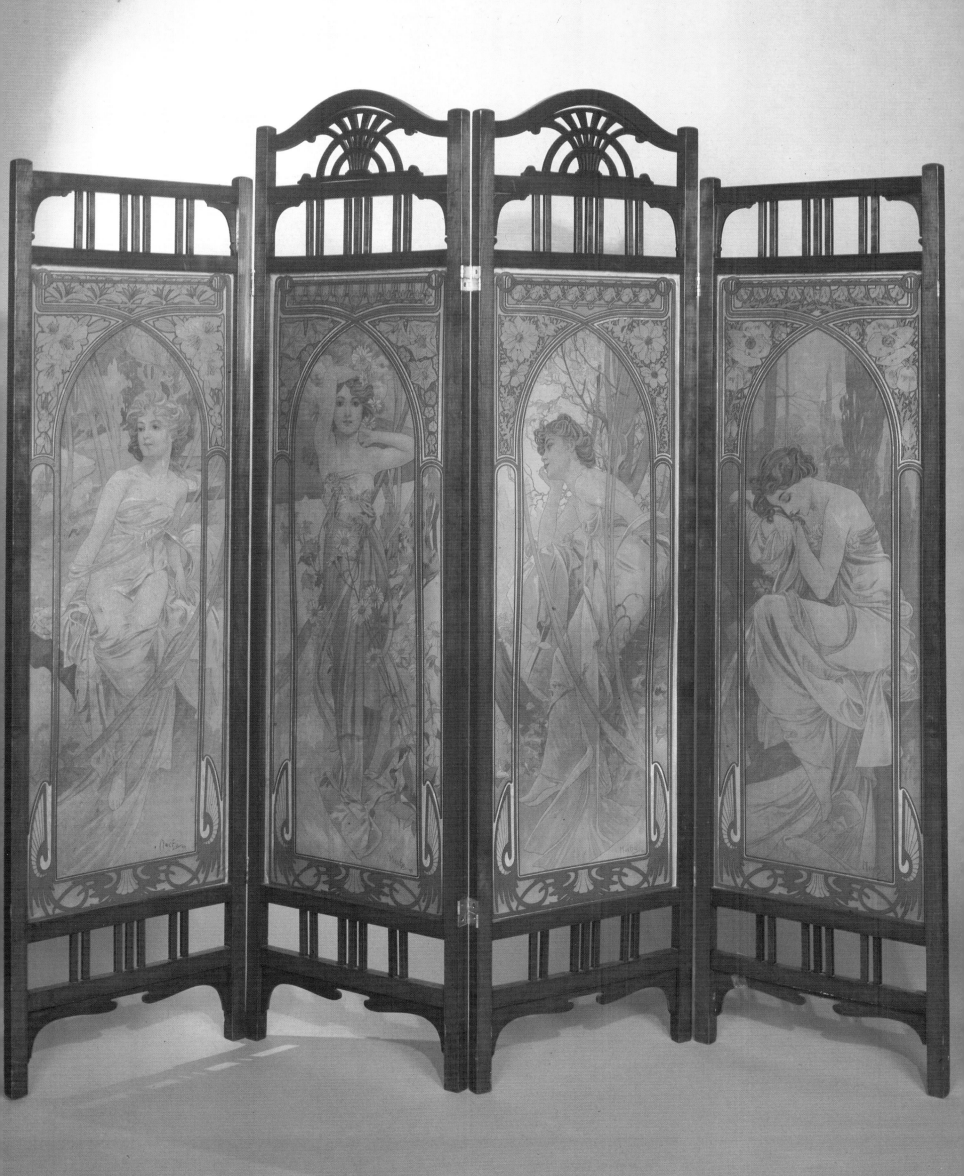

ground and first floors and the top floor, the intermediate levels could not be differentiated without considerably altering the structure. Sullivan had the idea of treating the whole of the middle area as one element by emphasizing the vertical partitions and contrasting them with the horizontal lowest sections and the crowning Art Nouveau attic. The horizontal spandrels upon which each storey is placed are recessed to allow the vertical piers to flow upward uninterrupted.

In the Guaranty Building, Buffalo (1895), Sullivan perfected the design he had been developing: a three-layer building, with the first layer of ground and mezzanine floors, the second layer with ten floors of offices, and the third layer consisting of a decorated attic storey and flat roof. Verticality is again the overriding quality of the building, a quality which is emphasized by mullions which run uninterrupted from the mezzanine level to the roof. Ornamental terracotta is worked in a filigree style and the motifs used are repeated in the ornate metalworks in the lobby. Only the ground-floor plate-glass windows and marble-clad walls are left free of ornament.

Sullivan was a prolific designer of architectural decoration, and produced many different kinds for a variety of purposes. Two years after Horta began his *Maison du Peuple*, Sullivan began work on the Schlessinger-Meyer Department Store (now Carson Pirie Scott and Co) in which he specified that the windows, to allow in extra light, should be larger and longer than those normally found in public buildings. These windows – much copied by designers of other buildings – came to be called 'Chicago Windows.' The enlarging of the windows to allow extra light on the sales floors demonstrates how Sullivan followed his dictum that 'form follows function.' Although the upper-storey windows are starkly functional, those of the first two floors are surrounded by decorative ironwork, composed of swirling scrolls, leaves and flowers. The profusion of Art Nouveau decoration, however, does not hide the exposed structural grid of the steel-cage construction. In this project, located at what has been called 'the world's busiest corner,' Sullivan demonstrated that the work of engineers could be put to architectural use, meeting the physical as well as the emotional and aesthetic needs of people.

After work on the Carson Pirie Scott building was completed in 1903, Sullivan's career declined and he received few important commissions. From then on he devoted much of his time to writing, although he was commissioned to produce five small-town banks, in which he concentrated on decoration. His writings bore fruit in 1924, the year he died, when Sullivan completed his books *Autobiography of an Idea* and *A System of Architectural Ornament According With A Philosophy of Man's Power*.

ABOVE: *Detail of the façade of the Chicago Auditorium.*

RIGHT: *The Carson, Pirie Scott and Co department store in Chicago by Louis Sullivan.*

BELOW: *Ornamental ironwork around the windows of the Carson Pirie Scott and Co store.*

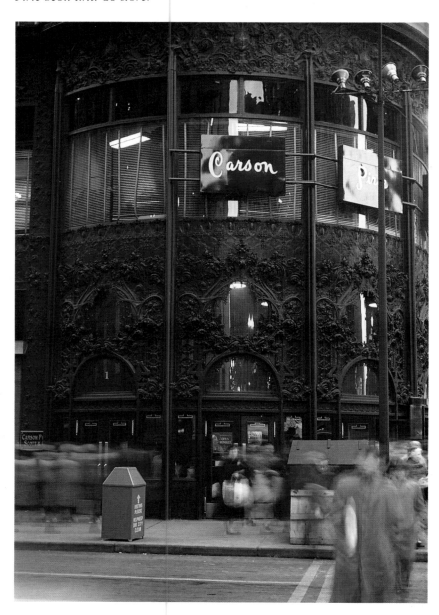

LEFT: *Many of Wright's houses, such as the Thomas House at Oak Park, Illinois (1901), are said to have begun at the central hearth and grown outward. This practice of grouping rooms around the main heating source was already established in vernacular building in America.*

BELOW: *Vernacular American buildings often included a porch; at the Robie House, Wright developed this feature into a cantilevered roof. As far as possible, Wright avoided combinations of materials in favor of a single material out of which the ornamentation grew.*

Since Wright believed that geometric forms and straight lines were the natural forms and lines of the machines that were used in building, the interiors of his buildings took on the same characteristic straight lines. Furthermore, the furnishings were to be 'one' with the building, designed in simple terms for machine production. The furniture Wright designed for his own home included chairs with tall spindle backs: later chairs would use slats or a single sloping board in the back.

Yet Wright believed his buildings to be characterized in their details by Sullivan's idiom: some of Wright's most beautiful ornament is Sullivanesque. Decorative friezes of stylized oak trees, flowers and foliage contained in rectangles and circles appear in many of his houses. In his own house there is a jigsawed ceiling grille behind which were placed recessed lamps. The grille's design combines pat-

terns of oak leaves and geometric elements, an echo of the medieval stained glass and Celtic interlaces that influenced the Scottish Art Nouveau designers.

Until 1909, when Wright went to Europe, he held a considerable influence over both his contemporary designers in America and his clients. In some cases this influence extended beyond the design of the house to the design of every single item within it, and, in some cases such as the Martin House of 1906 Wright even decided on the choice and arrangement of his client's Japanese prints and ceramics.

His larger buildings of Wright's early period share the same characteristic spatial concepts as his smaller houses. The Unity Chapel (1906) has its space articulated in all directions: the ceiling grid, balconies and open staircase all contribute. Where in the houses Wright had used a horizontal band such as a frieze which ran

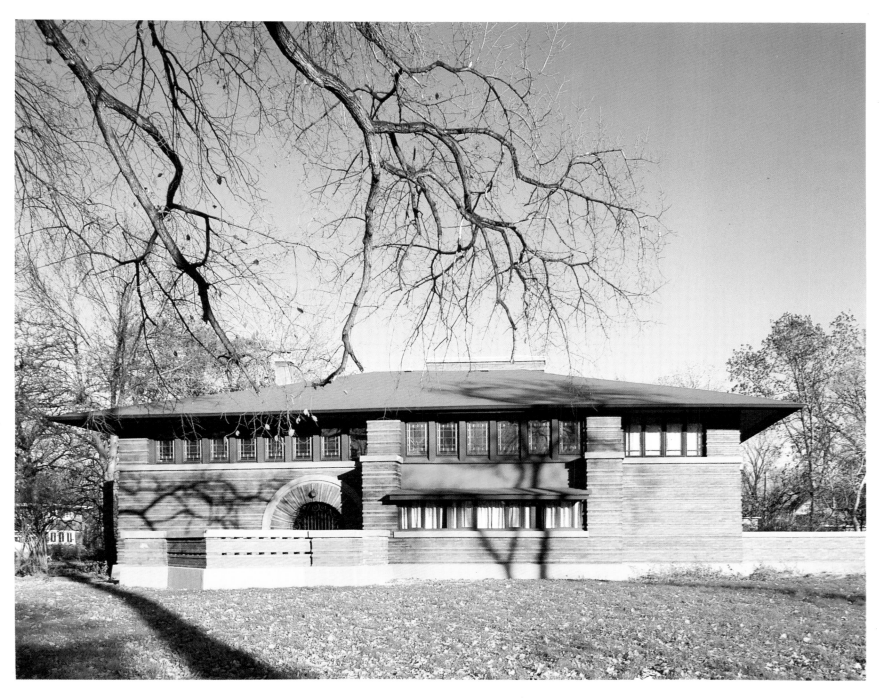

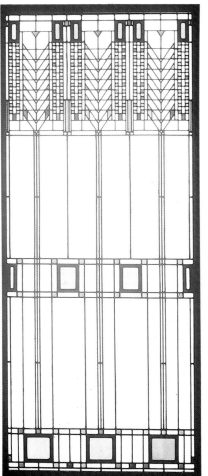

ABOVE: *As much light as possible was allowed to permeate the interiors of Wright's buildings. The Arthur Heurtley House in Oak Park, Illinois (1902) has windows running the length of the building and inside walls that are turned into screens to allow the passage of light into the interiors.*

LEFT: *The rectilinear style of Art Nouveau was continued throughout Wright's interiors, in decorative glass such as this* Tree of Life *design, and in the furniture.*

RIGHT: *Oak high back spindle chair (c 1908), by Frank Lloyd Wright.*

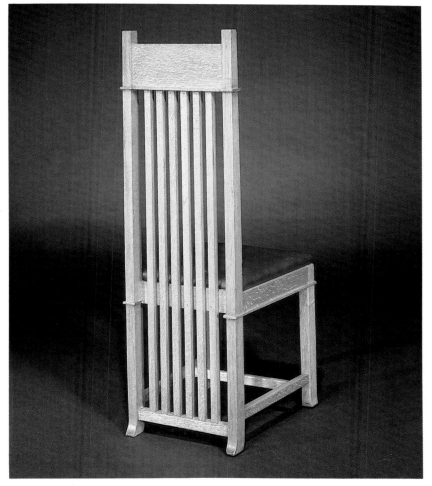

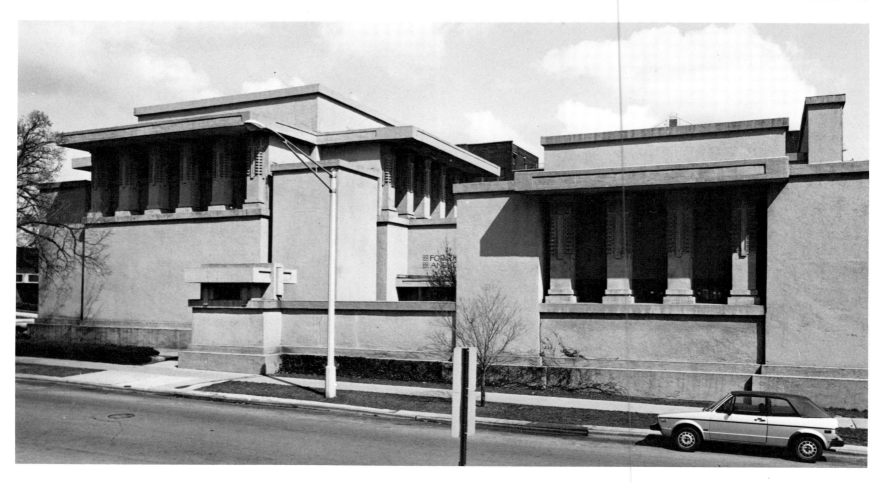

along the top edge of the doors to link each opening to the next, he now used these lines more subtly, to establish the relationship between planes and spaces. Each line makes us aware of the depth and solidity of the form as well as the size of the open spaces. The pattern that is made by the lines and their dark appearance against light walls are like those used by Mackintosh, or by Hoffmann on the exterior of the *Palais Stoclet*.

Up until the Depression, Wright continued to produce designs for silver, ceramics, glass and furniture, as well as the covers for *Liberty Magazine*. His *Autobiography* (1932) appeared at a time when his career was at a standstill, before it enjoyed a revival in 1936 with the house Fallingwater. Much of Wright's later work shows a continuity with his earlier designs, even to the point of retaining something of the Arts and Crafts atmosphere.

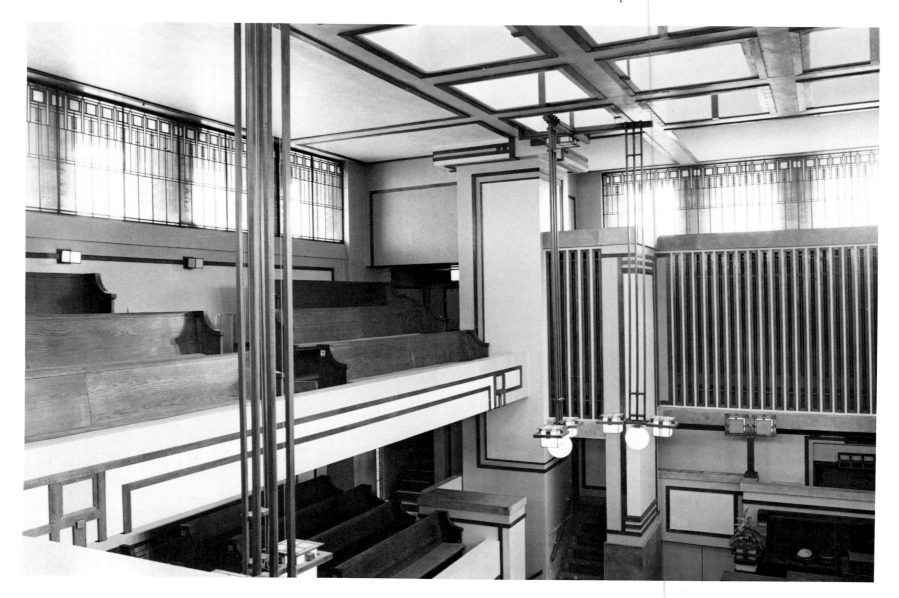

The impact of the Arts and Crafts movement in the United States was also felt by the Greene Brothers. Charles Sumner Greene (1868-1957) and his brother Henry Mather Greene (1870-1954) were born in Ohio, and later moved to St Louis. The Greenes studied at the Manual Training High School (set up by a family friend, Calvin Milton Woodward), in the hope of following in their great-grandfather's footsteps by becoming architects.

Under Woodward's guidance, the Greenes became influenced by Ruskin and Morris, learning the skills of craftsmanship and the relationship between form, function and materials. After studying architecture at MIT, each joined a distinguished architect's firm in Boston. In 1893 the brothers left the East Coast: their careers there had not developed as they had anticipated, and they decided to visit their parents who had moved to Pasadena, California. En route, the brothers also visited the Japanese Pavilion at the World's Columbian Exhibition. This, and their first real commission (to design a house for a butcher), led the brothers to establish a practice in California. Over the next two decades, Greene and Greene would design 180 buildings, 70 of which survive today.

The Kinney Kendall Building in Pasadena (1896), designed two years after the brothers had set up their practice, was one of the firm's few commercial structures. The Greenes, like their avant-garde American contemporaries, departed from European historicism, replacing it with strong, clear lines. By 1900 they had completely abandoned all the popular historical styles.

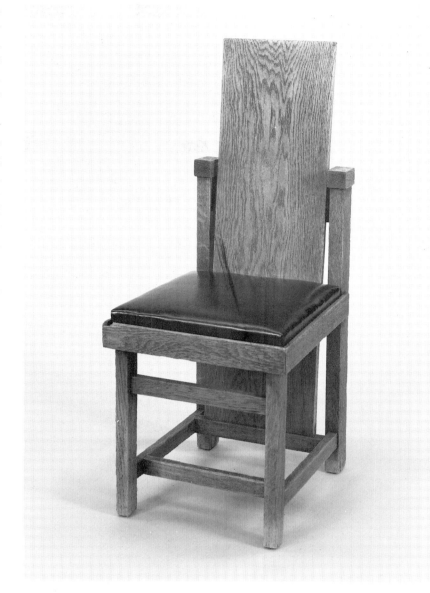

ABOVE LEFT: *The Unity Chapel in Oak Park, Illinois (1906) was Frank Lloyd Wright's first building in concrete.*

BELOW LEFT: *Inside the Unity Chapel, patterns of dark lines against light walls mark the depth of areas and enclose open space.*

RIGHT: *This oak side chair was designed by Frank Lloyd Wright in 1904 (102.2×40.5×46.4cm).*

BELOW: *Wright's Barnsdale House, Los Angeles (1917-22) was also known as the Hollyhock House on account of the stylized plant forms that were beginning to appear in Wright's work.*

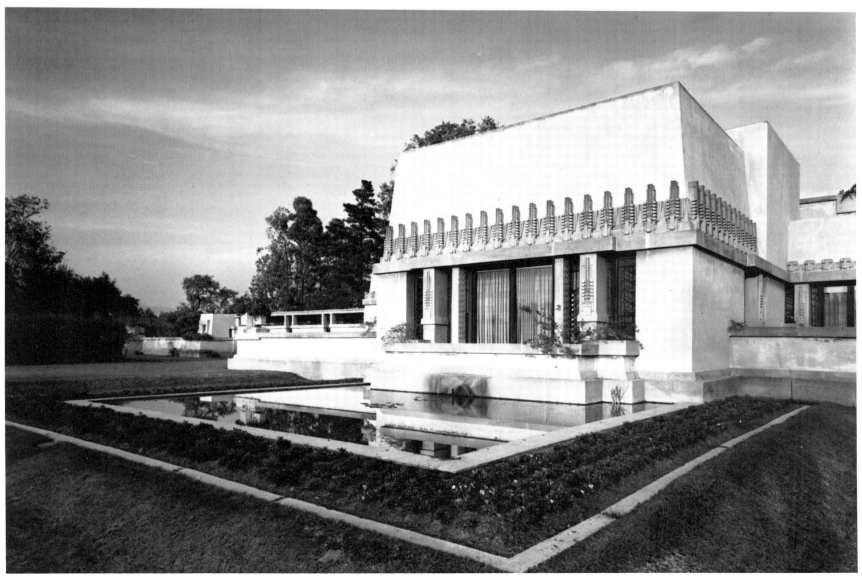

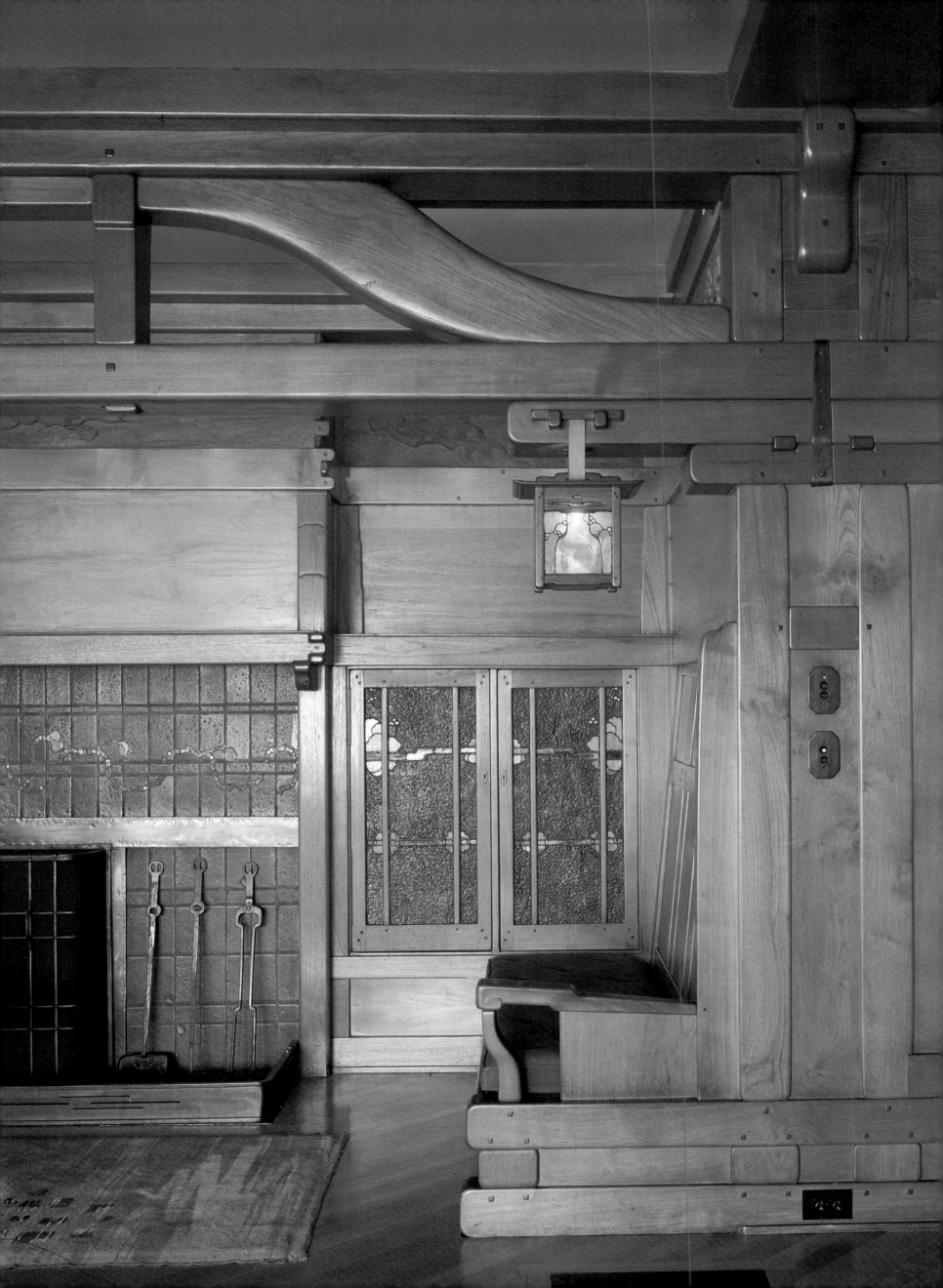

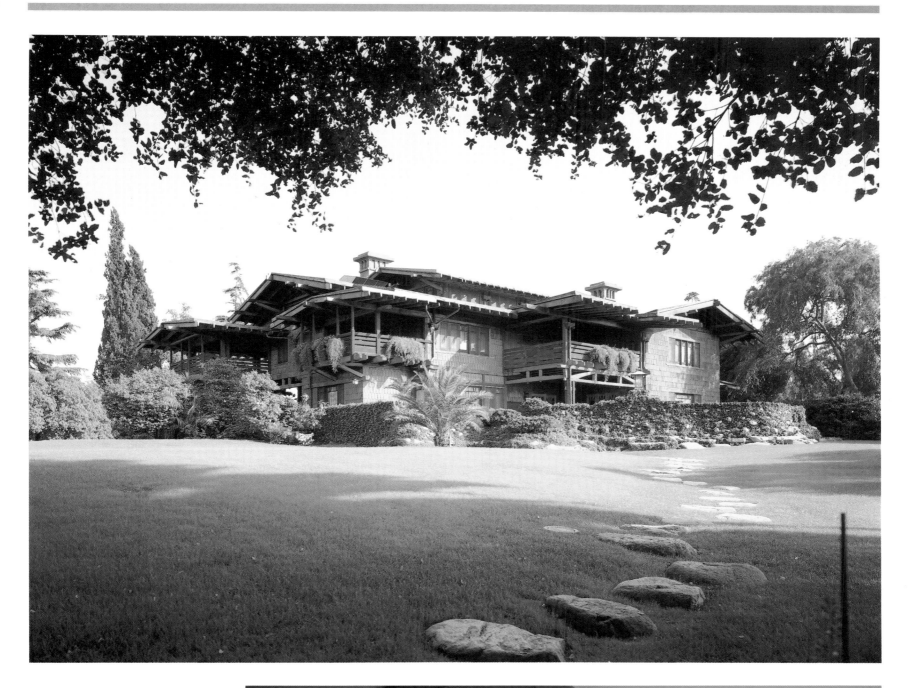

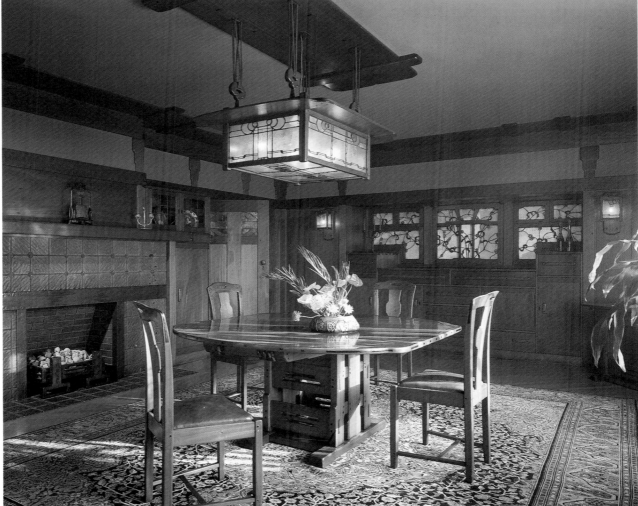

ABOVE: *The Gamble House, Pasadena (1896) by Greene and Greene is possibly their best known work, and became the center for the Arts and Crafts movement on the West Coast.*

LEFT: *The interior of the Gamble House, showing the hearth and built-in bench.*

RIGHT: *The dining room of the Gamble House.*

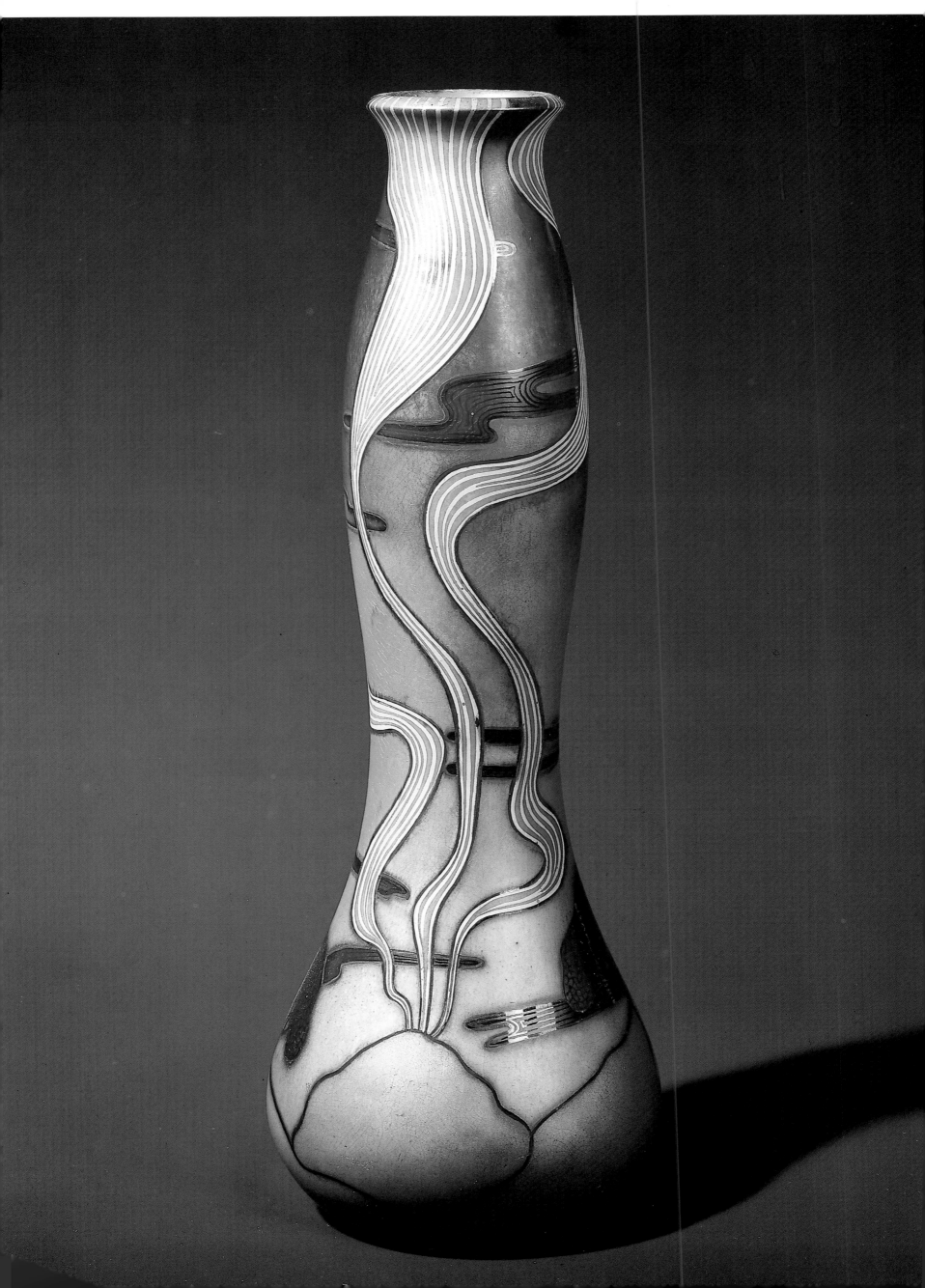

The
Applied
Arts

LEFT: *Vase in lustered stoneware designed by Joseph Rippli-Ronai (c 1890).*

ABOVE: *This lizard door handle on a house in the Avenue Rapp, Paris, was designed by Lavirotte in 1901.*

LEFT: *Arthur Silver supplied Liberty and Co with a range of textile designs suitable for the growing number of middle-class homes of the 1890s.*

RIGHT: *These 'Tudric' pewter clocks designed by Archibald Knox c 1903-4 and made by Liberty and Co, filled the demand for less expensive items in the same style at the 'Cymric' silver. With both 'Tudric' and 'Cymric,' decorative enamels were often used.*

ance around 1903 and soon proved Liberty right: several of the original *Tudric* designs were still in production in the 1920s.

The outstanding designer of *Tudric* was Archibald Knox (1864-1933), who had worked in Silver's studio in 1898. Knox's formalized plant forms and motifs were borrowed from medieval manuscripts and the *Book of Kells*, which were enjoying immense popularity at the time. Other designers of *Tudric* and *Cymric* are on the whole unknown personalities; many were young students in Birmingham working anonymously for the firm of William Haseler, the company responsible for the manufacture of the bulk of Liberty pewterware. Much has been made of this anonymity; some say identities were kept secret in order to stress the ideal of the medieval style of anonymous craftsmanship. But it is more likely that the firm of Haseler preferred to take the credit itself, rather than let it go to the individual designers. Nevertheless, the company produced quality objects that were precision molded, with their stylized decorations precise and clear. Inevitably though, the molds lost their clear definition, leading to the loss of detail that characterizes many of the later pieces. The *Tudric* and *Cymric* pieces are noteworthy not only for their fashionable Celtic and medieval motifs (as well as the more curvilinear styles to be found on the continent) but also for the combination of metals and other materials, such as wickerwork on the handles, enamels and semi-precious stones.

Earlier pieces were also finished by burnishing and hand-hammering. Areas of blue and green enamel colored the bright pewter –

bright because of its high silver content. A wide variety of products were made including decorative tableware, vases and desk sets. Complete tea and coffee services, which often retailed for as little as £6, made good design accessible to a wide public. This happy compromise between art and industry – the handcrafted appearance and the industrial production methods – enabled these wares to enjoy popularity long after Art Nouveau had ceased to be fashionable.

The English approach to the new age of the machine was seen by many artists and designers abroad as sound and sensible, and for many European designers it was epitomized by the metalwork of W A S Benson (1854-1924). Through his friendship with Edward Burne-Jones, Benson met William Morris, whom he had long admired, and was inspired to set up a workshop for the manufacture of metalwork in 1880. He later opened a well equipped factory in Hammersmith and, around 1887, a shop in Bond Street. Although he was a pupil and friend of Morris, an active member of the Art Workers' Guild from 1884 and a leader in the foundation of the Arts and Crafts Exhibition Society from 1886, even becoming chairman of Morris and Co after Morris's death in 1896, Benson was one of the few designers in the Art and Crafts circle who set out actively to use machines to mass produce his products. In brass and copper or in a combination of metals, Benson produced kettles, coat racks and electric lamps as well as some simple furniture, all designed with machine production in mind, using fine metal lines decoratively and also as structural supports. Exhibited at the opening of Bing's shop

LEFT: *Silver cup and cover with enamel decoration designed by Archibald Knox (1899-1900).*

ABOVE RIGHT: *These examples of Liberty-style glass from around 1905 and, right, an aubergine vase from the mid-1920s, reflect the Art Nouveau taste for glassware set in pewter mounts.*

BELOW RIGHT: *Liberty and Co did not confine themselves to producing fine pieces in precious metals, but proved that good design in base metals could be equally stylish and popular. This copper 'log' box, with a repoussé lid and enamel medallion dates from around 1905.*

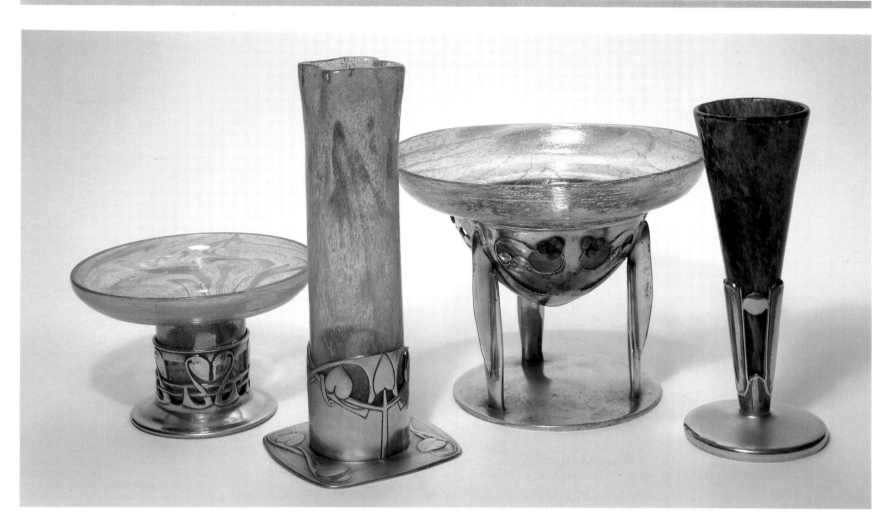

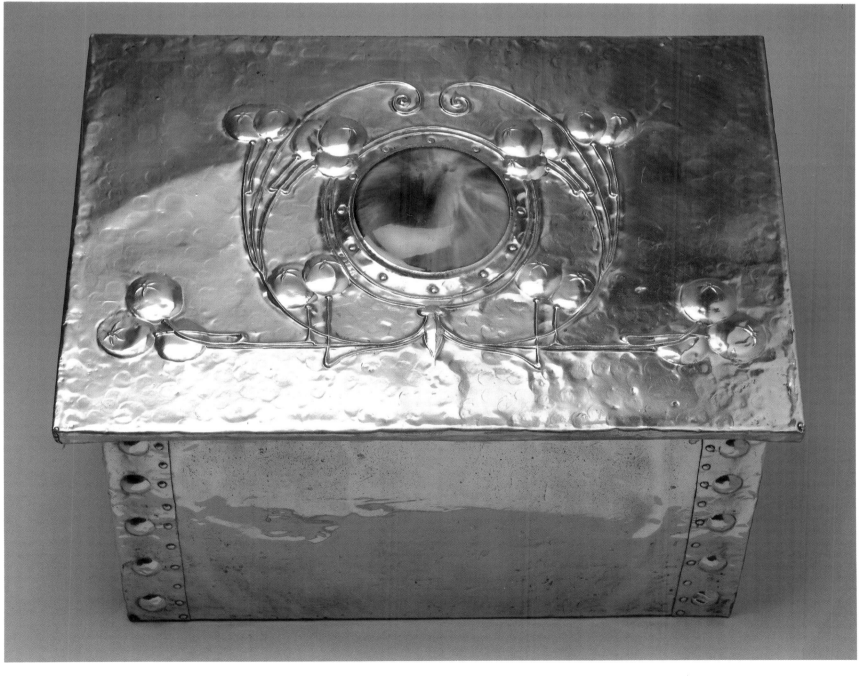

RIGHT: *With metalware such as this vase, Liberty and Co demonstrated that mass-production techiques did not necessarily produce poorly designed or low-quality goods.*

BELOW: *J P Kayser und Sohn of Cologne were the leading manufacturers of Art Nouvea pewterware in Germany. The success of their products such as this 1896 pewter tea service inspired Liberty to launch their 'Tudric' pewter range.*

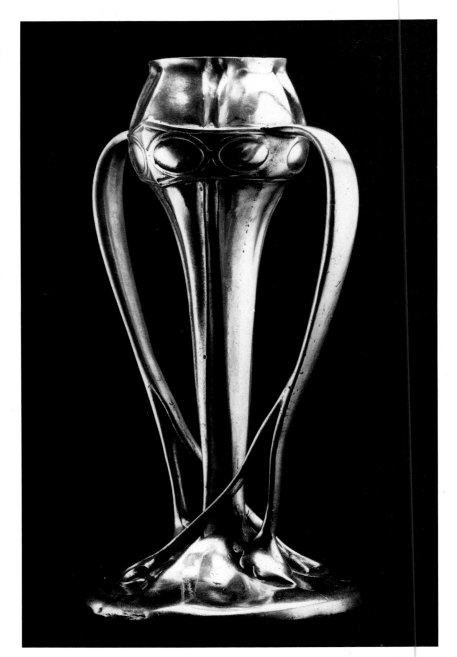

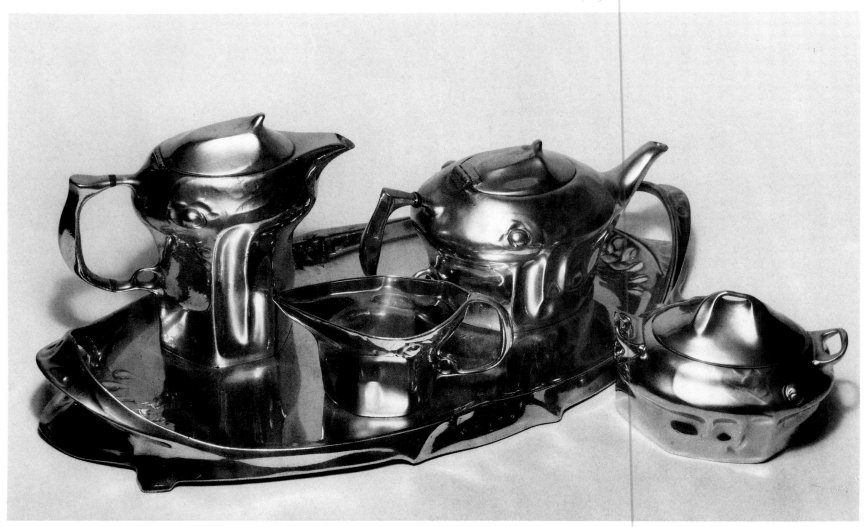

RIGHT: *W A S Benson's work, such as this 1910 cane-handled silver kettle, won him the acclaim of Samuel Bing, in whose shop-cum-gallery 'L'Art Nouveau' his work was exhibited.*

BELOW: *This modern-looking silver flatware was designed by Josef Hoffmann for the Wiener Werkstadt around 1905.*

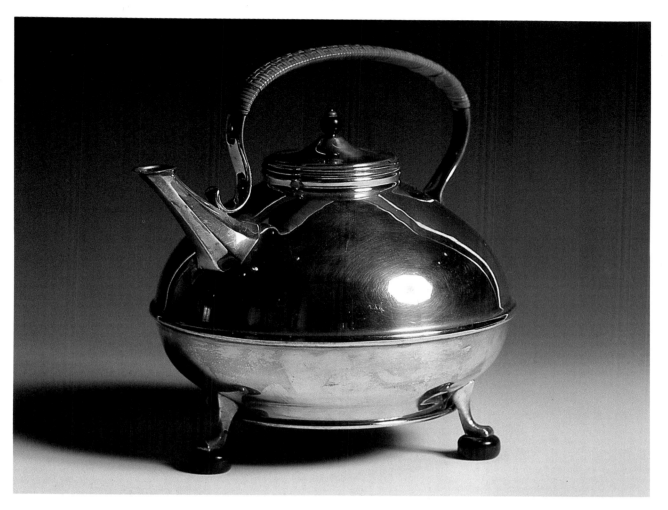

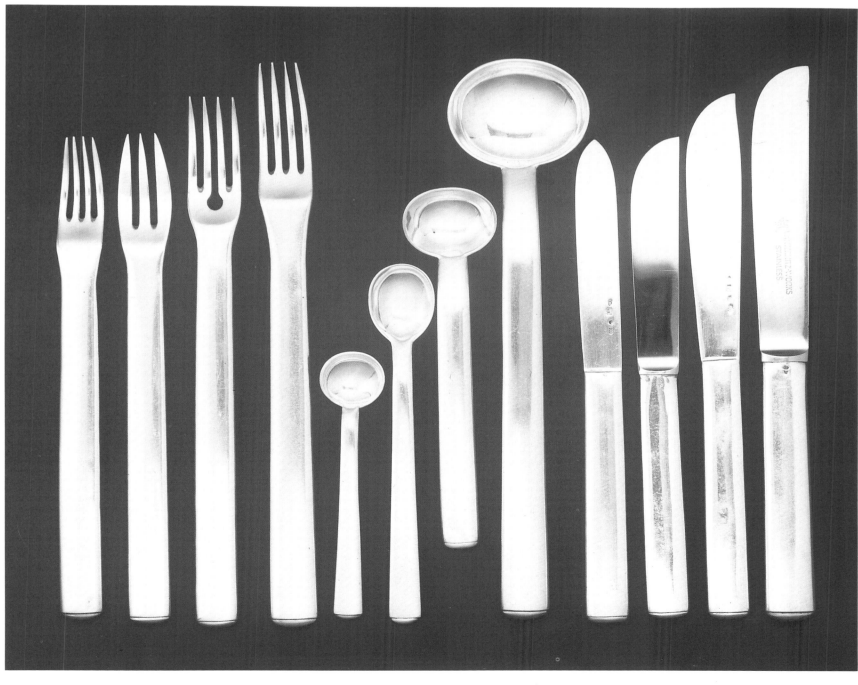

RIGHT: *Silver and painted casket by Josef Hoffmann and Carl Krenek (1910).*

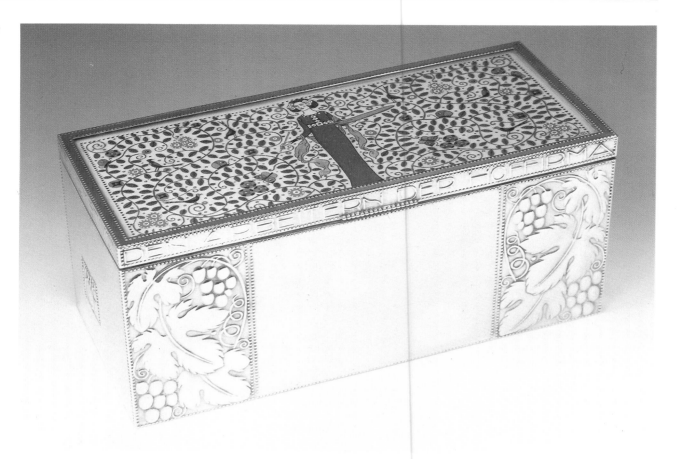

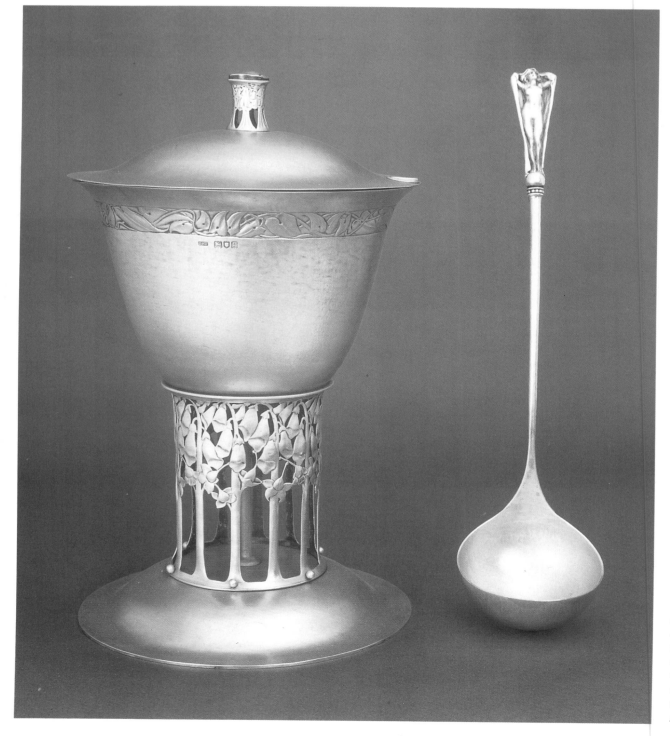

LEFT: *Where Victorian silverware was often highly wrought and elaborately fussy, Art Nouveau designers exploited the qualities of the metal by hand hammering the surface to provide textures, or by simply allowing areas of undecorated metal become part of the overall design. This 1902-03 Guild of Handicraft silver cup and cover and hammered silver ladle were designed by Charles Robert Ashbee.*

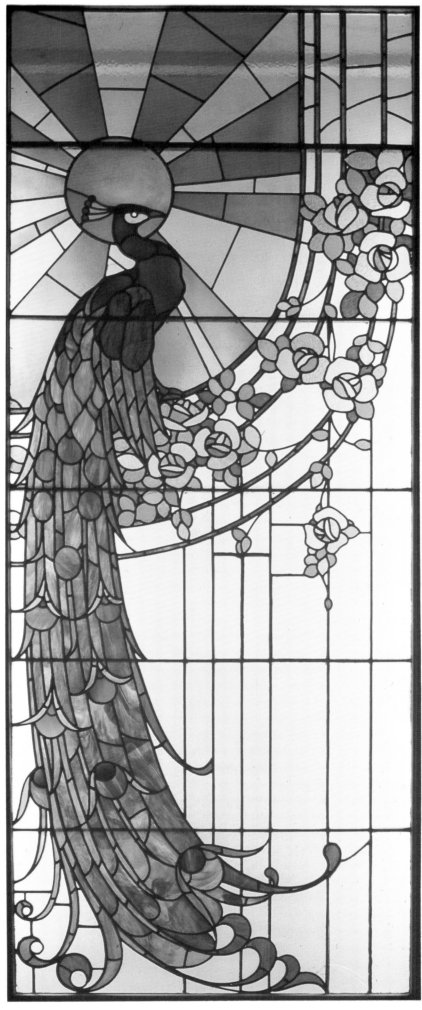

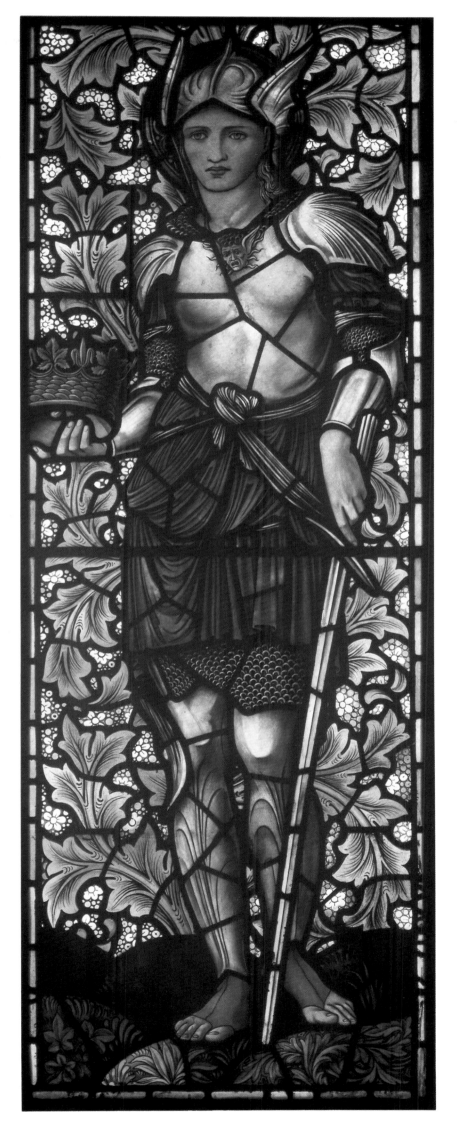

ABOVE: *This leaded peacock window, the work of an unknown designer around 1910, once lit the stairwell of a private house in Brighton.*

RIGHT: *The English image of women contrasts dramatically with that of European artists. On the continent, the archetypal Art Nouveau woman was the languid beauty or the femme fatale. English 'heroines,' such as the figure of Justice in this turn-of-the-century stained glass window by Morris and Co after a design by Burne-Jones, appear more war-like.*

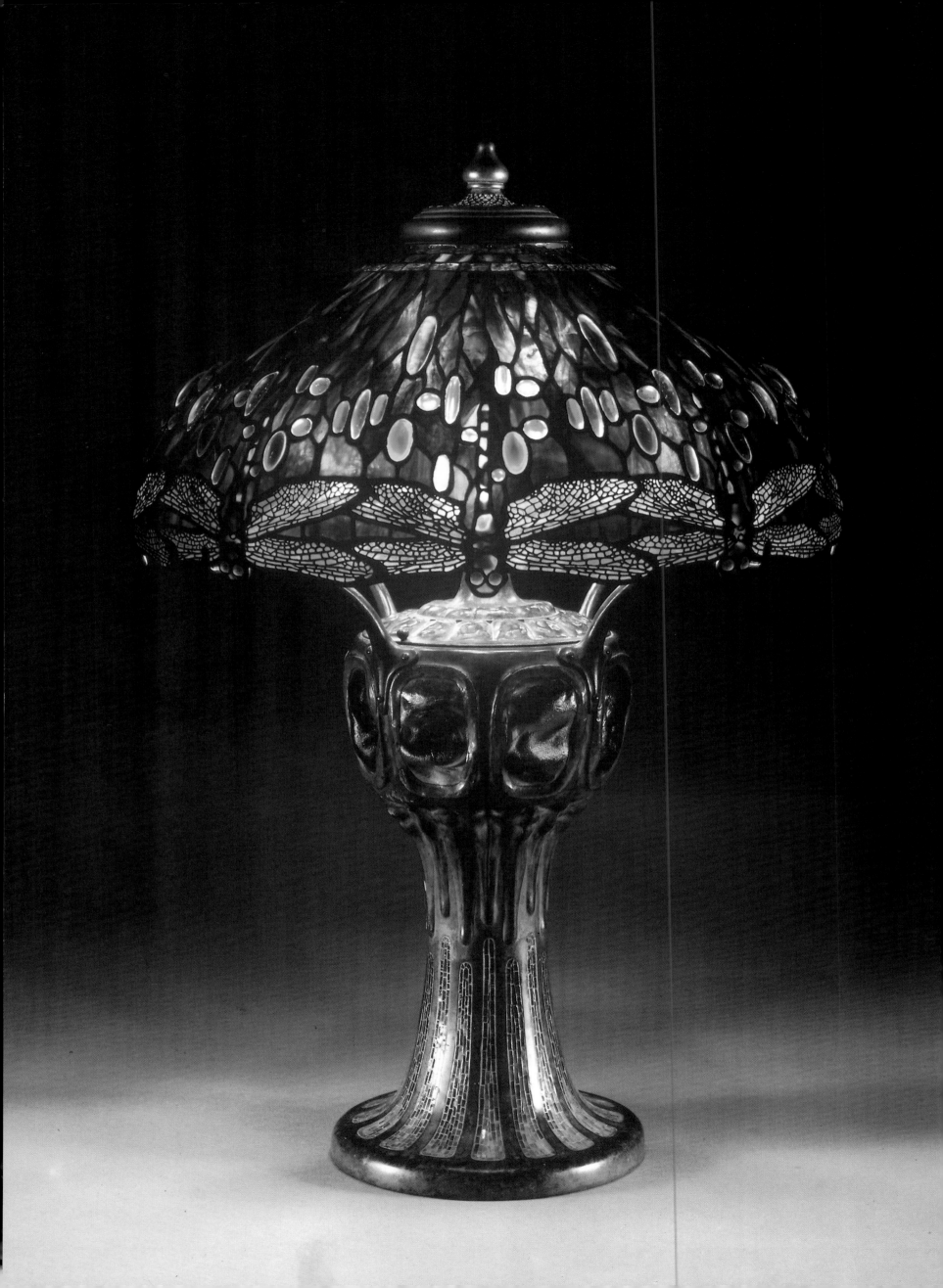

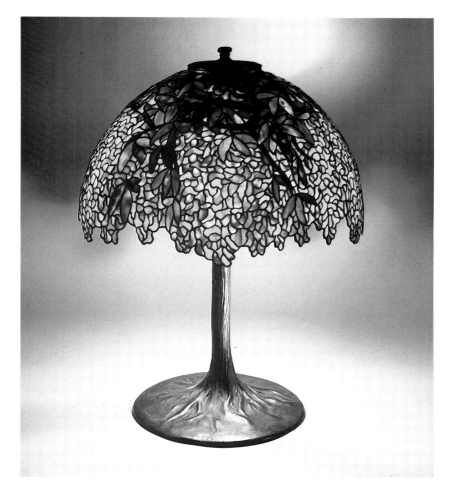

Throughout the nineteenth century and even today, silversmiths continued to produce decorative candlesticks and candelabra despite the widespread introduction of electricity for domestic lighting. In the late 1890s electric lighting encouraged a fashion which would sweep America: no fashionable home was complete without a Tiffany or Tiffany-style lamp. The introduction of stained glass in electric lamp shades by Louis Comfort Tiffany (1848-1933) was perhaps one of his most significant contributions to functional commercial design. The multi-colored shade of textured glass softened the harsh light of incandescent bulbs and the later turgiten bulbs as well as concealing the often ugly electrical fittings. The most popular Tiffany lamps were based on plants and trees, but Tiffany was not content simply to apply these motifs to the lamps. The plants and trees themselves 'became' lamps; bronze stems were transferred into trunks with tree roots spread out as the base, while the shades, irregularly shaped, hung as lily flowers, lotus flowers or wisteria blossoms.

Tiffany's father, Charles Louis Tiffany, had founded the firm of Tiffany and Young in 1837; by 1870, the name of Tiffany was synonymous with luxury and the firm acknowledged as America's finest outlet of jewelry and silverware, a fame later immortalized in Truman Capote's novel *Breakfast at Tiffany's*.

Despite the success of his father's business, Louis Tiffany preferred the fine arts and, as a student of George Innes, he developed into something of a romantic painter. After visiting Paris in 1868, Tiffany

LEFT: *The growth of electric lighting in the 1890s encouraged the fashion for Tiffany and Tiffany-style lamps. The most popular models were based on plant or tree forms, such as this Dragonfly lampshade on a turtle-back tile and mosaic base, made by Tiffany Studios.*

ABOVE LEFT: *'Laburnum' leaded glass and bronze table lamp, by Tiffany Studios.*

ABOVE RIGHT: *Bronze leaded glass and 'Favrile' glass table lamp by Louis Comfort Tiffany.*

LEFT: *'Zinnia' leaded glass, mosaic and bronze lamp, by Tiffany.*

LEFT: *Louis Comfort Tiffany designed this leaded glass window, depicting a Hudson River landscape, for the Beltzhoovers' house 'Rochroane' in New York in 1905. His other works in this vein included a glass screen for the White House.*

BELOW LEFT: *'Favrile,' a name Tiffany coined for wares such as this 1902 glass plate, was derived from the Latin* faber, *an artisan, and was intended to show that each piece was a unique art work.*

BELOW RIGHT: *Tiffany set up 'controlled accidents' to try and reproduce the color and textures of ancient and oriental glass in his collection. This 'Lava' vase, made around 1902, is set within a cast-bronze holder.*

traveled in Spain and North Africa where the Hispano-Moorish and Islamic art he saw deeply impressed him. Like so many of his generation, he also shared an interest in the Japanese art which was then being introduced into Europe. After acknowledging his shortcomings as a painter, Tiffany set himself up as a decorator in 1879 in partnership with Samuel Colman and Candace Wheeler. The major

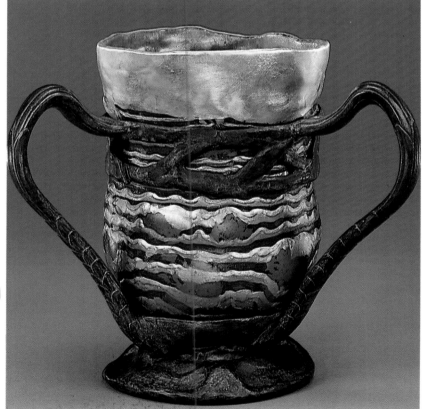

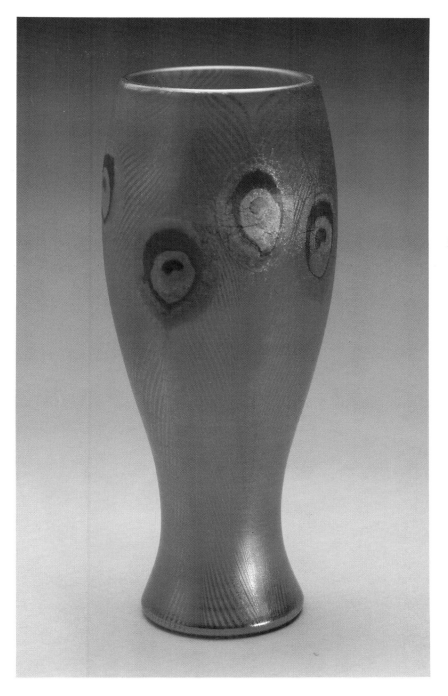

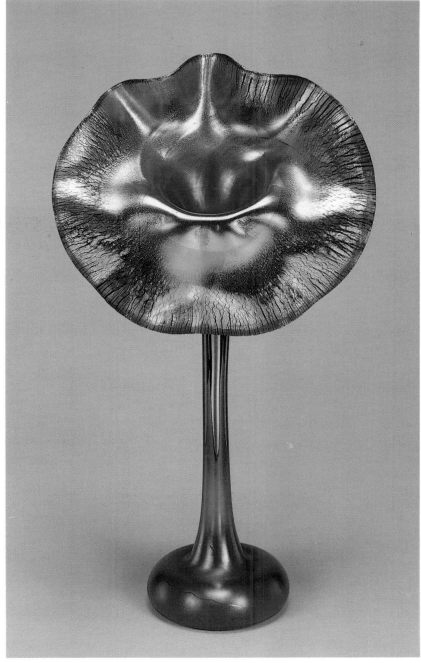

commission for the firm of Louis C Comfort and Associated Artists was for the redecoration of some of the rooms of the White House, including the manufacture of a magnificent glass screen.

In the mid-1870s Tiffany had become interested in glass-making techniques. This interest, by all accounts, grew into something of an obsession and led to the break up of his partnership. His collection of glass from the East and North Africa, with its freedom of form and often unintentional irregularity, appealed to Tiffany at a time when designers were attempting to escape from Western conventions. He was fascinated with the possibilities of incorporating decoration within the glass itself, and the iridescence of the antique glass he found on his travels inspired his best-known range of glassware, the gold and peacock lusterwares. During the centuries it had remained buried, the ancient glass had reacted with the surrounding soil, taking on an iridescent appearance. This natural process led Tiffany to set up 'controlled accidents' for his own glass.

In 1884 Tiffany re-formed his company as the Tiffany Glass Company. For ten years the firm concerned itself with experiments until, in 1894 it emerged as the Tiffany Glass and Decorating Company (which remained completely separate from the jewelry firm). In his so-called 'Jack in the Pulpit' vases, with their bulbous base with a long stem culminating in a large lily-like trumpet, Tiffany found the ideal shape to display the shimmering iridescent effects he had perfected. The vases were made in a variety of colors, of which a rich peacock blue proved the most popular and effective. The increased demand for Tiffany's glassware led to the firm's expansion and ultimately to the production of some less inspired works. The commercial wares that were produced included harsh gold iridescent decorative tableware, but Tiffany continued personally to produce or closely super-

ABOVE LEFT: *The best-known and the most popular glassware produced by Tiffany was the Peacock ware.*

ABOVE RIGHT: *Tiffany's blown and manipulated 'Jack-in-the-Pulpit' vases proved to be the ideal shape for showing off his iridiscent glass. Of all the colors produced, peacock blue was the most popular.*

vise the production of fine quality special orders and experimental glass. Special-order glass pieces, such as rare red glass pieces whose color was obtained from compounds of gold, carried an engraved number. But almost all his glass had his name, or at least his initials, engraved upon it, with or without the trade name 'Favrile.' Tiffany derived the term 'Favrile' from the latin word *faber*, an artisan, to show that each piece was an individual work of art which could never be repeated or reproduced. Where some of Tiffany's glass has decoration of the utmost refinement, other pieces are pure experiments with the potentials of glass, lacking specific decorative elements. The 'Paperweight' vases use millefiori details to create the illusion of depth in the walls of glass. These employed a technique similar to that used in the manufacture of French paperweights, where finely extruded rods of different colored glass are embedded in the main body of the glass. Other glass pieces imitate stones, like the 'Agate' ware, or dripping lava and corroded textures. The elegant forms and decoration of many of Tiffany's products won the acclaim of Samuel Bing, who provided him with a European outlet.

Despite the fact that Tiffany had acquired followers in America, like the Quezal glass works in Brooklyn and art glass manufacturer Victor Durand in New Jersey, for most Americans Art Nouveau remained an exotic, and predominantly French, import.

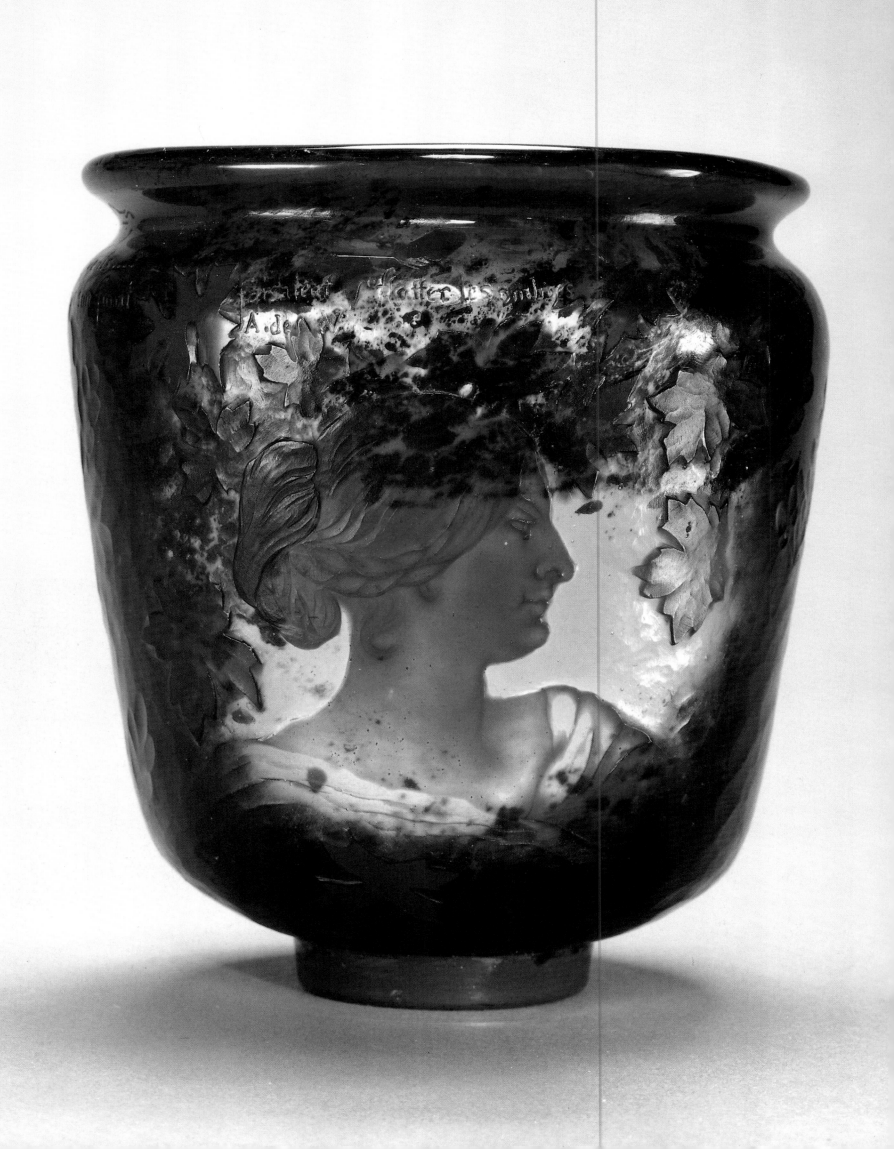

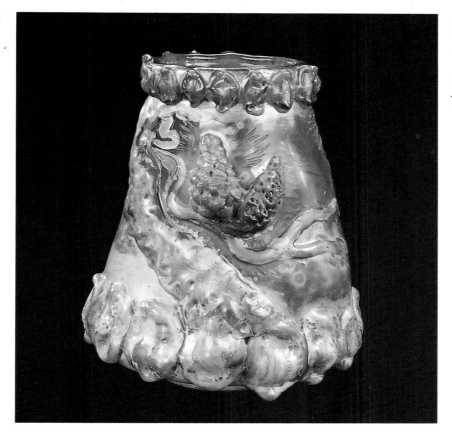

We are familiar with Emile Gallé as the designer of the fabulous Butterfly Bed, but he also produced glassware, and some of the most brilliant Art Nouveau pieces were made by his factory. In 1874 Gallé took over his father's firm and built it into possibly the largest manufacturer of luxury glassware in Europe. At the same time he pursued a course of experiments that resulted in a small output of works unrivaled in their invention. Gallé acknowledged nature as his greatest source of inspiration, and drew upon it for both the forms and decoration in his work. Gallé was convinced that glass was an infinitely variable medium that need not be simply clear and colorless, decorated only by engraving.

His initial experiments were confined largely to enameling on glass, but by 1884 he was coloring and decorating within the glass itself. At the Paris Exhibition of 1889 he displayed works in cameo glass and a technique he called *marqueterie sur verre*. This technique involved applying colored glass in a semi-molten state into the body of a still hot piece, which called for considerable skill and dexterity. Loyal to his native Lorraine, Gallé helped establish the *École de Nancy* which would rival Paris as a center for Art Nouveau production. His vases often contain decorations in the form of local flowers and trees, often are combined with lines of verse taken from the Symbolist poets.

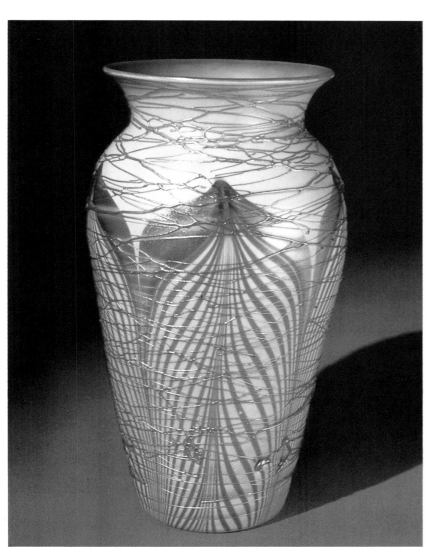

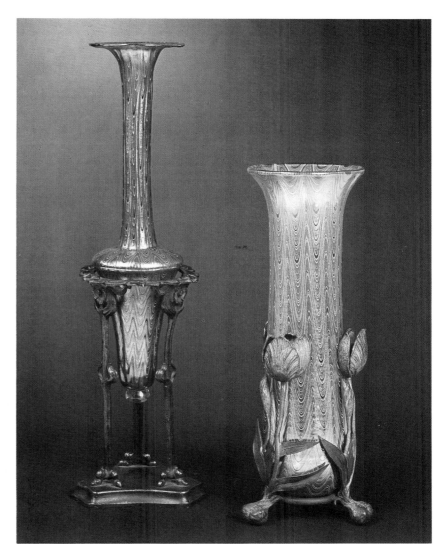

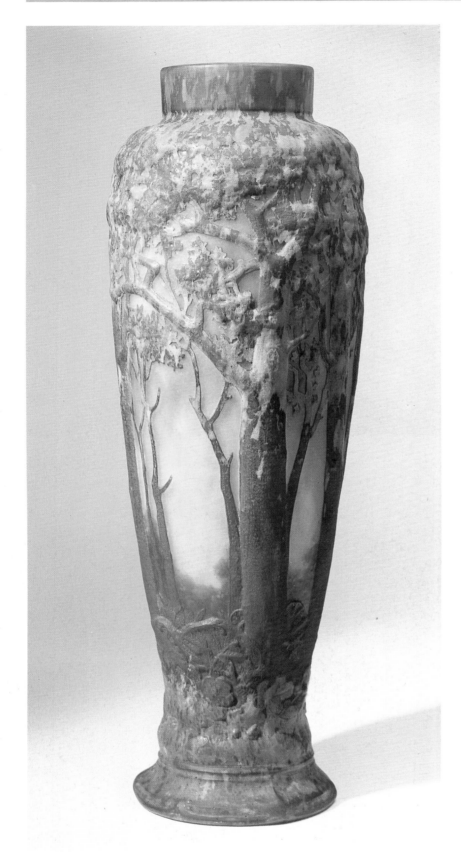

LEFT: *After seeing Gallé's work exhibited in Paris, the Daum Brothers started producing carved and acid-etched vases such as these at their factory, the* Verrière de Nancy.

ABOVE: *The Daum Brothers used both cameo and internal decoration on this silver-mounted vase.*

RIGHT: *'Iris' vase (c 1895), by Gallé.*

By 1904 Gallé's factory was employing over three hundred people and had retail outlets in London, Paris and Frankfurt. The factory's most successful pieces were the newly popular table lamps in acid-etched cameo glass but the finest pieces from an artistic viewpoint were destined for exhibition or designed for a small circle of friends and wealthy patrons, which included the dandy Count Robert de Montesquiou and Marcel Proust.

Of all the glassmakers to be influenced by Gallé, perhaps the most important were the Daum brothers, August and Antonin. In 1875 their father had acquired a glass factory in Nancy, the Verriere de Nancy, where decorative table and domestic glassware was produced. After seeing Gallé's work exhibited in Paris, the Daum brothers turned their energies to producing art glass. The results, especially their cameo glass, were closely akin to Gallé's products, although the Daum brothers glass is distinctive in their use of mottled glass bodies and enameled decoration on acid-cut vases.

The career of René Lalique (1860-1945) spanned the last years of the nineteenth century and most of the first half of the twentieth. His ability to change his style to match the mood of the period allowed him to reign supreme as a leader of taste. Even more remarkable was his change of career: having trained as a jeweller, Lalique turned his attention to glass. Apprenticed at 16 to the jeweller Louis Auroc, Lalique went on to design for August Petit. In 1884 he formed a partnership with a friend, M Varenne, to market his jewelry designs. After an exhibition at the Louvre, Lalique's work attracted the attention of the jeweller Alphonse Fouquet, whose son Georges would later employ Alphonse Mucha. In 1885 Lalique opened his own workshop and began to work as a subcontractor to well-known firms such as Boucheron, Vever and Cartier. Five years later, he was employing over 30 assistants and began to design stage jewelry for Sarah Bernhardt. By this time he was using new and varied materials, mixing precious with non-precious materials, including glass, which was cast into stylized flowers or the heads of women. His fascination with the possibilities of vitreous enamels led him further in his experiments with glassmaking. From the early years of the twentieth century came Lalique's most notable vases, unique *cire perdue* (lost wax) pieces on which one can see the thumbmarks of the modeller reproduced in the glass.

LEFT: *After starting his career as a jewelry designer, René Lalique was commissioned by the perfumier François Coty to design a range of scent bottles. This led Lalique to launch a new career as a designer and manufacturer of luxury and art glass such as this vase.*

LEFT: *Lalique employed grasshopper motifs on this emerald green glass vase.*

BELOW: *Deep pinks shade to mottled amber in an abstract floral design vase by the Daum Brothers (c 1911).*

The turning point in his career came with a commission from the perfumier Francois Coty to design perfume bottles, which launched Lalique as a manufacturer of luxury and art glassware. Unlike Gallé and Tiffany, Lalique went no further with his experiments: his output remained limited to blue opalescent glass and colorless frosted or polished glass. Though many designs were available in a wide range of bright translucent colored glass, there was no internal decoration like that of Gallé and Tiffany. Instead, decoration was molded in relief or in intaglio, employing a graphic style that was sophisticated and distinctly Art Nouveau. The variety of goods that the Lalique factory produced was vast: vases, bottles, lamps, the famous motor car mascots, boxes and, of course, jewelry.

When porcelain was introduced in Europe in the early eighteenth century, the new material was so highly revered that national workshops were established, in particular in France and Germany. In the nineteenth century these workshops continued to produce ceramic wares in the same patterns that had been initially so popular. As a result, the outstanding pieces of the period are fabulous for their extreme intricacy and exaggeration, for as the ceramic and porcelain industries became complacent they also became less innovative.

In the last quarter of the nineteenth century a new generation of inspired artist-potters emerged. Keen to explore all the possibilities their art presented and urged on by the exhibitions of Chinese and Japanese wares, they abandoned the fussiness of the established style in favor of freedom of form and truth to materials. Exquisite works, such as the Copenhagen vase with its sea-holly motifs, were created in porcelain, but the craze was essentially for earthenwares. The medium was not only used for vases; it was modeled into figures. The swirling scarves and hair of dancer Loïe Fuller was one of the favorite images of modelers and sculptors, who extended and exaggerated the sweeping lines of her dress in clay.

Early exponents of Art Nouveau in ceramics in Hungary were the Vienna *Sezession* artists, including Vilmos Zsolnay (1828-1900). Zsolnay produced a number of pieces in strong Art Nouveau styles. Some of his pieces have flowers and women with flowing hair, modeled in full relief, while on others, linear Art Nouveau motifs are applied to vases. But it is his use of color that characterizes Zsolnay's work, particularly the repeated use of blues and reds shading to purple.

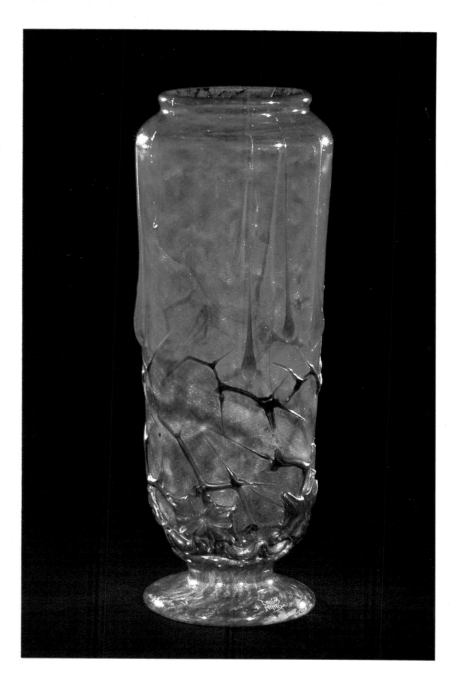

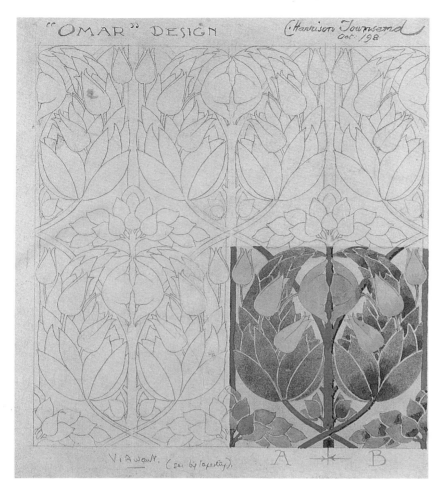

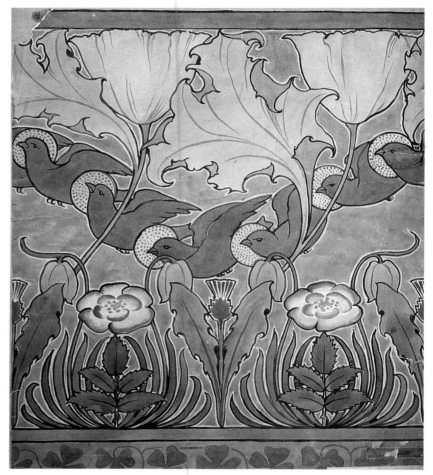

Alongside books and illustrations, the earliest – and some say the most important – vehicles of Art Nouveau abroad were textiles and wallpapers, including Mackmurdo's designs of the 1880s. It was in these lines that Liberty and Co were unsurpassed. Arthur Lazenby Liberty had prided himself on his imported Japanese fabrics and, on his return from Japan, opened a branch in the Avenue de l'Opéra to commemorate his success at the Paris Exhibition of 1889. The shop sold objets d'art and Liberty fabrics designed by Arthur Wilcox, Lindsay Butterfield and Arthur Silver, and these became a source of curvilinear motifs for continental artists and designers. As a result of the growing taste for simpler furnishings in the home, cotton and wool replaced silks and velvets. By the mid-1890s, when Silver was designing Liberty textiles, cotton had become associated with the image of country cottages and the simple (if idealized) rural lifestyle. Although cheap, Silver's fabrics were also sophisticated.

Victorian taste in wall coverings had favored 'all-over' patterns. The Art Nouveau interior designers preferred plain walls, to which decorative friezes were often added. The painter and illustrator Walter Crane (1845-1915) extended his repertoire to include a Lion and Dove Frieze design for Jeffery and Co, which was shown at the 1900 Paris Exhibition.

The Art Nouveau style in fabrics would not be confined to the textiles themselves: in the early years of the twentieth century, Liberty and Co issued a catalogue of what were called 'artistic' dresses, illustrated with color designs showing the wearer in a typical interior. In fact all the furniture and furnishings depicted could also be bought from Liberty's. The 'Amelia Evening Wrap' in muted blues and greens with hand-embroidered collar and cuffs reflected the fashion for Art Nouveau clothing. Even shoes would have the whiplash curve, the leitmotif of Art Nouveau, applied to them.

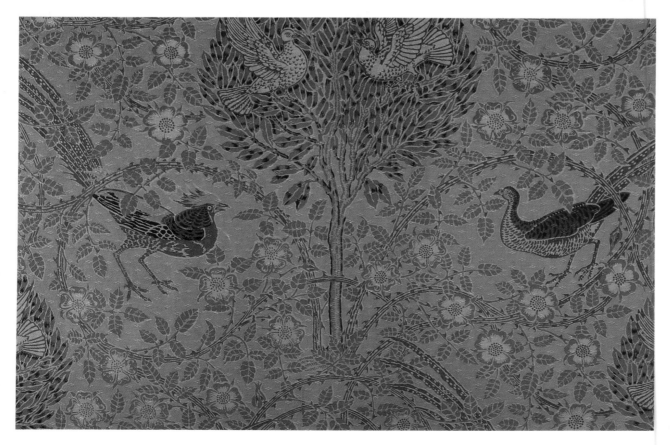

ABOVE LEFT: 'Omar' design for silk and wool double cloth (1898), by the architect of Great Warley Church, C H Townsend.

ABOVE RIGHT: Design for 'Isis' frieze by C A Voysey.

LEFT: 'Pheasant and Rose' textile design (1896), by Walter Crane.

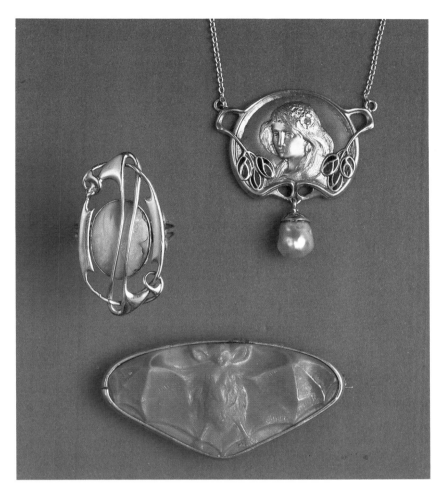

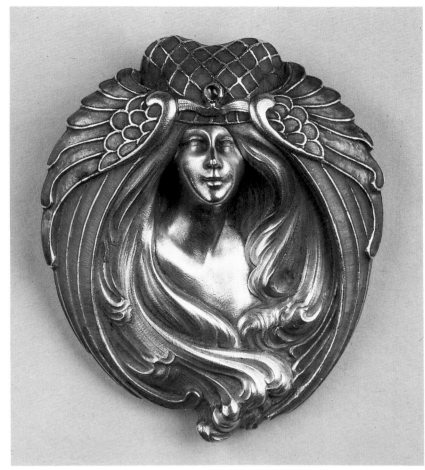

Quite possibly the Art Nouveau objects that are most admired (and most coveted) are the fabulous pieces of jewelry designed by Lalique, Bing, Mucha and Tiffany, to name just a few. And it is in these pieces that Art Nouveau revealed an interest in a new type of woman. Where the image and ideal of Victorian womanhood was sober, virtuous, moral and conventional, the ideal Art Nouveau woman was the 'femme fatale,' a mysterious goddess whose splendor and beauty was to be glorified. The leaders of this revolutionary cult of womanhood were themselves women: theater stars, dancers and celebrities, whose manners and dress were looked to for influence. Among them were the actress Sarah Bernhardt, who was also a sculptor and patron of the leading Art Nouveau artists, the American dancer Loïe Fuller, and Cléo de Mérode, a classically trained dancer who broke the rules by dancing with her hair loose and flowing and was called the most beautiful woman in France. And then there were the stars of the music hall, immortalized by Toulouse-Lautrec in his lithographs:

ABOVE: *A selection of Art Nouveau jewelry. The gold and opal ring is by A Knox and the gilt and luster glass brooch by Lalique.*

RIGHT: *A section of brooches, buckles and buttons by English, German, French and Scandinavian makers. The haircomb and* parure de corsage *are by Lalique.*

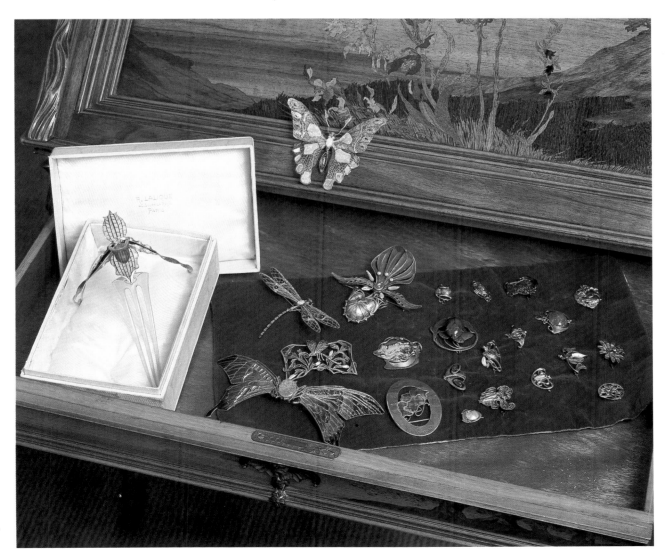

ABOVE RIGHT: *A gold and enamel pendant in the form of a woman's head, by Marcel Bing (c 1901)*

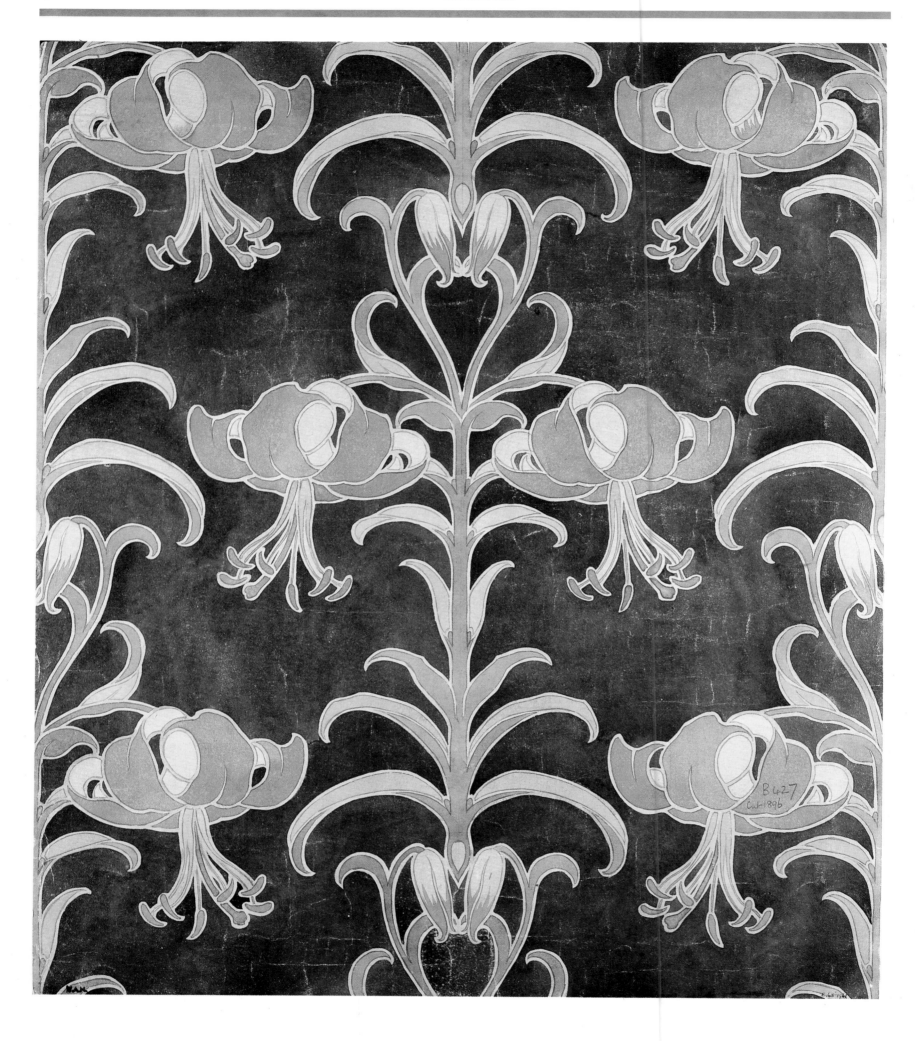

ABOVE: *L P Butterfield's 1896 watercolor sketch for a printed textile, 'Tiger Lily,' displays the Art Nouveau designer's love of floral patterns.*

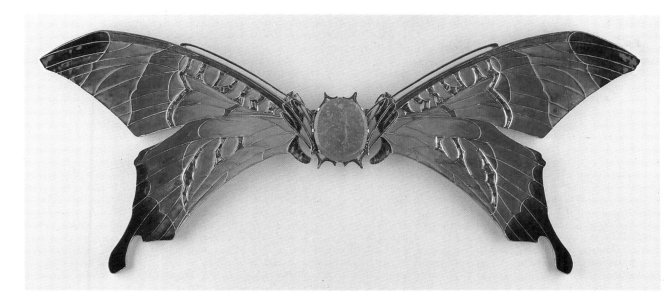

LEFT: *This gold and enamel buckle by René Lalique, set with sapphire and opal, takes the forms of two stylized swallowtail butterflies (1903-04).*

BELOW: *A gold and enamel pendant by Lalique features a low-relief profile of a young woman. Made between 1898 and 1900, it still has its original box.*

BOTTOM LEFT: *Georges Fouquet used* plique-a-jour *enamel and baroque pearls on this orchid flower brooch-pendant (c 1900).*

BOTTOM RIGHT: *This Lalique brooch-pendant uses the popular peacock form.*

Yvette Guilbert, Jane Avril and La Gouloue. Add to these public stars the famous courtesans of the 'demi-monde,' Liane de Pougy, Emiliene D'Alençon and Caroline Otéro, who between them amassed the most fabulous collection of Art Nouveau jewels, all gifts from their lovers and admirers. Where jewelry had in the past been created to adorn women, Art Nouveau jewelry celebrated woman, using her very image as the basis for designs.

Attitudes towards jewelry and its manufacture changed. Technical inventiveness became as important as inventive subjects. A variety of enamelling techniques were brought to bear, including *champ levé*, where the pattern is cut out of the surface of the enamel, *cloisonné*, where different colored enamels are separated by thin bands of metal, and *plique-à-jour*, where enamels are set like gems into a metal framework which has no back, allowing light to pass through the enamel so that it glows like a stained-glass window. The idea that jewelry was merely a setting for a precious stone was swept aside. Under the influence of Symbolist writings and Eastern mysticism, Art Nouveau designers became interested in semi-precious stones such as opals, moonstones and chrysoprase. As little importance was attached to the intrinsic values of the materials, designers were free to exploit misshapen stones, baroque and black pearls in their search for the unusual. Freely mixing their materials, French designers inclined towards the grotesque and fantastic: jewelry was made in the form of women's heads, nudes being swallowed by insects or metamorphosed into butterflies, their hair entwined with flowers. These extravagant curiosities appealed to a limited number of avant-garde customers, and the expensive and elaborate craftsmanship required to produce them depended on patronage.

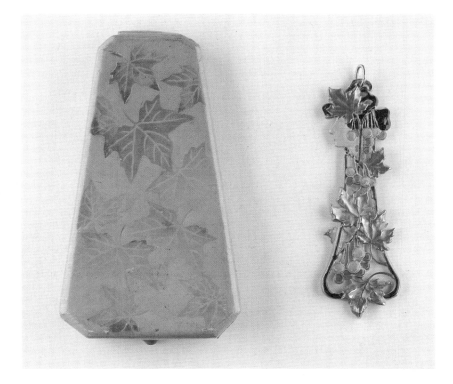

Lalique and Georges Fouquet, who worked with Alphonse Mucha, enjoyed the patronage of Sarah Bernhardt. For Bernhardt's first night in the title role of *Cleopatra*, Fouquet translated Mucha's sketches into enamelled gold, carved ivory, pearls and semi-precious stones to create the famous Serpent Bracelet. (Evidently Miss Bernhardt had

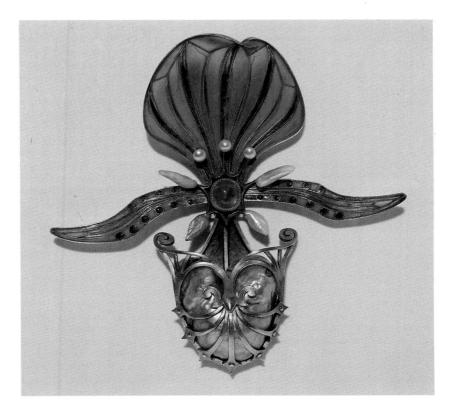

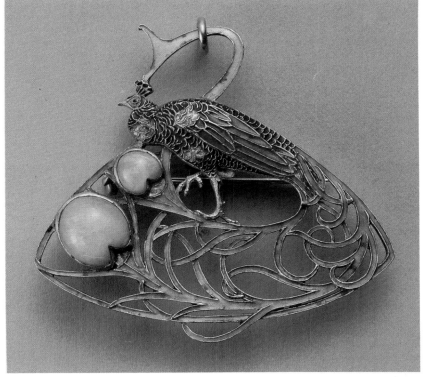

RIGHT: *Much English Art Nouveau silverware, such as this silver cup by C R Ashbee (1893), bears a strong resemblance to English ecclesiastical silver. The church was a major patron for such expensive metalware.*

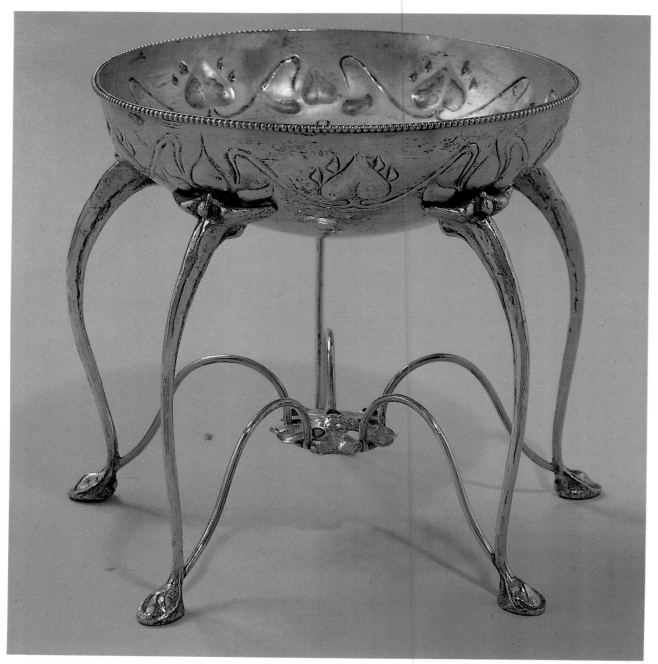

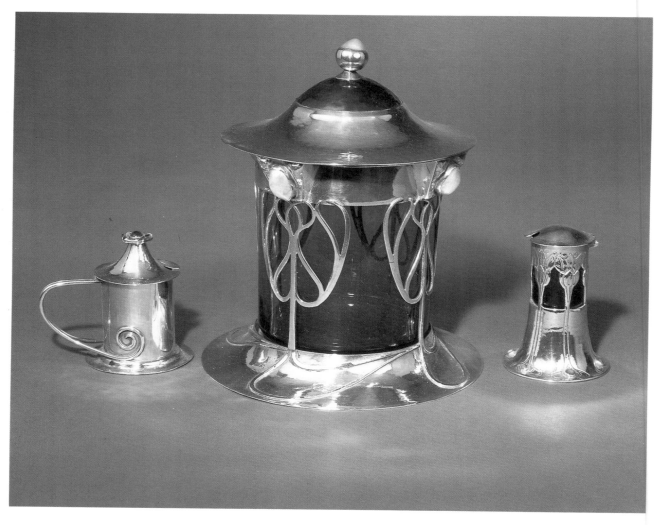

LEFT: *Ashbee designed these mustard pots for the Guild of Handicrafts.*

RIGHT: *Silver belt buckle designed by Henri van de Velde.*

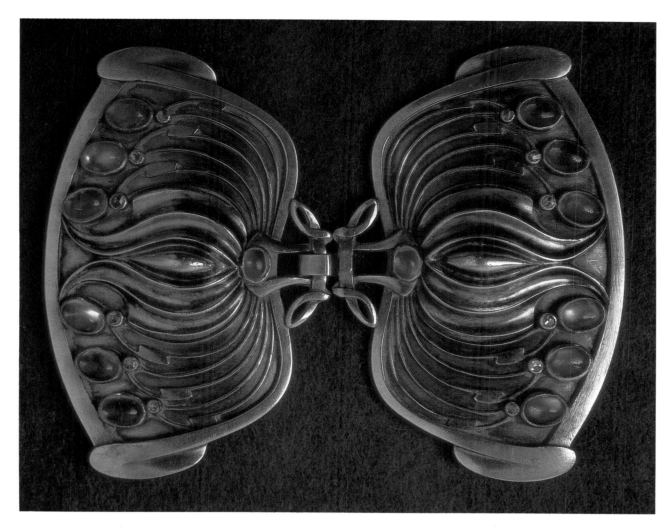

BELOW: *Left, hair comb by Gaillard (c 1900); top middle, hair ornament by Gautrait (c 1900); bottom middle, pair of clasps by Huber (c 1901); right, peacock brooch by C R Ashbee (c 1900).*

trouble paying for this jewel, and messengers were sent each night to claim a portion of the box office receipts.) Hearing of Lalique's talent, Bernhardt asked him to design jewels for her roles in *Izeÿl* and *Gismonda*. The public acclaim that followed was enhanced when, at the Paris Exhibition of 1895, Lalique showed a piece of jewelry in the form of a female nude for the first time.

Where the French and Belgian jewellers such as Philippe Wolfers produced work that reflected the rarified, hot-house culture of the European Art Nouveau, with its synthesis of mysticism, symbolism and orientalism, British designers used comparatively understated natural motifs. Though they did not lack the skill, they lacked the customers and, to a great extent, the sexual freedom to produce jewels like their European counterparts. British Art Nouveau jewelry was still handmade, often created for wealthy patrons, and it is not surprising that some of the finest English jewelry was the result of ecclesiastical commissions.

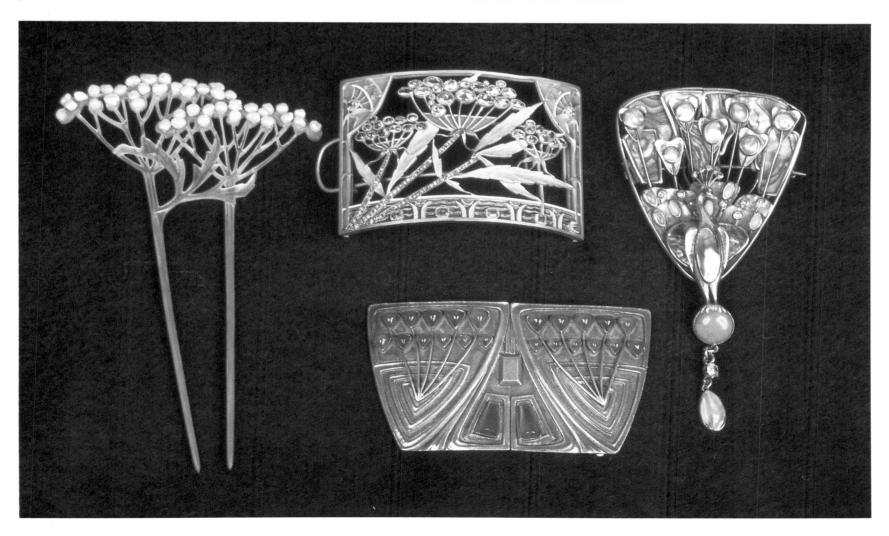

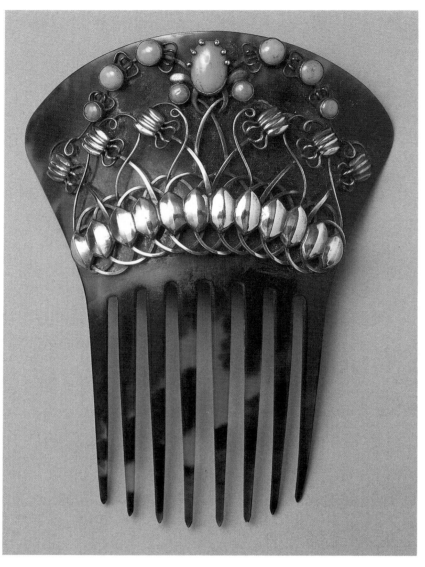

Charles Robert Ashbee worked in gold and silver, pearls, jade and turquoise to produce a pendant in the form of that popular subject for Art Nouveau fantasy, the peacock. Here, design is all important, for the gemstones are set within the metalwork rather than overwhelming it. The stones themselves reflect the expanding British Empire; the opals are from Australia, the pearls from India, the moonstones from Ceylon and the diamonds from South Africa. The pendant's subtle coloring and gentle luminosity contrasts strongly with the heavy, diamond-encrusted jewels of the Edwardian period. The most consistently attractive pieces of British Art Nouveau jewelry, however, are the buckles, pendants and brooches commissioned and sold by Liberty and Co: fine quality, reasonably priced silver-and-enamel pieces with semi-precious stones worked in abstract natural forms.

There are few examples of Art Nouveau earrings. The fashion for loose, flowing hair made them redundant; Art Nouveau women tended to prefer elaborate hair combs. There are, however, many fine gold chains culminating in pendants which could be detached and worn as brooches.

Contemporary journals encouraged British designers to work in silver instead of gold and to use enamel work in place of precious stones. After the 1900 Paris Exhibition, the more conventional types of jewelry in the Art Nouveau style were more or less mass produced, and the designers who made lasting commercial success were those, like Liberty in England and Jensen in Denmark, who adapted their designs to suit machine production.

LEFT: *Tortoiseshell and silver hair comb.*

BELOW: *Necklace by Haseler for Liberty and Co (1903).*

BELOW LEFT: *Pendant and chain by Ashbee for the Guild of Handicrafts (c 1903)*

RIGHT: *A selection of Art Nouveau jewelry; few earrings were made, as the fashionable long hair would have obscured them.*

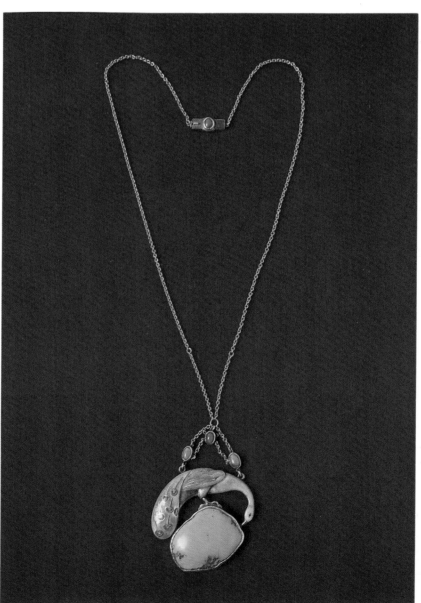

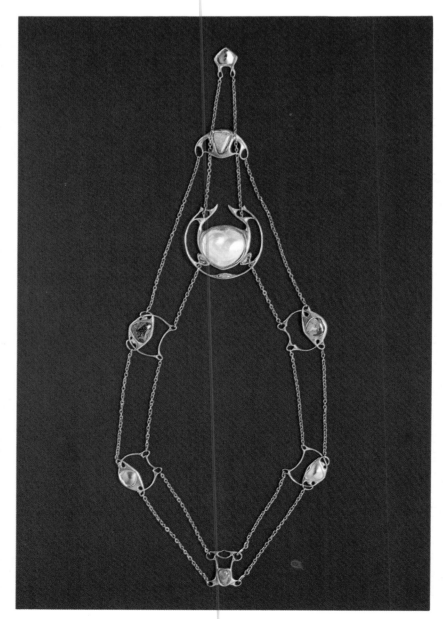

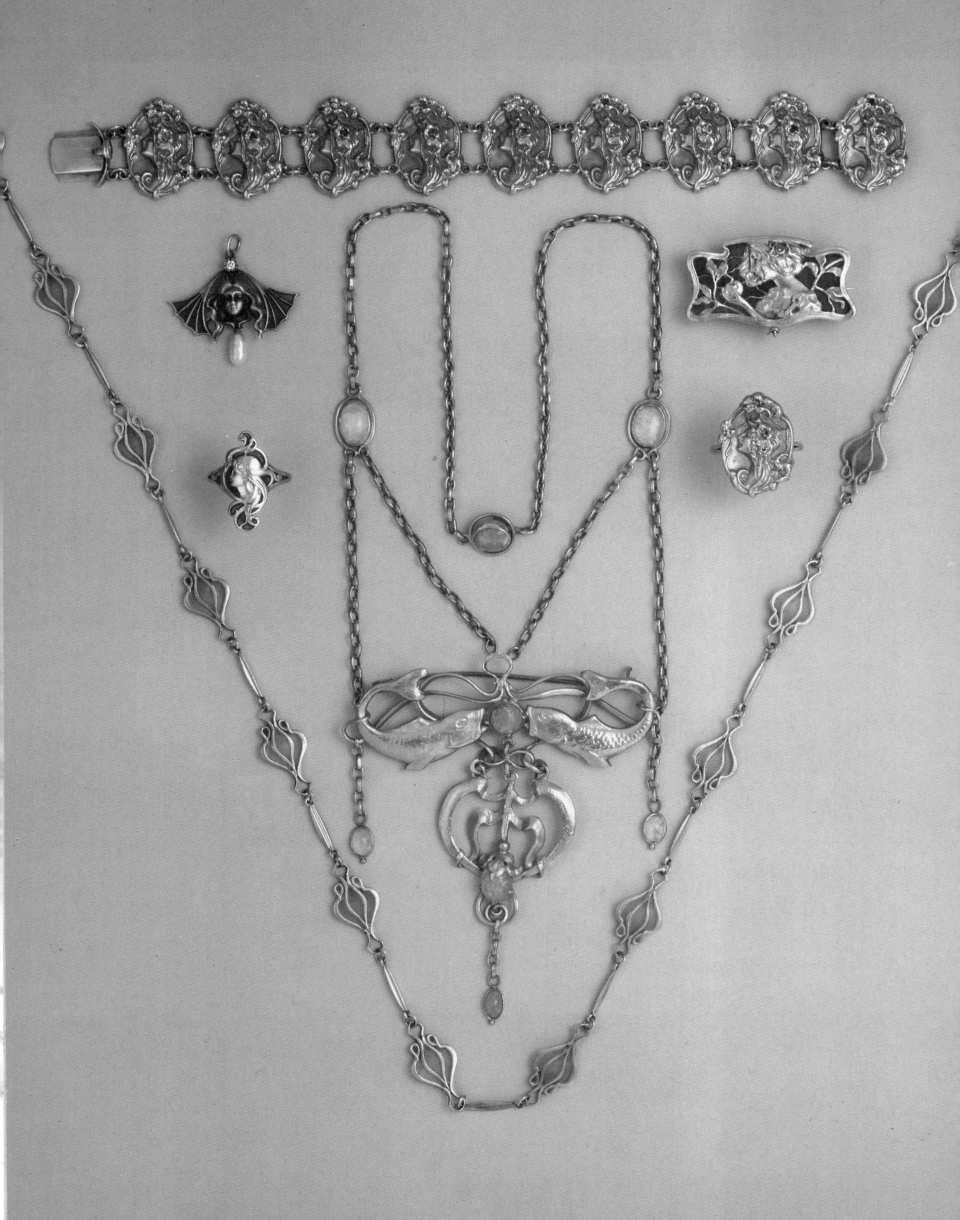

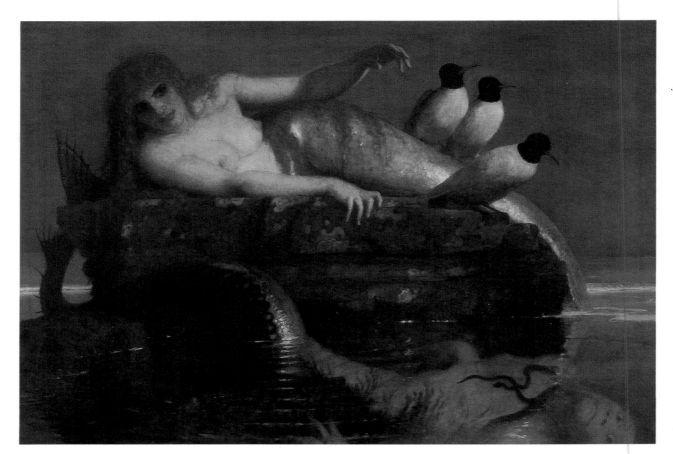

LEFT: *Arnold Böcklin's* Calm Sea *(1887) is perhaps the archetypal representation of the half-human, half-animal creatures that so fascinated Art Nouveau painters and jewelers.*

BELOW: *Hodler believed that true beauty could be found in nature's external elements, and many of his works were of single figures in landscapes. In* Night *(1890), however, a more disturbing beauty is revealed.*

oriental figure, Astarte, betrays a symbolist influence, but where the commission as a whole was basically an opportunity for Sargent to show that he was more than a portrait painter.

In pre-Revolutionary Russia, the influence of symbolism would be maintained by Serge Diaghilev, Alexandre Benois and Leon Bakst, who were part of *Mir Iskusstva* (the 'World of Art' group) in St Petersburg. Diaghilev's interests lay with the work of Puvis de Chevannes, while Benois was an ardent fan of Wagner; his first designs for the stage were for a production of *Götterdämmerung* in 1903. In fact the St Petersburg symbolists made their reputations not as easel painters but as stage designers: Diaghilev took his *Ballet Russes* to Paris in 1909, with a program of *Prince Igor* and *Cléopâtre* (starring society beauty Ida Rubenstein) with decor by Leon Bakst. In the 1910 season, *Schéhérazade* was presented with sets and costumes by Bakst, whose vision of harem life was derived from Moreau's treatment of the theme of Salomé with some influence from Beardsley, whose work was well known in Russia from the mid-1890s onwards. Like Beardsley's work, Bakst's designs show a concern for decoration and elegant display.

If Art Nouveau painting and sculpture has one dominant image, it is surely that of women. The cult of woman at the end of the century would feed artists' desire for resonant imagery and lead them down a path of morbid fantasy. These images of 'femmes fatales' first appeared as Pre-Raphaelite beauties and evolved into Klimt's *Salomé* by way of Moreau's pagan goddesses and Oscar Wilde's poem to the Sphinx, the ultimate symbol of feminine power and mystery.

The representation of half-human figures was a favorite theme of many painters: Swiss-born Arnold Böcklin (1827-1901) depicted centaurs in 1873 and, in *Calm Sea* (1887), a mermaid and a triton. The mermaid is the dominant figure: like a siren on her rock she gazes not at the male triton sinking into the depths but directly at the spectator. Böcklin was not the only Swiss Symbolist painter; next to him, the most important was Ferdinand Hodler (1853-1918), who drew much of his inspiration from Swiss history and landscapes and whose bold, simple style was well suited to large murals. Hodler's work also bears the traces of Puvis de Chevannes; many of his works feature single figures in landscapes in a manner similar to Chevannes' paintings in this genre. As a result of this resemblance, Hodler was invited to show at the first exhibition of the *Salon de la Rose + Croix* in 1892. In 1897 Hodler explained that his motives were to express the external elements of nature in which, he believed, its essential beauty was to be found. Among Hodler's works that are closest to Art Nouveau in appearance and to the Symbolists in style are *Night* (1890) and *The Chosen One* (1893), in which no spatial or atmospheric values are

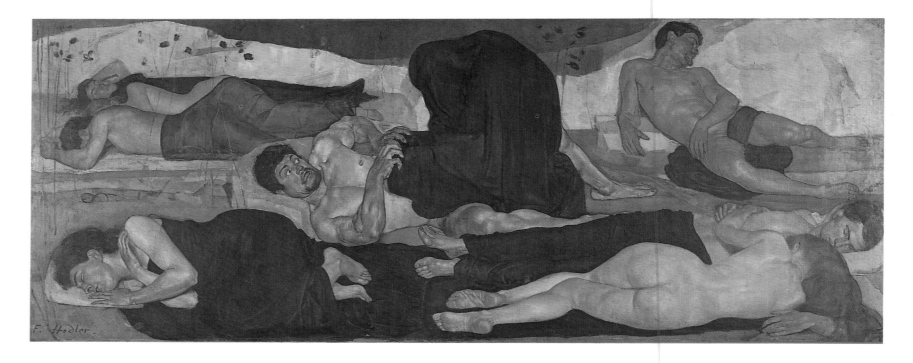

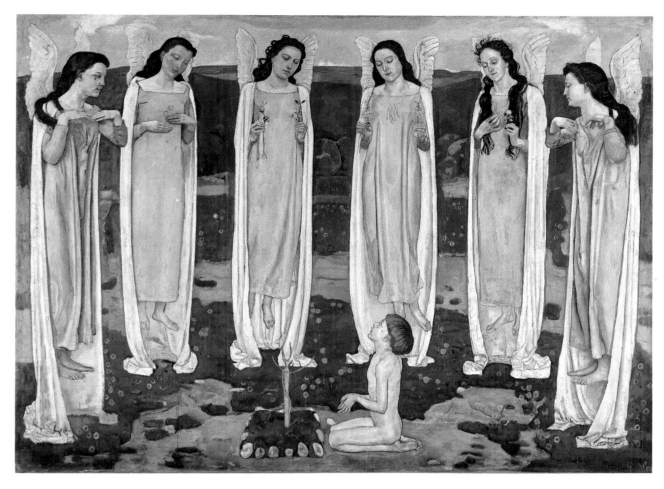

RIGHT: The Chosen One (1893) is the closest of Hodler's paintings to Art Nouveau style; the six guardian angels appear to be neither standing nor flying and appear almost dissociated from the background.

admitted. In *The Chosen One*, the six guardian angels neither rest their feet on the ground nor appear to be flying, for there is no 'air' beneath their feet or behind their bodies. In *Night*, the apparent ease of the sleeping figures is contrasted with the central character's horrified expression at the cloaked figure which straddles him.

The most outstanding Dutch Symbolists were Jan Toorop (1858-1928) and Johan Thorn Prikker (1868-1932). Toorop was an artist of mixed Dutch and Javanese parentage, who had come to Holland as a child. After studying art in Brussels, Toorop came into contact with the artists of the Belgian avant-garde group *Les Vingt* with whom he

exhibited in 1885, as well as visiting London where he was in contact with Pre-Raphaelite circles. During the 1880s and 1890s Toorop was subject to a wide range of artistic influences, but he also made many acquaintances in literary circles including the Dutch avant-garde writers known as the *Tachtigers* and the Symbolist poet Verlaine. In his work Toorop brought together a linear art and symbolism fused with Javanese art. In the 1890s he began to abandon the logical spatial constructions of Western art for compositions that resemble batiks, the traditional Javanese wax-resist designs on fabric. The surfaces of his pictures were now organized by means of undulating lines in

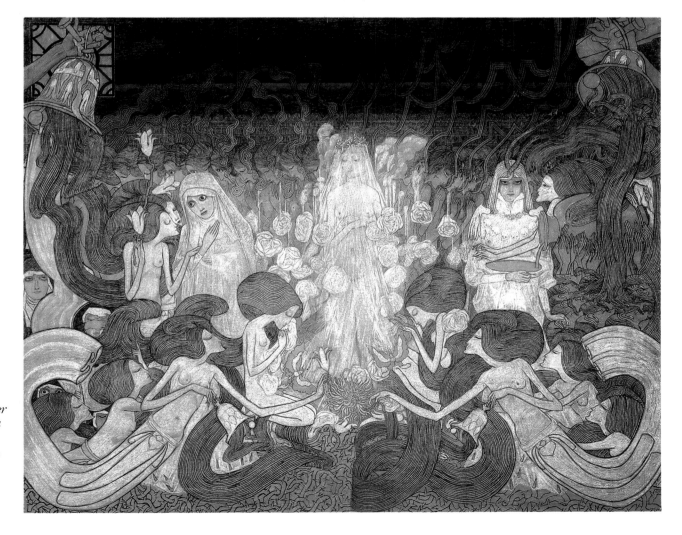

RIGHT: *Jan Toorop, a Dutch painter of partly Javanese descent, fused a linear style of art with Symbolism and traces of his oriental heritage. In paintings such as* The Three Brides *(1893), his figures appear like shadow puppets and his compositions like batiks.*

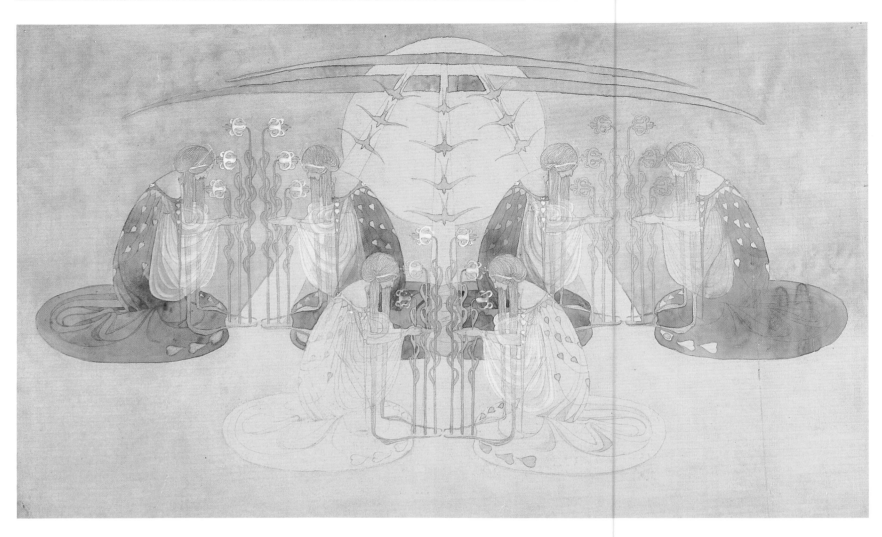

complex, shallow patterns. In *The Three Brides* (1893) Toorop makes use of this symbolic content of line: an innocent bride is shown standing between a spiritual, nun-like bride and one who closely resembles the archetypal 'femme fatale.' This last figure is drawn with sharply etched lines, while the innocent bride is depicted in softer, less defined strokes. Other influences are apparent in *Faith in Decline* (1894) and *Girl with Swans* (1896): Toorop was deeply interested in the mystical ideas of Richard Wagner, and his swans were suggested by *Lohengrin*.

In 1905 Toorop converted to Catholicism, after which the fluid linearity so evident in his work gave way to an angular and far less ornate style. The abstract elements in Toorop's work influenced the artists of the Glasgow School, thanks to illustrations of his work in *Studio* magazine. Although the circle of artists around Mackintosh devoted most of their creative energies to design, the paintings by the Macdonald sisters, Frances and Margaret, in particular *Mysterious Garden* and *Moonlit Garden*, show a Symbolist tendency towards abstraction.

Johan Thorn Prikker's commitment to Symbolism would prove to be short lived: having begun his career as an Impressionist, he moved towards Symbolism in the early 1890s when he produced a series of drawings illustrating the life of Christ. After exhibiting with *Les Vingt*, he came into contact with Henri van de Velde and the poetry of Verlaine, and began to produce work with an even more extreme – and often more abstract – sense of religious mysticism than Toorop's. Prikker's best known Art Nouveau works are *Madonna of the Tulips* (1892), with its linear style and mottled color that gives it the appearance of a stained-glass window or a mosaic, and *The Bride* (1892-3). This work is even more abstract; the bride has been reduced to a transparent veil, the flowers appear more like skulls and the tulips as phalluses.

ABOVE: The Moonlit Garden *(1895)*, *by Frances MacNair Macdonald, shows how the artists of the Glasgow School were influenced by the abstracted linear quality of Toorop's paintings.*

BELOW: *The Symbolist tendency towards abstraction is evident in* Mysterious Garden *(c 1904-06), by Margaret Macdonald Mackintosh.*

RIGHT: The Bride *(1892-03), by Johann Thorn Prikker, carries Symbolism and stylization to the extreme, with flowers appearing as skulls and phalluses against the figure of a bride.*

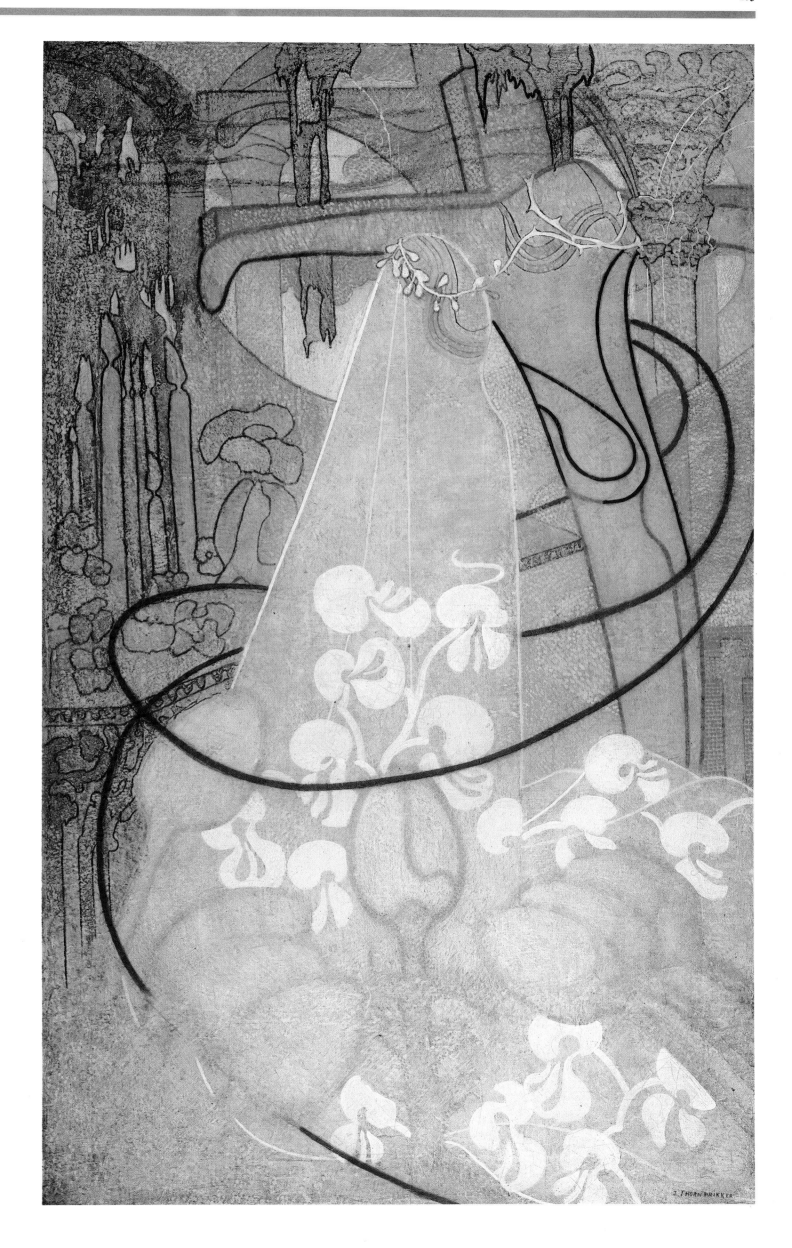

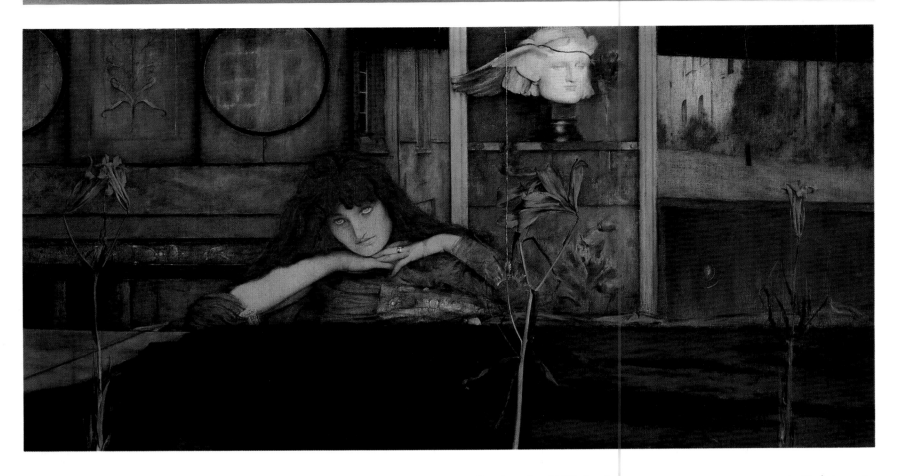

ABOVE: *Fernand Khnopff was one of the foremost Belgian Symbolists. His works, such as* I Lock My Door Upon Myself *(1891), are the more disturbing for their realism and the fact that the female figures are based on his sister, whose beauty obsessed him.*

Chief among the Belgian Symbolist painters was Fernand Khnopff (1858-1921), the creator of mysterious works which are made more disturbing by the use of ostensible 'realism' and by the fact that the feminine types he used in his compositions all seem to be based on his sister Marguerite, whose beauty obsessed him. Born in Bruges, Khnopff first studied law, which he abandoned in order to study under the Belgian symbolist artist Xavier Mellery. In 1877 Khnopff visited Paris where he studied for a short time with Moreau; after seeing works by the Pre-Raphaelites at the 1878 Paris Exhibition he took their ideal of beauty as his model.

BELOW: *The eyes of Khnopff's figures always seem to evade those of the viewer, as in* The Caresses of the Sphinx *(1896).*

During the 1880s he began to score some success in Belgium: in 1883 he was a founder-member of *Les Vingt* as well as exhibiting with Péladan's *Salon de la Rose + Croix*. Khnopff worked in many mediums, including watercolor, oils, pastels, engravings, sculpture and reliefs, and was widely exhibited abroad. He was always subject to literary influences, illustrating Péladan's novel *Le Vice Suprême* and taking the enigmatic title of *I Lock My Door upon Myself* (1891) from a poem by Christina Rossetti. In this painting Khnopff's sister is surrounded by objects from his own collection, including a white winged head depicting Hypnos, God of Sleep, symbolic of the dream element within the painting.

A true dandy and something of a recluse, Khnopff built an exotic and palatial home, a retreat from everyday life which he dedicated to 'himself.' The few privileged visitors to this sanctum were reminded of des Esseintes in *À Rebours.* Khnopff was a pessimist who took as the themes for his paintings pride, isolation and cruelty. Typical of his languid aristocratic heroines, the figures in *I Lock My Door upon Myself* and *The Offering* (1891) fix their eyes on the spectator but, distant and isolated in their dream worlds, do not communicate with us.

Edvard Munch (1863-1944) is an artist who is traditionally associated with Expressionism, although his painting has links with Art Nouveau in general and with Symbolism in particular. Much of Munch's art is connected with feelings about womanhood, a subject he treated with a great simplicity of line. Between 1893 and 1908 Munch spent much of his time in Germany and it was during this

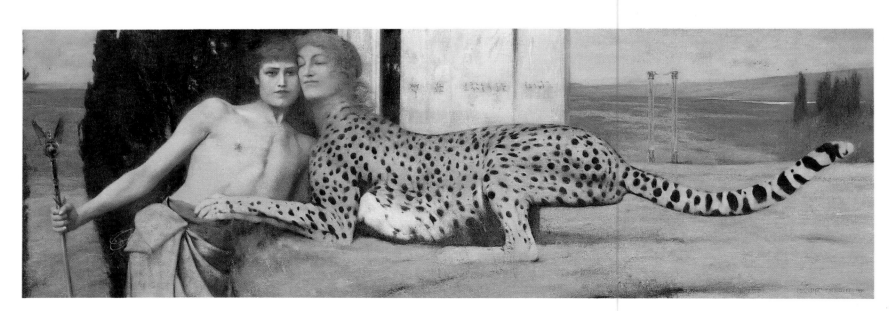

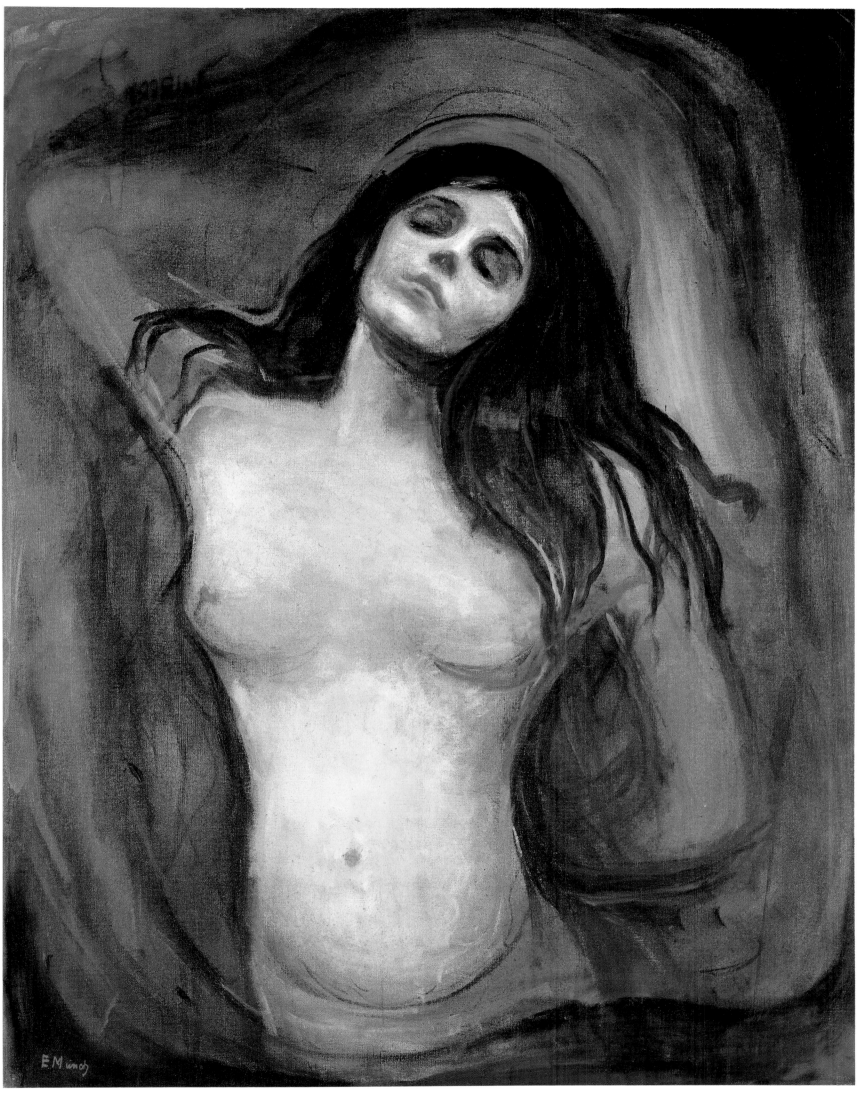

ABOVE: *Much of Edvard Munch's work deals with themes of womanhood. His* Madonna *(1894-95) is far removed from the traditional European representations.*

BELOW: *Using various archetypal figures such as* Despair *(1893), Munch planned to create symbolic representations of his experiences that had led him to identify sex and love with death and disease.*

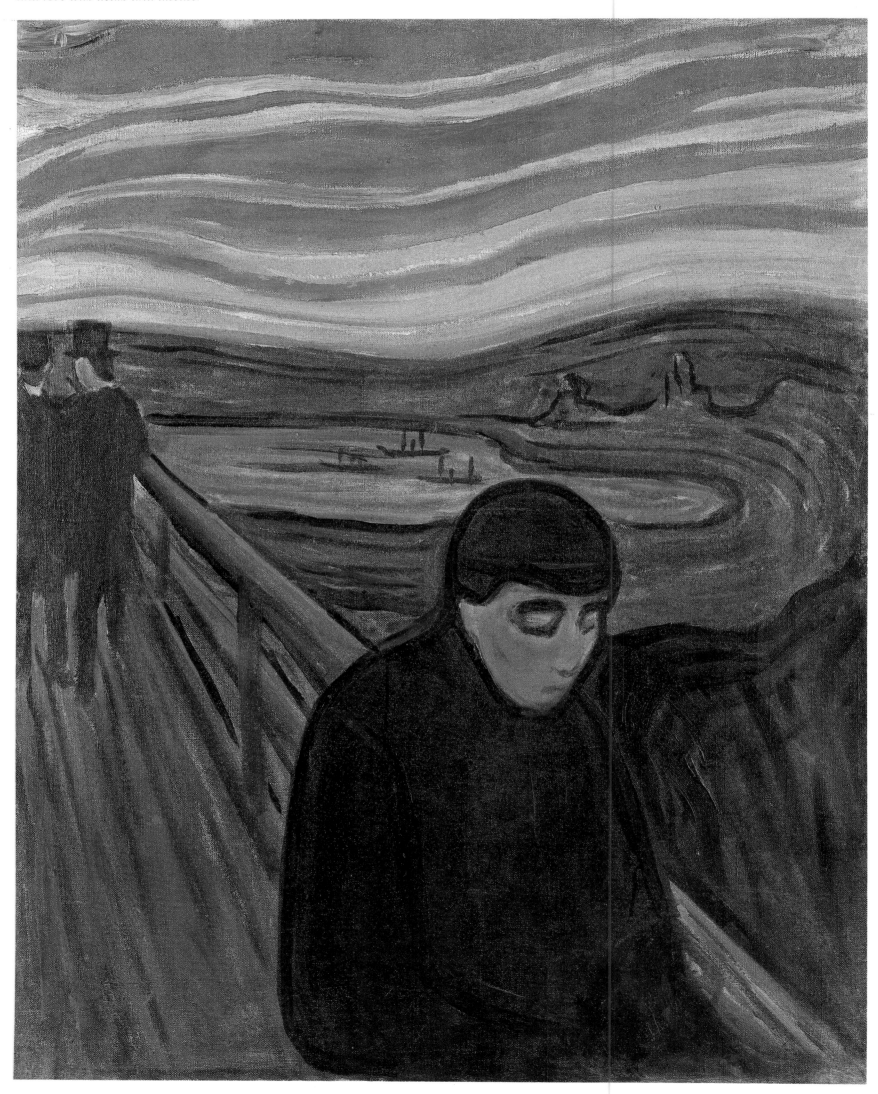

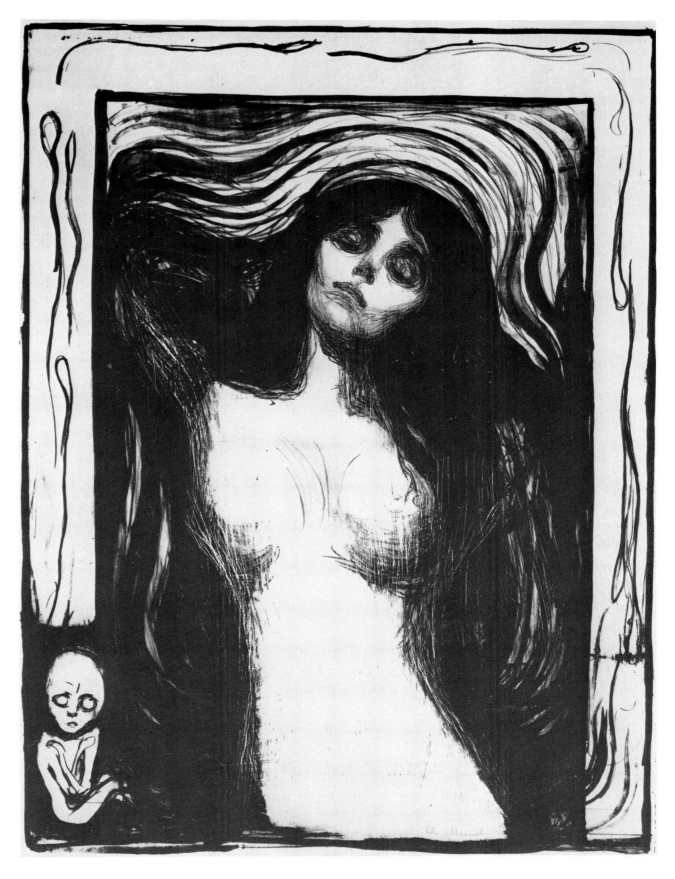

period that the *Frieze of Life* was conceived and partly executed. Using various archetypes, Munch planned to make a Symbolist presentation of his life and experiences. As with Gauguin, Munch's childhood experiences were decisive – his mother had died of tuberculosis when he was five and throughout his life he was to identify sex and love with death and disease. In *The Dance of Life* (1900), rather like in Toorop's *The Three Brides*, the female figure is shown in the successive roles of the innocent, the temptress and, finally, the undesirable. By 1895 Munch was closely linked to the Symbolist circle in Paris: his lithograph of *The Cry* was published in *La Revue Blanche* and in 1896 he exhibited at Bing's gallery L'Art Nouveau; that same year, he met the Symbolist poet Stéphane Mallarmé.

Munch's *Madonna* (1895) is a further instance of the Art Nouveau in fine art, original, striking and independent of painting traditions. The long wavy hair and the sinuous movement of the figure, placed against a background of swaying lines, are the most apparent quality. But to evoke the dominant female sexuality, the image is placed within a framework of floating spermatozoa while an embryo 'sits' at

the bottom left. In *Anxiety* (1894) the theme is naturalistic, but Munch treated it 'synthetically,' and instead of symbolizing a state of harmony, the synthetic style creates a feeling of anxiety with its abrupt angles and tortuous lines. The outstanding quality of Munch's work is the way each element in the composition is carefully placed with the specific purpose of creating emotions.

If Munch is more familiar for his links with Expressionism, Gustav Klimt (1862-1918) is probably the artist best known for his contribution to Art Nouveau painting. Klimt became associated with Art Nouveau and Symbolism at the formation of Vienna *Sezession* in 1897; he was its first president. By 1900 Klimt had developed his own personal 'Art Nouveau,' no doubt influenced by the *Sezession's* exhibitions, which included the works of Mackintosh and the Glasgow School, Walter Crane, Aubrey Beardsley and Whistler. Like most other Secessionists, Klimt never lost interest in decoration, and in much of his work he confined patterns to distinct areas to create relationships between shapes. There is a tension in his works between the representational and the abstract, between illusionistic perspective and flat

RIGHT: The Hills of Dream, *by George Dutch Davidson, employs an almost pure Art Nouveau painting style; it is clear how the style lent itself to both fine and applied art.*

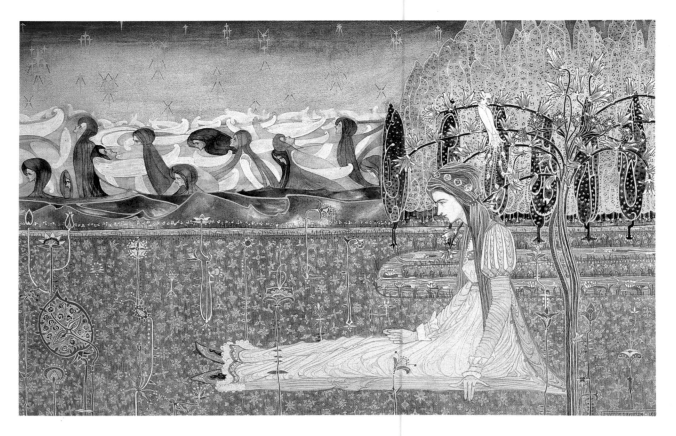

BELOW: *Work such as* Music *(1895) made Gustav Klimt possibly the best-known Art Nouveau painter.*

patterns, which results in a break-up of spatial continuity. The combination of photographic realism and pattern, similar to that employed by the Pre-Raphaelites, produced a striking fusion of the decorative and the symbolic. The patterns themselves are often based on geometric shapes, in particular circles, squares and triangles, in a man-

ner reminiscent of Josef Olbrich's work as well as Mackintosh's Warndorfer Music Room murals of 1902.

Alongside the direct influences of his contemporaries, Klimt's stylistic influences extended from the ancient orient through nearly all the periods of Western and non-Western art. Even contemporary

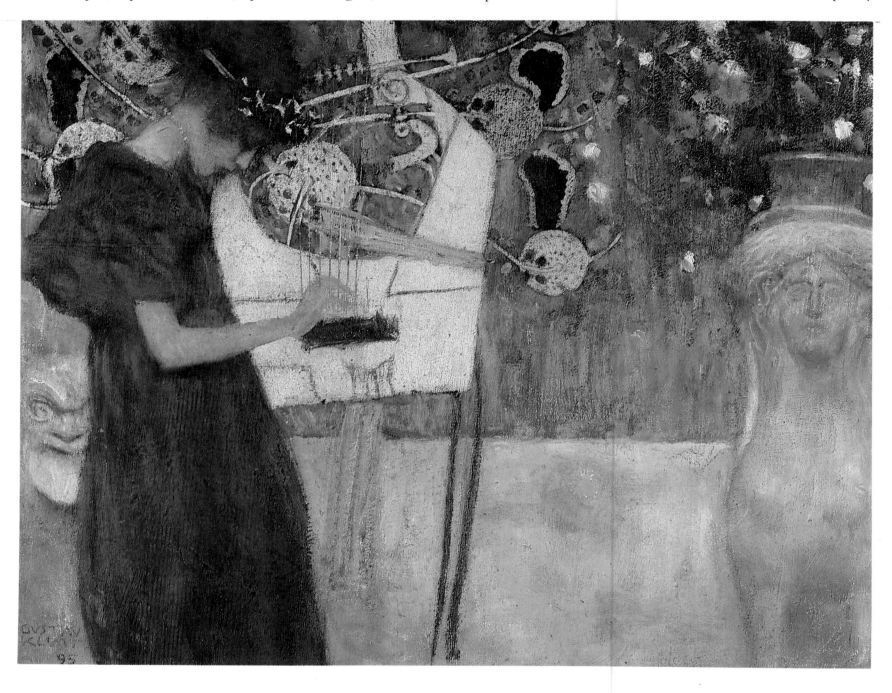

dance would touch Klimt; Isadora Duncan had emphasized Greek dance and Ruth St Denis used Egyptian and Indian motifs which were paralleled in Klimt's orientalized decoration. Both dancers had in fact performed in Vienna – St Denis's 1906 *Dance of the Touch* sent Vienna into raptures. Furthermore, the 'screen' behind the figure in the portrait of *Frederica Maria Beer* (1916) is an enlargement of the decoration on a Korean vase in Klimt's collection of oriental ceramics. In this portrait, Klimt fully developed the Art Nouveau thesis that decoration should also be content.

The extraordinary event that occurred in Vienna in 1899 and which would further influence Klimt was the publication of Sigmund Freud's *The Interpretation of Dreams*. Though only six hundred copies were printed at the time, Klimt no doubt became aware of the sexual fixations in Freud's writings through the close-knit artistic and literary circles of Vienna. Reversing Freud's process of interpreting imagery into content, Klimt translated his view of the world and things into latent sexual symbolism so that the 'façade' of ornament could be seen as just that or as more, depending on the sensibility of the spectator. Even straightforward sexuality as presented in *The Kiss*

(1907) was able to pass censorship because of its overwhelming (or distracting) beauty.

Not hesitating to use earlier art works for their shapes, Klimt borrowed a headdress, popular among seventeenth-century royalty, that appeared in Velasquez's paintings in the Vienna museums, and transferred the shape to his portrait of Berlin patroness *Fritza Riedler* (1906), where it is translated into a repetitive wall motif. Like many Symbolist painters (and many of the jewelry designers), Klimt fixed upon the image of woman, portraying her both as rational (in his portraits of *Fritza Riedler* and *Frederica Maria Beer*) and irrational: Judith delighting in the display of the decapitated head of Holofernes (a far cry from the Renaissance portrayals of the pious widow) and Salome, the most terrifying femme fatale to date.

BELOW: The Kiss *(1907-08) demonstrates how Klimt deployed a latent sexual symbolism within a façade of ornamentation drawn from all eras of western and non-western art.*

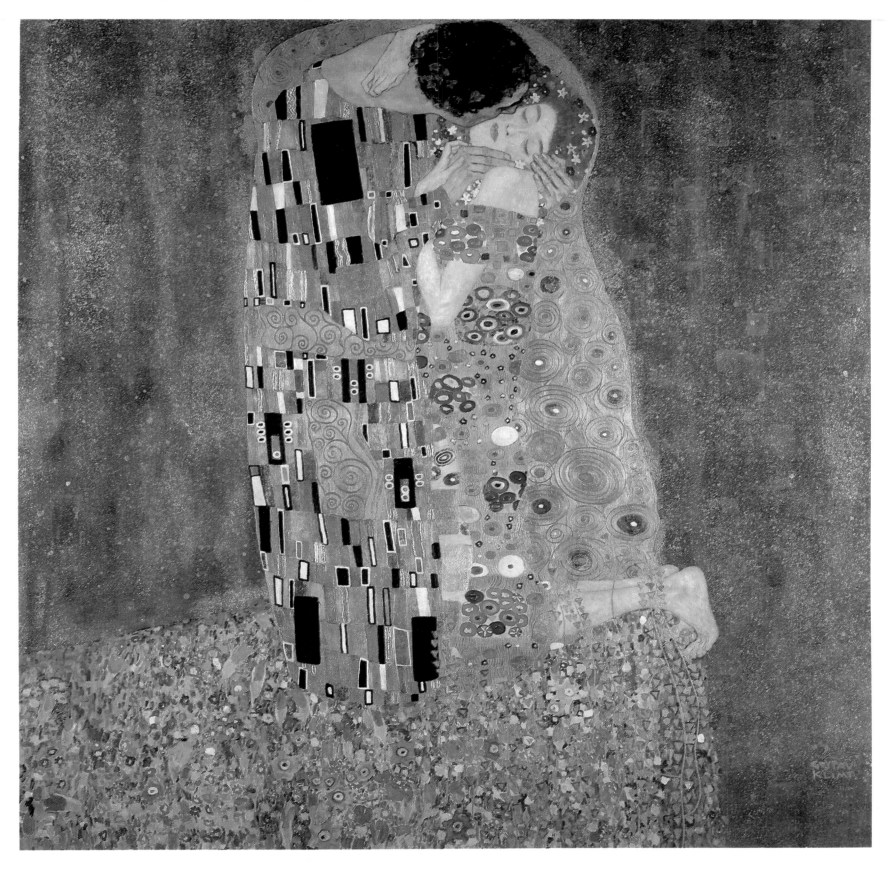

Where Klimt's work stands between naturalism and stylization , it also stands, in keeping with Art Nouveau ideals, between fine art and craft. The most important of his commissions was for the mosaics in the *Palais Stoclet*. In 1903 Klimt had visited Ravenna to see the Byzantine mosaics. These made a great impression on him and were to affect his painting. By using mosaics for the *Palais Stoclet* murals, Klimt was brought closer to the realms of collage. So successful were the decorative interpretations of the Stoclet images that Klimt painted a life-size oil version of the Stoclet *Fulfilment* panel. Titled simply *The Kiss*, the figures appear to kneel on a flower-decked pedestal in a golden space. In this composition, the figures recline against vibrant patterns of peacock feathers and spirals.

BELOW: *Like many of the Art Nouveau designers, Klimt was obsessed with images of women. In works such as* Female Friends *(1904-07), he portrayed them as both calm and rational and terrifyingly irrational.*

In a wider context, Klimt's work shows a new kind of pictorial composition; one in which abstract geometric shapes are arranged to create visual rhythms; by their effect on each other they produce a new sensation of pictorial depth. Unlike Munch, Klimt, was not a reclusive painter. In Vienna he was surrounded by other artists, many of whom worked in a similar style. One of the most talented was Kolo Moser (1868-1918) who like many of his contemporaries portrayed the sinuous movements of the dancer Loïe Fuller.

Félix Vallotton (1865-1925) was one of the most active graphic designers among the *Nabis* group, executing a series of woodcuts for *La Revue Blanche*. His approach has been called documentary, for the woodcuts recorded everyday, contemporary life. But this approach did not stop him from using sinuous lines, black-and-white patterns and the interplay of positive and negative space. These features, all of which can be found in *La Paresse* (1896), mark Vallotton's work as Art Nouveau.

Pierre Bonnard, who produced the poster for *La Revue Blanche*, demonstrated the Art Nouveau tenet that painting had to be useful and not confined to easel painting. His *Screen (Promenade of Nurses)* is a color lithograph on the four panels of a folding screen.

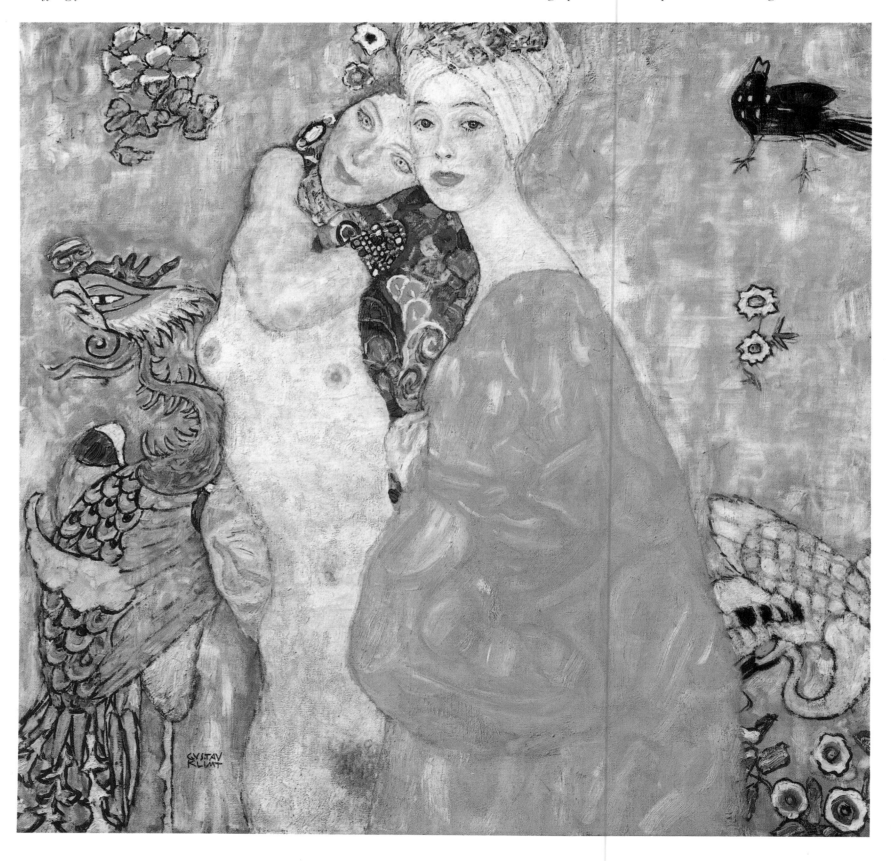

Picasso's later fame as an artistic innovator has somewhat obscured his early commitment to Symbolist ideas. (It is also important to remember that during his 'Blue Period', *La Revue Blanche* discovered him.) Growing up in the artistic climate of turn-of-the-century Barcelona, Picasso was not immune from the influence of the English Art Nouveau designers. The Spanish avant-garde journal *Juventut* which

ABOVE: *The flowing movements of Loïe Fuller's dance – itself an expression of Art Nouveau – provided inspiration for many artists such as Koloman Moser.*

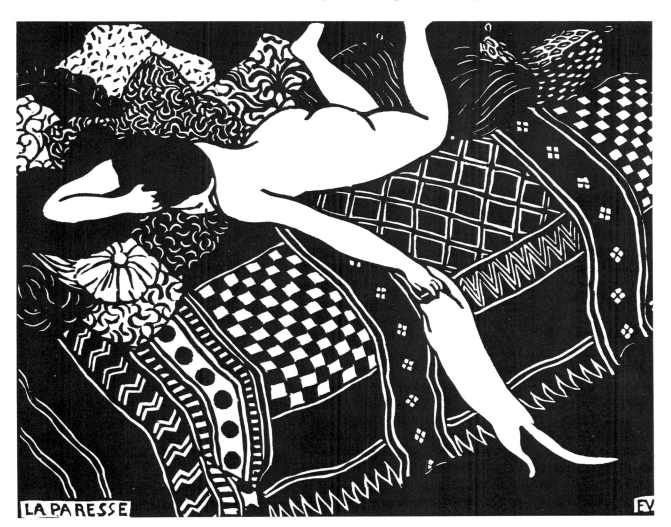

RIGHT: *Félix Vallotton was a member of the* Nabis *group, and designed illustrations for the* Revue Blanche. *The engraving* La Paresse *(1896), like much of his work, is marked by sinuous lines and a constant interplay of positive and negative space.*

LA PARESSE

RIGHT: *Sculpture was often treated as a decorative art by Art Nouveau artists. Figures of women in bronze were copied in other cheaper metals and transformed into decorative table fixtures such as this inkstand (c 1900) by the Wurttembergische Metallwarenfabrik.*

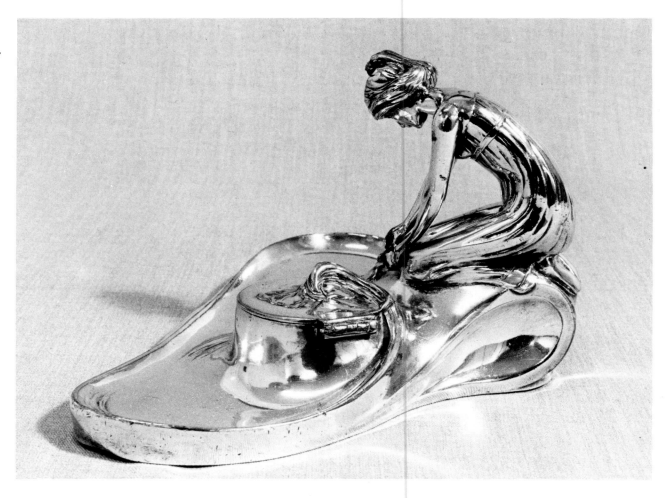

first appeared in 1900 and which Picasso helped to found, had in its first issue a long illustrated biography of Beardsley; subsequent issues contained illustrations by Burne-Jones and Rossetti. During his visit to Paris in 1900, Picasso saw the Seurat retrospective exhibition organized by the *Revue Blanche* and an exhibition of pastels by Odilon Redon. In 1903 he saw the Gauguin memorial exhibition. With all these artists' works available, Picasso had to choose from the artistic possibilities available to him. Though he admired Rossetti and Burne-Jones, in the early stages of his career it was the work of French urban realists such as Toulouse-Lautrec that he chose to re-

work with a Symbolist flavor. Picasso's *Courtesan with a Jewelled Collar* (1901) is, not surprisingly, reminiscent of Lautrec's music-hall characters although it is also touched by the influence of the Symbolists' femmes fatales.

As a result of the Art Nouveau theorists' desire to break down the barrier that existed between the arts, few artists practiced sculpture as an independent activity unrelated to a general scheme of interior decoration or furnishing. Sculpture was thus treated as something of a decorative craft, and helped to feed the vogue for small works which transcended the barriers by being crafted as table lamps and

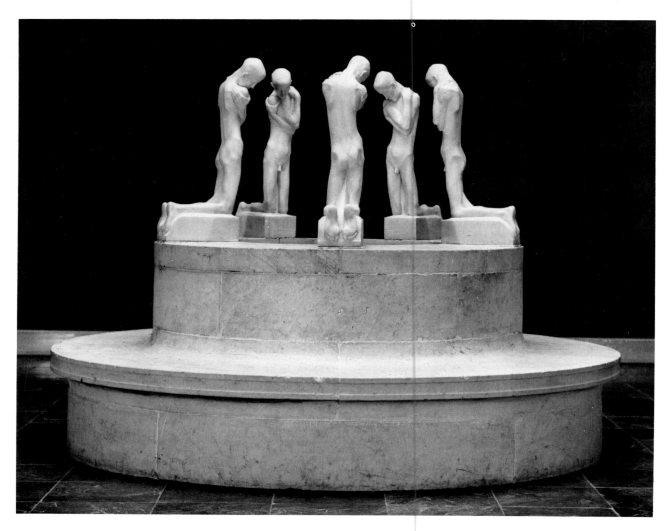

RIGHT: *The Belgian Symbolist Georges Minnes specialized in three-dimensional works such as this* Fountain with Kneeling Youths *(1898-1906) that are less sensual than those of his contemporary Maillol.*

paperweights. These small sculptures were often the work of jewellers, incorporating semi-precious stones, ivory and enamel. The true sculptural masterpieces of the Art Nouveau period are really to be found among the furniture of the Nancy School, the ironwork of Guimard and Gaudí and the glassware of Gallé, Tiffany and Lalique.

Many of the artists who worked in sculpture produced small, decorative bronzes, often later imitated and mass produced in base metals such as spelter and pewter. The largest commercial manufacturer of debased Art Nouveau bronzes was the German company *Württembergische Metallwarenfabrik*, who adapted the typical French maidens to a variety of products. Some of the best quality Art Nouveau bronzes carry French foundry marks: Susse Frères and Siot-Decouville cast many of the works of the leading artists of the day.

Those artists who were sculptors in the fullest sense of the word included Aristide Maillol (1861-1944). Having started his career as a graphic designer and painter, Maillol was associated with the *Nabis* and used the curvilinear style, smooth flowing lines and mythological themes that he would later translate into three dimensions. In the spirit of the 'fin de siècle,' Maillol's figures such as *Flora* were intended to represent the spirit of nature.

Another artist who specialized in sculpture was the Belgian Georges Minnes (1866-1941), a Symbolist and member of the *Salon de la Rose + Croix*. Where Maillol's work was sensual, Minnes' sculpture was ascetic; rather than dreamy-eyed voluptuous women, Minnes' characters were skinny youths and weeping women, as in *Mother Crying Over Her Two Dead Sons* (1886). Minnes' kneeling, praying youths in *Fountain with Kneeling Youths* (1898-1906) are not abandoned to their grief but, like Brancusi's figure in *The Prayer* (1907), have a somewhat languid pose.

LEFT: Flora, *by Aristide Maillol.*

BELOW: Mother Crying Over Her Two Dead Sons, *by Georges Minnes.*

If sculpture was a specialized activity, it was often practiced as a 'side-line' by many painters. Among the first was Paul Gauguin who carved Breton and Polynesian folklore themes on wooden bas reliefs. Gauguin's example of woodcarving was followed by the often overlooked *Nabis* sculptor Georges Lacombe (1868-1916), whose *St Mary Magdalen* (1897) continued Gauguin's religious themes without the roughness of his forms. Lacombe's assured handling of materials ensures that the lines of the figure's hair and garments flow into fluid, rhythmic patterns.

One aspect of Art Nouveau sculpture is the expression of mystery, and many sculpted figures of the period are depicted with closed or downcast eyes. Equally important is the expression of movement. The asymmetrical flowing lines are the most readily identifiable feature of Art Nouveau, and artists experimented with these lines and curves in their attempts to capture movement. Among the finest examples are Paul Roche's studies in bronze of the dancer Loïe Fuller, who at the time of the 1900 Paris Exhibition was at the peak of her career and whose dance was itself an Art Nouveau creation.

In England there was no comparable school of Art Nouveau sculpture. But long after Post-Impressionism and even Cubism had been launched on the continent, something of the spirit of Art Nouveau could still be found lingering in England. The *Shaftesbury Memorial Fountain* (1892), known as *Eros*, was not originally designed to occupy a public site of the character of Piccadilly Circus, since the background and foreground 'attractions' somewhat overshadow the delicacy of the swirling forms and details of the fountain's base. Its designer, Alfred Gilbert (1854-1934), was a musician as well as sculptor who, having trained in Rome, France and Paris, won the Grand Prix at the Paris International Exhibition in 1889. Gilbert, like Charles Ashbee, also designed jewelry, and much of his work was intended to be examined at close quarters. Although the memorial is on such a large scale (at the time it was the largest-ever cast aluminum sculpture), Gilbert's interest in lively forms and movement is apparent.

LEFT: *Georges Lacombe followed Gauguin's lead in experimenting with wood carving. In this figure of* Mary Magdalene *(1897), the lines of the carving flow rhythmically down the figure.*

BELOW LEFT AND RIGHT: *Sir Alfred Gilbert's* Shaftesbury Memorial Fountain *(1892) in London's Piccadilly Circus contains some fine Art Nouveau details.*

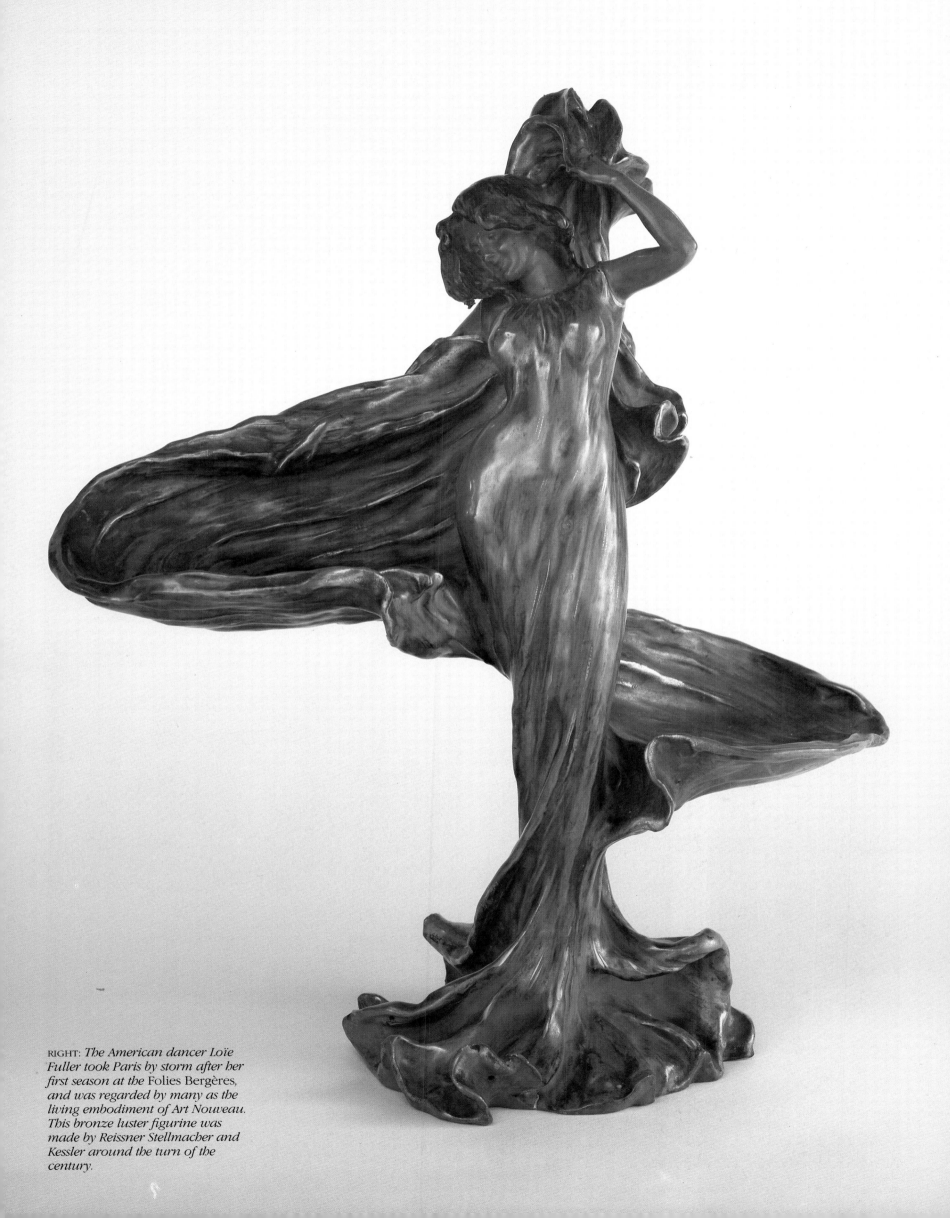

RIGHT: *The American dancer Loïe Fuller took Paris by storm after her first season at the Folies Bergères, and was regarded by many as the living embodiment of Art Nouveau. This bronze luster figurine was made by Reissner Stellmacher and Kessler around the turn of the century.*

Even in 1911, the Art Nouveau spirit was still evident: in that year Sir George Frampton exhibited a memorial to the imaginary character Peter Pan at the Royal Academy. (The choice of subject illustrates the basic differences between British and European sensibilities at the time!) Once again the style in which Frampton worked had a considerable affinity with Art Nouveau jewelry.

Probably the greatest sculptor of the Art Nouveau period, however, and a formative influence on twentieth-century sculpture, was Auguste Rodin (1841-1919). Though Rodin's work redefined sculpture and cannot be confined within Art Nouveau, it is nevertheless a product of its time and could not have been produced in any other. With their corroded, unfinished quality, Rodin's works removed sculpture from all mechanical verisimilitude. The *Memorial Statue to Balzac* was commissioned by the Société des Gens de Lettres in 1891 and was completed in time for the official Salon exhibition of 1898. The sculpture caused an outburst of fury and was eventually withdrawn. Having made a number of studies of Balzac both clothed and nude, Rodin finally represented the novelist in a dressing gown – a garment in which Balzac often worked – but with the sleeves empty and hanging loose. The curves of the drapery and the outline of the figure are not unrelated to those used by other artists of the period, but Rodin's object, unlike that of his counterparts, was not to stress the optical effects but to emphasize the process of the creation.

LEFT: *The aims of Art Nouveau may have been universal, but its themes were often local. Sir George Frampton's* Peter Pan Memorial *in Kensington Gardens immortalized a popular sentimental fairytale.*

BELOW LEFT AND RIGHT: The Burghers of Calais, *by Auguste Rodin.*

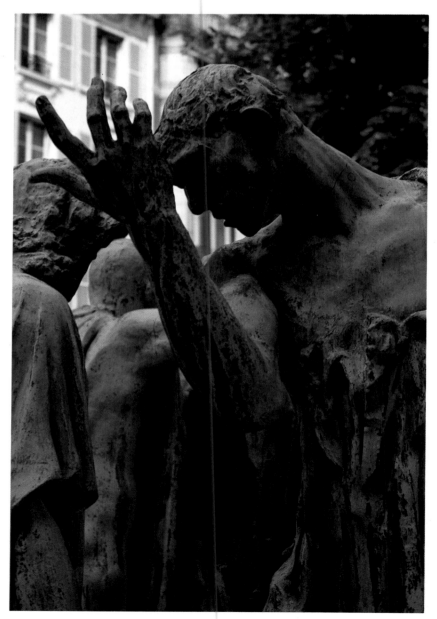

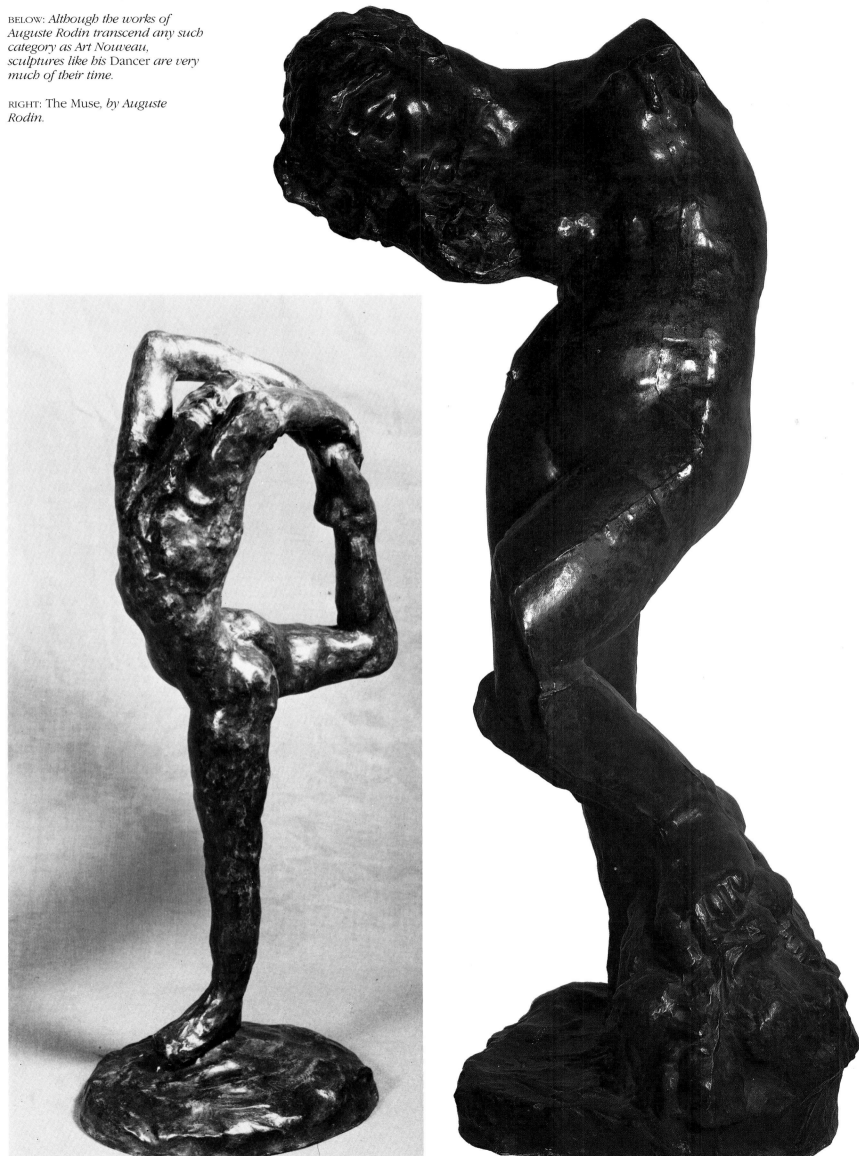

BELOW: *Although the works of Auguste Rodin transcend any such category as Art Nouveau, sculptures like his* Dancer *are very much of their time*.

RIGHT: The Muse, *by Auguste Rodin*.

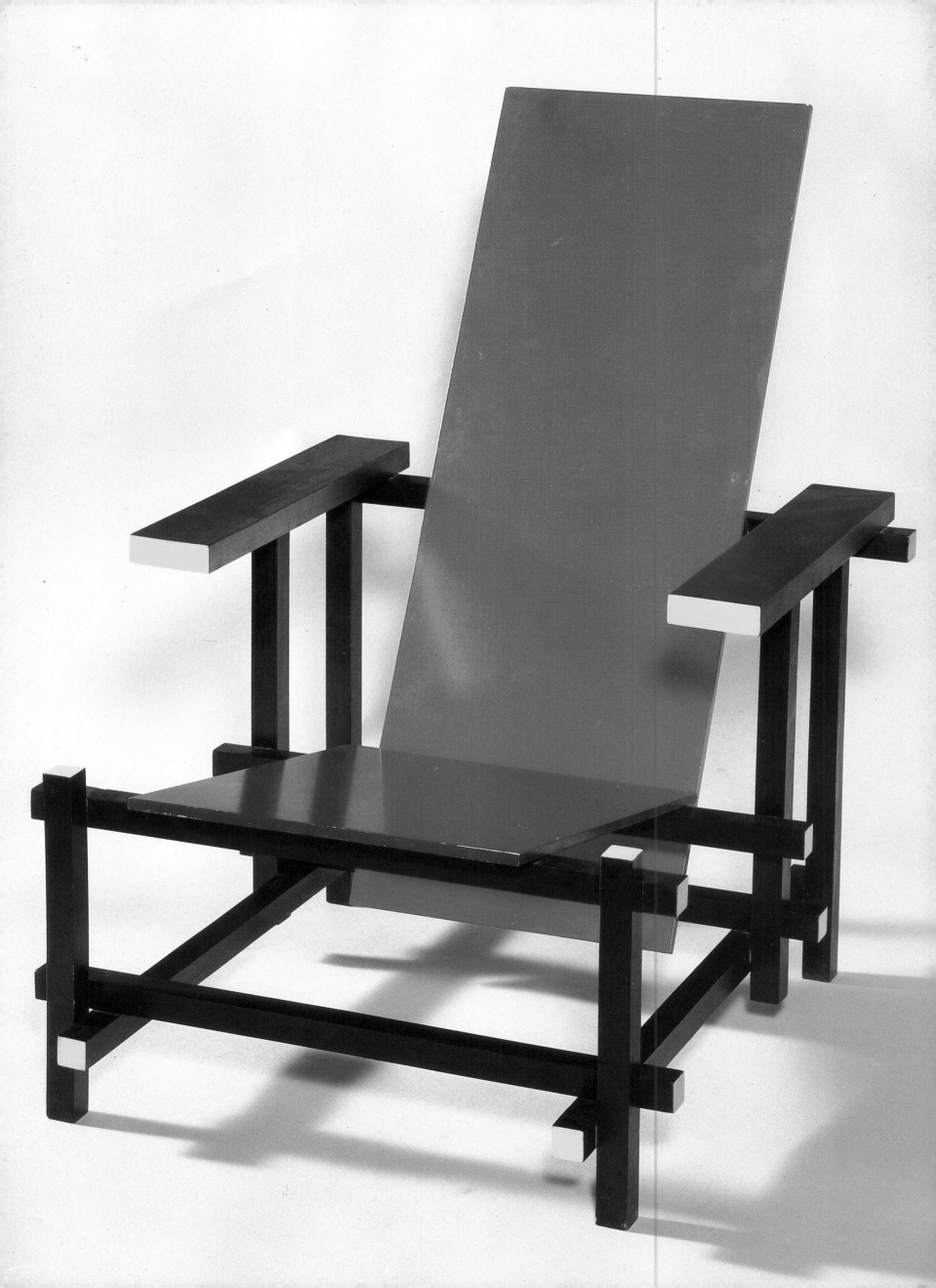

A Far-Reaching Style

LEFT: De Stijl *artist Gerrit Rietveld designed this* Red Blue Chair *in 1917*.

Just as Art Nouveau did not miraculously appear from nowhere, the style did not suddenly vanish, but grew with the technical changes of the age and altered its forms to suit the times. It is useful to remember that many of the leading figures of Art Nouveau died only recently. Throughout the twentieth century both the rectilinear forms that had been favored by the Scottish and Viennese and the curvilinear forms of Art Nouveau were to reappear. Furthermore, the Art Nouveau designers' interest in the function of objects, and their investigations into the capabilities of materials, were continued by twentieth-century practitioners.

The idea that Art Nouveau suddenly disappeared on the eve of World War I is a fiction that has been adopted for the sake of neatness, part of the general tendency on the part of historians to place movements or styles into convenient time slots. But Erich Mendelsohn's use of organic curvilinear forms in the Potsdam Tower (1920) shows how misleading this attitude can be. Though now destroyed, Mendelsohn's drawings show that he was aiming for a plasticity of form that was expressive of both the emotional and functional aspects of the building.

The curvilinear forms of Art Noveau are again to be found in the most famous chair of the twentieth century: Mies van der Rohe's cantilever steel Barcelona Chair of 1929. In spite of its functional appearance, the chair was in fact hand made; yet another reminder of Art Nouveau working methods.

The rectilinear mode of Art Nouveau was developed in the twentieth century at the Bauhaus under Walter Gropius and in Holland by the *De Stijl* artists. The geometricity of Mackintosh and Behrens would be stripped down further in the Schroder House (1924), while the Rietveld Chair (1917) would later be transformed into the familiar modern stacking unit furniture. Although rectilinear Art Nouveau is the precursor of the modern style, particularly in architecture, in certain instances architects and designers would revert to the more curving forms. A case in point is Charles Edouard Jeanneret-Gris (1887-1965), more familiarly known as Le Corbusier. Le Corbusier's flat-roofed buidings with their horizontal bands of windows look like Cubist paintings in three dimensions, but in the *Chapel de Notre Dame du Haut* at Ronchamps, Corbusier returned to the more undulating lines of Art Nouveau.

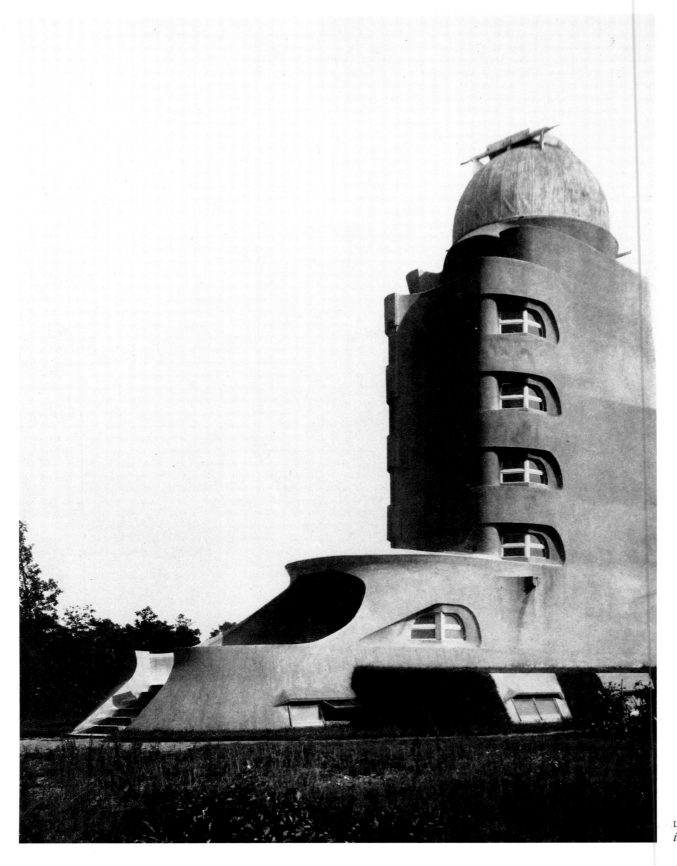

LEFT: *Erich Mendelsohn's influential 1920 Potsdam Tower.*

RIGHT: *The Bauhaus Complex at Dessau (1925-26) by Walter Gropius pointed towards the shape of things to come.*

BELOW: *Le Corbusier's church of Notre Dame du Haute at Ronchamps (1950-54) betrays a lingering taste for the curvilinear.*

The importance that had been placed by Art Nouveau designers on plant forms and their structural capabilities, combined with their enthusiasm for new materials, would all be investigated further by modern architects and engineers. Gaudí's parabolic curves would appear again in the reinforced-concrete constructions of Robert Maillart and Hans Levsinger such as the Cement Hall at the Swiss

LEFT: *The Art Nouveau love of plant forms persisted well into the 1920s in works such as this lily vase by Frederick Carder of Steuben Glass.*

ABOVE RIGHT: *A 1928 printed textile design by Douglas Cockerel shows the continuing influence of the Arts and Crafts tradition.*

BELOW RIGHT: *This 'Simple Solar' fabric design by Shirley Craven, hand printed on cotton satin by Hull Traders Ltd in 1967, reflects the renewed popularity of Art Nouveau in the 1960s.*

National Exhibition in Zurich in 1938-9, and the 'leaning tree' system of supports that Gaudí used in the *Sagrada Familia* would be improved upon by Eugène Freyssinet in the underground Basilica of Pius X at Lourdes (1958).

The Art Nouveau pioneers of concrete such as August Perret would extend their influence over many engineers. Felix Candela, a Spanish-born engineer who had fought with the Republicans during the Spanish Civil War, emigrated to Mexico where, for the University City, he designed the Cosmic Ray Lab (circa 1960). Like Gaudí,

Candela made use of a series of hyperbolic parabaloids for the reinforced concrete roof, the strength of the shape allowing him to reduce its thickness to around half an inch. But it is in the TWA Terminal at Kennedy Airport, designed by Eero Saarinen in 1961, that the organic rhythmic forms of the curvilinear tradition of Art Nouveau are most apparent.

As the twentieth century advanced, the belief in the possibility of a purely rational world began to decline and was finally shattered by the events of the World War II. During the following years, there was

a movement away from 'rational'; geometric forms in design; curving, biomorphic forms with a close affinity to those used by the Art Nouveau artists now began to find favor. The functional, straight-lined objects of the 1920s and 1930s were gradually giving way to gentle whiplash curves. Even automobile design felt the influence of this trend as the functionalism of the earlier models gave way to an increased irrationality of form; compare the box-like appearance of an army jeep or a Model T Ford with the curves of a classic British or American car of the 1940s and 1950s. Their design was no longer a mere reflection of their function; the car had become a symbol of prestige, class and power.

With the emergence of Pop Art, artists once again focused as Lautrec had done on everyday urban scenes and domestic objects, and in doing so once again made use of the techniques of poster art. The Art Nouveau posters that celebrated modern life became an important source of approaches and styles. In an effort to achieve harmony with nature and the environment, the pop culture of the 1950s and 1960s promoted a revival of the familiar organic and expressive forms of Art Nouveau. New materials such as plastics, fiberglass and foams facilitated the production of molded chairs with flower-like stems and bases and tulip-shaped seats; thus the new materials facilitated not just a revival, but a genuine extension of Art Nouveau forms.

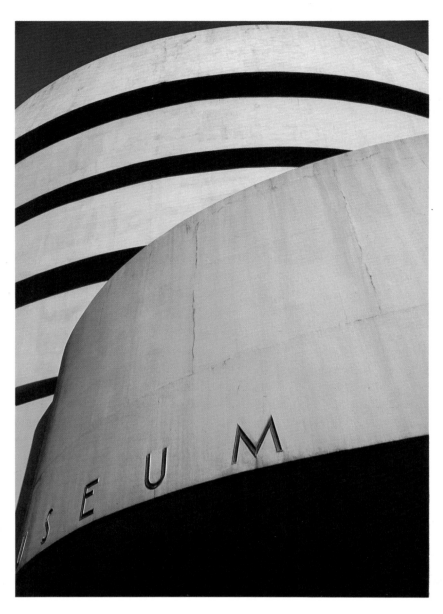

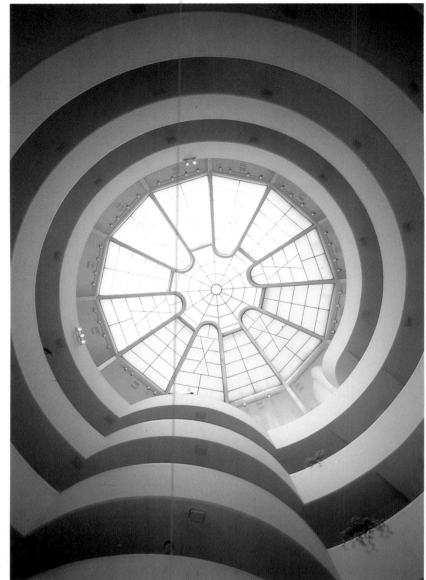

The psychedelia of the 1960s and early 1970s was perhaps the development that came closest in style to Art Nouveau. Even the drug culture of these years was an aspect shared with many turn-of-the-century Symbolist writers and artists. The pop preoccupation with nostalgia, the desire to 'drop out' of society in favor of a somewhat idealized 'simple life' parallels the Pre-Raphaelites' preoccupation with medieval craft society and the Art Nouveau artists' quest for

'Truth to Nature.' Not surprisingly, therefore, Art Nouveau enjoyed a considerable revival. The original artifacts were prized once more, and imitative designs flourished. Swirling tendrils and Pre-Raphaelite heroines graced shop fronts, record sleeves and rock concert posters. And in the 1960s the symbols of revolution and freedom were those also found in Art Nouveau art and design – the nude and long flowing hair.

ABOVE LEFT AND RIGHT: *Details of the Guggenheim Museum in New York (1959), by Frank Lloyd Wright. The spiral ramp echoes Gaudí's original plan for the* Casa Mila *in Barcelona.*

LEFT: *'Dondolo' rocking chair in molded fiberglass by Cesare Leonardi and Franca Stragi, first exhibited in Milan in 1968.*

RIGHT: Three figures in a silk dress by Julian Tomchin, *photographed by Hiro (1967).*

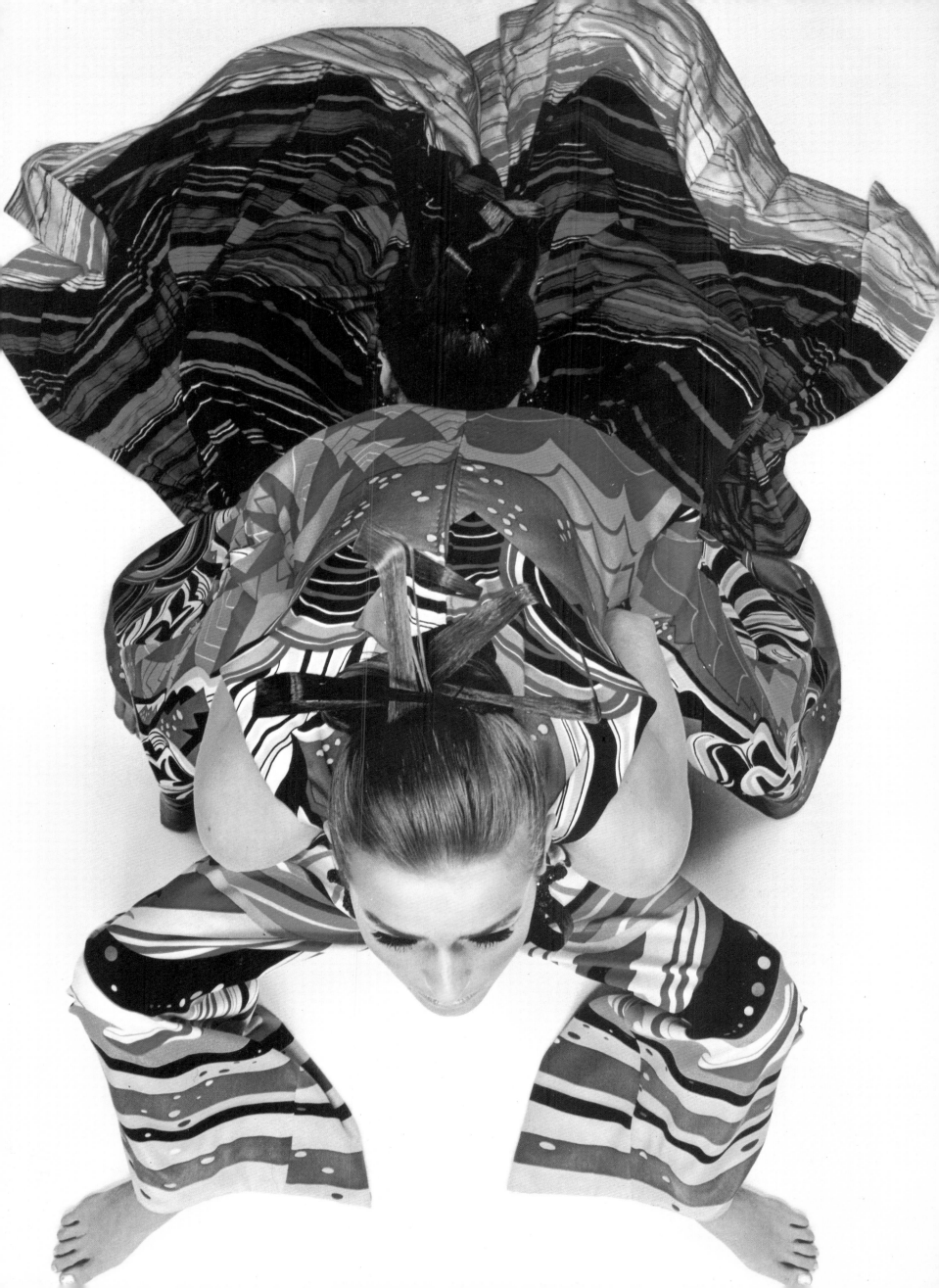

Chronology

	World Events	Art	Literature/Music	Science/Technology
1848	Revolutions in France, Austria, Germany and Italy	Pre-Raphaelite Brotherhood formed	Dickens' *Dombey and Son* published	
1851		Great Exhibition at the Crystal Palace, Hyde Park, London		
1853-6	Crimean War			
1855		Paris World Fair		Bessemer process of steel making introduced
1856		Bracquemond discovers Japanese prints in Paris		
1857		Victoria & Albert Museum opens at South Kensington, London	Flaubert prosecuted for immorality in *Madame Bovary* Offenbach's *Orpheus in the Underworld* (le can-can)	
1859				Darwin's *Origin of the Species* published
1860	Unification of Italy			
1861	American Civil War begins	William Morris founds Morris & Co		
1862			Hugo's *Les Misérables* published Flaubert publishes *Salammbô*	Nobel uses nitroglycerin as explosive
1863		Salon des Refuses – Whistler, Cézanne, Manet, Pissarro exhibit Moreau's first success at Paris Salon		Nadar raises balloon over Paris Arc lamps in use for lighting
1864	1st International. Pius IX issues *Quanta Cura*			
1865	Assassination of Abraham Lincoln		Wagner's *Tristan and Isolde* performed Tolstoy's *War and Peace* published	
1866	Austro-Prussian War	Crinolines out of fashion	Dostoevsky's *Crime and Punishment* published	
1867	Mexican Revolution Reform bill extends franchise in Britain	Paris World Fair – Courbet and Manet show works		Siemens brothers introduce dynamo Lister develops antiseptic Suez Canal opens
1868	Disraeli PM in Britain		Rossini dies	
1869			Berlioz dies	Walter Press allows for continuous printing
1869-70	Vatican Council, first council in 300 years, declares Pope infallible when speaking *ex cathedra*			
1870	Franco-Prussian War declared 18 July Third Republic in France declared 4 September Prussian King becomes German Emperor Period of European emigration		Dickens dies	
1871	Second Reich in Germany, 1871-79 Armistice declared in Franco-Prussian war 28 January Paris Commune March 18-28 May		Nietzsche publishes *The Birth of Tragedy*	Dryplate photographic process developed by Richard Leach Maddox
1872	Economic boom in Europe	Durand-Ruel exhibition of 'Impressionists' in London		
1873	Economic crash followed by 6 years' depression Death of Napoleon III	Vienna exhibition	Spencer's *The Study of Sociology* published	
1874		1st group exhibition of painters dubbed 'Impressionist'		
1875	Monarchical Constitution in Spain Turkey at war with Serbia and Russia	Liberty opens shop	Bizet dies	
1876			Mallarmé publishes *L'après-midi d'un faune* George Sand dies	Internal combusion engine perfected
1877			Tchaikovsky's *Swan Lake* performed Zola's *Nana* published	Edison develops phonograph
1878		Paris World Fair – Barbizon painters		Bell develops telephone, Edison invents incandescent lights
1878-1903	Leo XIII issues *Rerum Novarum* – restates belief in private property and sanctity of family			
1881	Czar Alexander II assassinated			
1882	Death of Garibaldi	Manet paints *Bar at the Folies Bergère*	Mackmurdo publishes *Wren's City Churches*	

	World Events	Art	Literature/Music	Science/Technology
1882		Century Guild formed, London	Huysman's *L'Art Moderne* published	
1883	Marx dies	Whistler's *Portrait of his Mother* exhibited in Paris	Wagner dies	Pasteur vaccinates against anthrax
1884		Art Workers Guild formed, London *Les Vingt* formed, Brussels	Bruckner's 7th Symphony performed; *Hobby Horse* published	Development of steam turbines Development of Linotype
1885		Delacroix retrospective exhibition, Paris Van Gogh in Paris	Zola's *Germinal* published	Development of Monotype Bicycle 'chain drive' introduced
1886		Beginning of Post-Impressionism; Synthesists at Pont-Aven Douanier Rousseau at Salon des Indépendants Whistler Exhibition, Paris Seurat paints *Sunday Afternoon at the Island of the Grande Jatte* Statue of Liberty dedicated, New York	Verlaine publishes *Illuminations* by Rimbaud Moreau publishes *Symbolist Manifesto*	Eastman develops Kodak Camera
1887			Richard Strauss's *Macbeth* performed Verdi's *Otello* performed	
1888		Arts & Crafts exhibition, London	Huysmans' *À Rebours* published	
1889	British occupation of Egypt Boulanger Crisis, Fall of Bismarck	Paris exhibition, Eiffel Tower	Bernhardt opens in *Hamlet* in London	Pneumatic tires developed
1890s		Morris founds Kelmscott Press	W B Yeats founds Rhymer's Club, explores the occult	Electric transport systems introduced in Europe
1891		Gauguin in Tahiti		
1892	Panama Scandal	*Les Cinq* formed World Fair Chicago, Japanese Pavilion	Debussy completes *Prélude à l'après-midi d'un faun*	
1893		Munch paints *The Cry*	Tchaikovsky dies	
1894	President Carnot of France assassinated by Italian anarchist Czar Nicolas II crowned Dreyfus Affair (acquited 1906) Irish Question Milan riots Spanish-American War: Spain cedes Puerto Rico, Guam and Philippines to US and withdraws from Cuba Boer War	Monet begins 'Rouen Cathedral' series	*Revue Blanche* published Wilde's *Salomé* published Mahler's 2nd Symphony performed	Marconi develops wireless telegraphy Gum print photo process developed First Paris-Rouen car race
1895		Bing opens 'L'Art Nouveau' in Paris	*Pan* published Will Bradley's *Bradley: His book* published	Röntgen discovers X-rays First motion-picture show in Paris by Lumière Brothers
1896		Munich Secession, *Jugend* published Lautrec designs his first poster	Puccini's *La Bohème* performed *Ver Sacrum* published	Henry Ford builds his first car First public film show in US
1897	Assassination of Spanish Prime Minister	1st Vienna Secession exhibition Henry Tate presents Tate Gallery to nation		Aspirin produced Malaria identified
1898	Empress of Austria assassinated	'Mont St Victoire' paintings by Cézanne. *Ver Sacrum* published	Wilde's *Ballad of Reading Gaol* published	Curie discovers Radium
1899		Darmstadt Colony set up by Archduke of Hesse		
1900	King Umberto of Italy assassinated	Paris Exposition Universelle – Art Nouveau on show	Joseph Conrad's *Lord Jim* published	
1901	US President McKinley assassinated Queen Victoria dies; Edward VII accedes	Pan American Exhibition, Buffalo, USA École de Nancy formed		
1902	Alfonso XIII of Spain comes of age	Turin Exhibition, 1903 *Wiener Werkstadt*	Caruso makes his gramophone recording	
1903				First powered flight at Kitty Hawk by Wright Brothers
1904	Russo-Japanese War	Louisiana Purchase Exhibition Muthesias publishes *Das Englische Haus*		
1905	Uprising in Russia			
1906	Clemenceau Prime Minister of France			
1907		*Deutsche Werkbund*		Blériot flies the English Channel

Index

Page numbers in *italics* refer to illustrations

Bibliography

Abbate, Francesco (Elizabeth Evans) *Art Nouveau* Octopus, 1972

Amaya, Mario *Art Nouveau* Studio Vista, 1966

Anscombe, Isabelle *A Woman's Touch: Women in Design from 1860 to the Present Day* Virago, 1984

Battersby, Martin *The World of Art Nouveau* Arlington Books, 1968

Bowman, John S *American Furniture* Exeter/Bison Books

Bradbury, Malcolm and McFarlane, James (eds) *Modernism* (Pelican Guide to European Literature) Penguin, 1976

Casanelles, E *Gaudi: A Reappraisal* New York Graphics Society, 1965

Evers H G *The Modern Age* Methuen, 1967

Forty, Adrian *Objects of Desire: Design and Society 1750-1980* Thames and Hudson, 1986

Frampton, Kenneth *Modern Architecture: A Critical History* Thames and Hudson, 1980

Gallo, Max *The Poster in History* New American Library, 1974

Gaunt, William *English Painting* Thames and Hudson

Hanks, David A *The Decorative Designs of Frank Lloyd Wright* Studio Vista, 1979

Hauser, Arnold *The Social History of Art: Vol 4 Naturalism, Impressionism, The Film Age* RKP, 1951

Henderson, Philip *William Morris: His Life, Work and Friends* Thames and Hudson, 1967

Lucie-Smith, Edward *Symbolist Art* Thames and Hudson, 1967

MacCarthy, Fiona *All Things Bright and Beautiful: Design in Britain, 1830 to Today* Allen and Unwin, 1972

Macleod, Robert *C R Mackintosh* Countrylife Books, 1968

Naylor, Gillian *The Arts and Crafts Movement* Studio Vista, 1971

Nuttgens, Patrick *Mackintosh and his Contemporaries* John Murray, 1988

Pevsner, Nikolaus *Pioneers of Modern Design* Penguin, 1960
　　The Sources of Modern Architecture and Design Thames and Hudson, 1968
　　History of Modern Architecture Vol 1: The Tradition of Modern Architecture MIT Press, 1977
　　Studies in Art Architecture and Design: Victorian and After Thames and Hudson, 1968

Pollack, Peter *Picture History of Photography* Abrahams, 1969

Powell, Nicholas *The Sacred Spring* Studio Vista, 1975

Rowland, Kurt *A History of the Modern Movement* Van Rostrand Rheinhold, 1973

Schaefer, Herwin *Nineteenth Century Modern* Praeger, 1970

Sweeney, J J and Sert, J L *Antoni Gaudi* Architectural Press, 1960

Thompson, E P *William Morris: Romantic to Revolutionary* Lawrence and Wishart, 1955

Walken, R A *The Best of Aubrey Beardsley* Chancellor Press, 1985

Watkinson, Roy *William Morris as Designer* Studio Vista, 1967

Acknowledgments

The publisher would like to thank Chris Schüler the editor, Martin Bristow the designer, Mandy Little the picture researcher and the individuals and agencies listed below for supplying the illustrations:

PICTURE CREDITS

Aberdeen Art Gallery and Museums page 11 below; Anderson Collection of Art Nouveau, University of East Anglia, Norwich pages 12 right, 101 top, 151 top centre and left, 172 top, 175; T & R Annan and Sons Ltd, Glasgow pages 62, 70, 71 right, 74, 75, 78 below; ARCAID/ Richard Bryant pages 68 top, 88 right, 91, 116 both, 117 top; Architectural Association pages 80 right, 88 below, 92, 97 below, 100 top, 112 both; Courtesy of the Art Institute of Chicago/The Alfred Steiglitz Collection pages 59, 60, left, 61 /Department of Architecture page 111 centre, /Bessie Bennet Fund page 119 top, /Gift of Mr and Mrs Phillip R Dunne page 122 below, /Gift of Malcolm, Kay, Kim and Kyle Kamin page 185, /Gift of Mrs Philip Wrigley page 107 right; The Art Museum, Princeton University page 122 top right; C H Bastin and J Evrard pages 29, 83, 85 top and below, 88 left; Bibliothèque des Arts Decoratifs, Paris/ Weidenfeld Archive page 39; Bison Picture Library pages 35 left, 42, 43 top right, 50 both, 184 below; Courtesy of the Trustees of the Boston Public Library page 158 top; The Bridgeman Art Library/Private Collection pages 10 left, 104 below left, 143 left, 149 below; The British Architectural Library, RIBA, London pages 94 both, 97 top left, 99

right, 110 top, 111 below, 180, 181 top; The British Museum, London/The Bridgeman Art Library page 18 below; Cassina S P A page 184 top, /The Design Council page 79 below; Martin Charles pages 68 below, 69, 84; Chicago Architectural Society/ Weidenfeld Archive page 110 below; Christie's pages 11 top, 49, 53 all three, 99 left, 108 top, 109, 117 both, 123 both, 135 below, 136 both, 137 right, 138, 139 all three, 144 both, 147 top, 149 left, 152 below, 155; Conway Library/Courtauld Institute pages 95, 118 both; The Corning Museum of Glass, Corning, New York pages 10 right, 140 top and right, 141 right, 142, 143 top and right, 145, 146, 147 below, 182; The Design Council page 135 top; Dundee Art Galleries and Museums page 168 top; Moira Dykes pages 174 bottom two, 176 bottom two; ESTO/Peter Aaron pages 120, 121 both, 122 top left, /Wayne Andrews pages 86, 87, 90 both, 98 top, 111 top, 114 below, 115, /Ezra Stoller page 119 below; E T Archive/Victoria and Albert Museum pages 17 below, 34 right; Courtesy of the Freer Gallery of Art, Smithsonian Institution, Washington DC page 23, /The Bridgeman Art Library pages 20-21; Folkwang Museum, Essen page 172 below; Fondation le Corbusier page 181 below; Frank Lloyd Wright Foundation/Weidenfeld Archive page 114 top; Philippe Garner, London/The Bridgeman Art Library page 124; Gernsheim Collection, Harry Ransom Humanities Research Center, The University of Texas at Austin page 54; Glasgow School of Art/The Bridgeman Art Library page 73 both; Graphische Sammlung Albertina, Vienna page 171

top; Greater London Photograph Library pages 66 both, 67 both; Hessisches Landesmuseum, Darmstadt page 45 top right; Angelo Hornak pages 2, 25 top, 26 top, 72, 81 top, 85 center, 93, 96, 97 top left, 100 below, 113, 128 top, 140 below left, 141 left, 178; Hunterian Art Gallery, University of Glasgow, Mackintosh Collection pages 71 left, 76 below right, 77, 78 top, 80 left, 162 both, /The Bridgeman Art Library page 127 below left; International Museum of Photography at George Eastman House pages 55, 57 top, 58, 60 below; State Museum Kroller-Muller, Otterlo, The Netherlands page 161 below, 163; Kunstindustrimuseet, Copenhagen pages 126 below, 154 top, 158 below; Kunstmuseum Bern/Staat Bern pages 160 both, 161 top; Kunstmuseum, Winterthur page 173 left; Leeds City Art Galleries page 177 left; Liberty and Co/ Weidenfeld Archive pages 129, 130 top, 132, 133, both, 148 top right; Lords Gallery/Weidenfeld Archive page 40; Mappin Art Gallery/The Design Council page 148 below; Metropolitan Musem of Art/David A McAlpin Fund page 56,/ The Alfred Steiglitz Collection page 60 right; Munch-Museet, Oslo pages 156, 166, 167; München, Neue Pinakothek/ ARTOTHEK pages 164 above, 168 below; Musée des Arts Decoratifs, Paris/Photo MAD/Sully-Jaumes pages 102 top left, 104 below right, 149 top right, 151 right,/Weidenfeld Archive page 106 both; Musée Cantonal des Beaux Arts, Lausanne page 171 below; Musée des Beaux Arts, Lille page 174 top; Musée de l'Ecole de Nancy/Cliche Studio Image Nancy pages 52 both, 101 below, 105; Musée Gustav Moreau, Paris pages

30, 159; Musée du Louvre, Paris page 31; Musée de la Publicité, Paris pages 41 left, 45 top left, 48 left; Musées Royaux des Beaux Arts de Belgique pages 164 below, 173 right; Museum Bellerive pages 107 top, 126 top; Nasjonalgalleriet, Oslo page 165; National Galleries of Scotland, page 28 below; Nordenfjeldske Kunstindustrimuseum, Trondheim pages 16, 17, top two, 127 top, 128 below, 153 top; Österreichische Galerie, Vienna/Verlag Galerie Welz page 169, 170; Österreichische Nationalbibliothek page 98 below; Punch Publications Ltd page 64 below; Royal Pavilion, Art Gallery and Museums, Brighton pages 13 right, 102 top right and below, 104 top, 108 below, 131 both, 137 left, 153 below; Staatsgalerie, Stuttgart page 35 right; Jessica Strang page 64 top and center; The Tate Gallery, London pages 6, 24, 177 right; Topham Picture Library page 89; The Board of Trinity College, Dublin page 19; Victoria and Albert Museum, London pages 27 top, 36, 41 right, 43 top left, 46, 47 both, 57 below, 107 left, 154 bottom, 183 below,/ The Bridgeman Art Library pages 14, 76 below left, 148 top right, 150, 152 top, 183 top, /Weidenfeld Archive page 13 top and bottom left; Weidenfeld Archive pages 8 both, 9, 12 left, 18 top, 27 below left, 32, 34 both, 79 top, 82 both, 103, 127 below right, 129, 130 below, 134 both; The Whitworth Art Gallery page 21; The William Morris Gallery, Walthamstow, London pages 22 both, 26 below, 27 below right, 28 top; Stuart Windsor pages 65 all three, 81 below, 176 top; Woodmansterne/The Design Council page 25 below.